STENCIL
NATION

GRAFFITI,
COMMUNITY,
AND ART

By Russell Howze

Manic D Press
SAN FRANCISCO

Library of Congress Cataloging-in-Publication Data

Howze, Russell, 1969-
 Stencil nation : graffiti, community, and art / by Russell Howze. --
 1st ed.
 p. cm.
Includes bibliographical references.
ISBN 978-1-933149-22-6 (trade pbk. original)
1. Stencil work. 2. Street art. 3. Graffiti. I. Title.
NK8654.H69 2008
745.7'3--dc22

 2008013236

Cover Art by Francisco Garcia AKA Dogcat
Cover Photo by Francis Mariani
COVER AND BOOK DESIGN BY JUSTINE IVES

Previous page: artist unknown, photo by D.S. Black, San Francisco, CA, 1993
Opposite page: artist unknown, photo by David Drexler, Madison WI, 2007

Dedicated to

MY FAMILY, AND LAURA, FOR THEIR LOVE, ENCOURAGEMENT, AND SUPPORT

Acknowledgments:

Al Kizziah for being at the right place at the right time
Josh MacPhee, Claude Moller, and Scott Williams for inspiration
The fine people at Manic D Press
The contributing artists and photographers (and researchers) for all their support, dedication, and hard work!

Contents:

Timely Stencils, Timeless Meanings

Chris Carlsson

Ours is a curious moment in history. A greater number of people are traveling for more reasons than ever before, cross-pollinating, miscegenating, hybridizing, and inventing new media, new multilingual expressions, and new art forms. At the same time, the vast diversity of human languages that once covered the planet in a real Tower of Babel is shrinking. The preponderant influence of U.S. media and culture has promoted American English as the lingua franca underlying the monocultural monotony slowly oozing across the world—at least for now. While literacy is more prevalent than before, books, magazines and newspapers are all suffering a decline in popularity and diminished commercial viability.

In the face of all this, a curious hybrid form has been popping up in diverse places: stencil art on walls and sidewalks. Sometimes stencils rely on words and text, other times they present graphic juxtapositions that make our heads spin. The artists and agitators who are decorating our built environment are simultaneously invoking millennia-old art forms, echoing pre-literate and pre-industrial signage, and jumping across the chasms of the digital divide and the complete commercialization of public communication. To a real extent, stencil artists are inventing a new language that resonates deeply because it's also one of the oldest languages, a language that transcends nation, tribe and ethnicity.

This is most true to the casual observer who is wandering the streets of a strange city. This past summer in Istanbul, Turkey, I came upon a curious sight: a stencil of Malcolm X staring at me from the walls of the quasi-bohemian neighborhood of Cihangir. About twenty meters down the street was a stencil of Osama bin Laden, and around the corner was a poignant black stencil of a woman clutching her ribs while yelling in despair (in red paint): Savas Öldür Öl Geber. Black paint then wrote over the last word replacing Y for G and t for b. All in Turkish, I needed my pal Ali to translate: Savas = war or wage war, Öldür = kill, Öl = be killed, Geber = die, and then the addition turns the last word to Yeter = enough.

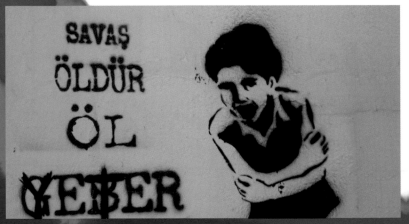

But even with the much deeper meaning provided by the translation, somehow the image communicated despair and refusal even before I knew what was being said.

Long before modern stencils, pre-historic peoples found their own ways to communicate on the physical surfaces of their environment. I came upon a

remarkable collection of petroglyphs one time while rambling across Nevada's Great Basin land-scape. Driving along Highway 50, only a dozen miles from the state capitol, we stopped at the Grimes Point Archeological Area, where 10,000-year-old rock paintings decorate the shores of what was once Lake Lahonton and is now a dry desert. Juxtaposing the public writings of that time to today's urgent words and images brings home the timelessness of the form. It also sheds light on the history contemporary stencil artists and other purveyors of public art are creating around us all the time.

Who knows how long a given piece will last? Will this book and others like it be the only repositories of the work we find in its pages, or might the stencils transcend this epoch and appear mysteriously opaque to generations in the distant future? Communicating across time, space and culture is a persistent challenge to human beings. This collection is a great window on a passion and practice that spans not just cultures and generations but millennia, and also cogently captures the contradictions, humor, poetry and grace of our crazy time on this wet rock called Earth.

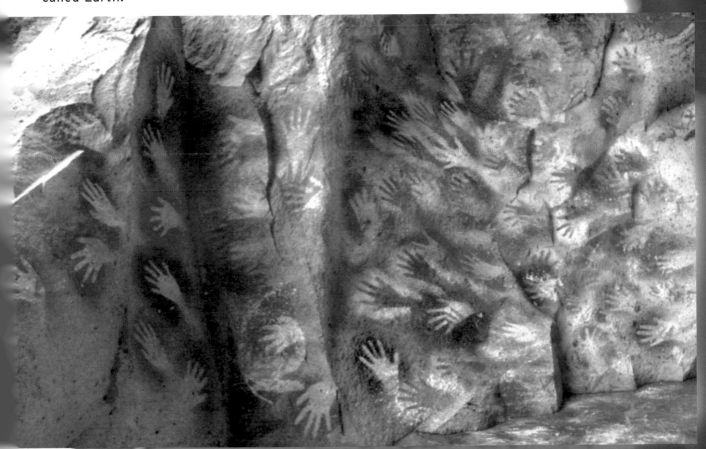

This Page: prehistoric hand stencils, Cueva de las Manos, Argentina.
Opposite page: artist unknown, Istanbul, TK, photo by Chris Carlsson, 2007

7

WELCOME. BIENVENIDOS. WILLKOMMEN. ようこそ.

A newly discovered country exists without borders, leaders, and ironclad laws. Its citizens carry no official identification: the paint stains on clothes and hands, or a camera for photographing an alley wall, stand as informal documents of citizenship. This land has no military defense; its only protection is a good hiding place for a piece of cutout material and a spray can, and extra pairs of eyes looking out for the police. To become a member of this nation, one only has to think up an idea, put it on a piece of paper or plastic, cut it out, and paint it somewhere. Another path to citizenship originates with those who appreciate the painted art, seek it out, document it, and enjoy a fresh alternative to mainstream urban culture.

Since the 1970s, and maybe earlier, the ambiguous boundaries of this Stencil Nation have woven together into a unique early 21st century art form. With roots going back thousands of years, this body of people has finally united, and together push and pull at the interpretations of graffiti, art, commerce, politics, and language. Unified via medium yet with different visions, stencil artists and fans confront problems and complexities through a rich landscape of spray-painted possibilities.

In cities, on the streets, the ironies and contradictions of our times are summed up in simple images, often with a bit of text, stirring emotions and begging questions. The artists of this nation work quietly yet speak loudly from the dark urban landscapes. Their visions are sometimes accepted by the members of the cultural mainstream, who may express interest by paying for a piece of a citizen's work. Galleries and museums have noticed the power of this community's voices and visions, and their walls reflect their newly acquired tastes. Yet Stencil Nation continues to take the do-it-yourself ethic to heart, and build unique community frameworks around a shared culture. These attempts to wall in and commodify the freeform nature of stencils continue to spread the grassroots concepts from which the art form originated.

Stencil Nation: Graffiti, Community, and Art attempts to take these emotions and connections and share them with others who may or may not know about the art form. Artists, documenters, and fans from the communities present their own perspectives on stencil art, offering insight and creativity that may help someone fall in love with the art of negative space, while enriching appreciation for it as well. Stirred together into a tasty stew of art, culture, and constant change, these characteristics make Stencil Nation an exciting place to be.

No fences keep you from entering this country. No visas or passports are needed, and you may already be a citizen. Your ability to change your routine, look for the unexpected, and tap into your creativity is the only thing necessary for admission to this dynamic, creative land. With this book as your guide, you should find enough inspiration to keep your eyes and mind open.

Opposite page: stencil + photo by Russell Howze, San Francisco, CA, 2007

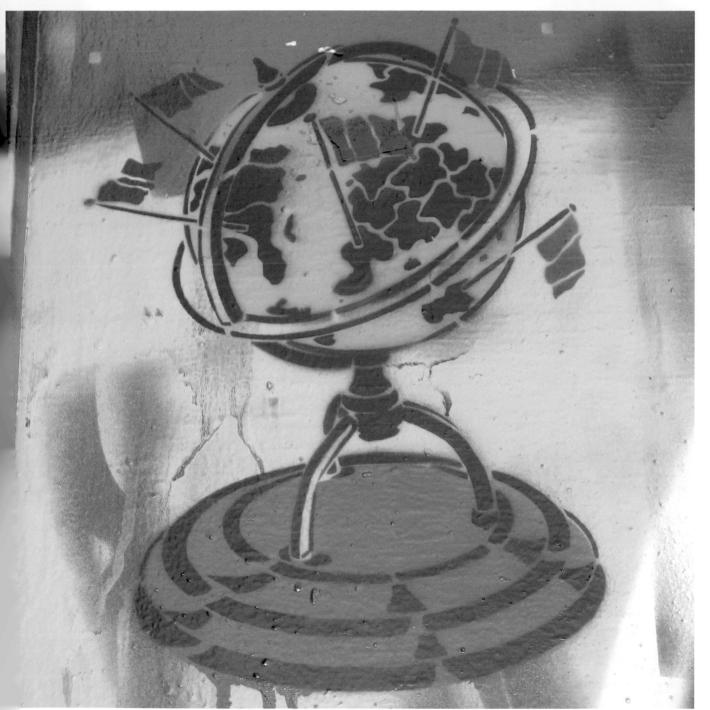

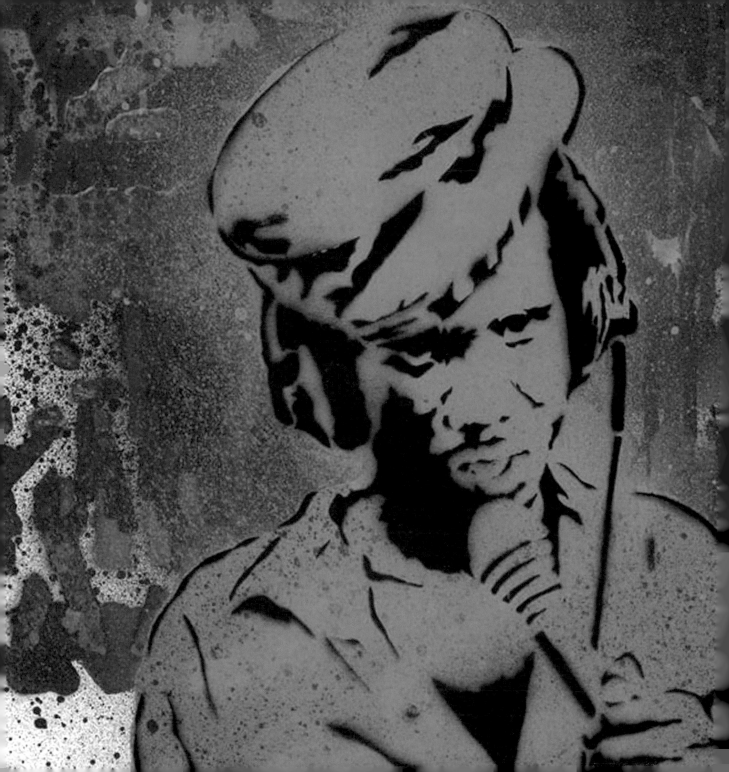

ORIGINS:

Chronology

CITIZEN: JOHN FEKNER (AEROSOL PIONEER)

CITIZEN: JEF AÉROSOL (AEROSOL PIONEER)

CITIZEN: SCOTT WILLIAMS (AEROSOL PIONEER)

CITIZEN: D.S. BLACK (DOCUMENTARIAN)

origins

The stencil's intriguing history constantly raises questions about its origins and usage. What motivated ancient humans to apply colored pigment to their hands, tools, and weapons? How did this idea occur independently on at least three different continents? Which ancient Egyptian artist or engineer thought of using a stencil as a template for tomb decoration? In the 1970s, how did different political movements all come to rely on stencil art as a form of expression?

The story of stencil art creates a curious puzzle. The most telling pieces no longer exist or have not yet been found. The tool's ancient history holds piecemeal accounts of its use, yet fragments of the storyline can be found: artists in China used the cut-out template, Japanese artists refined it, and France's design companies turned it into an industrial art form in the early 20th Century. Surprisingly, the stencil's late-20th century history remains relatively undocumented as well. Many artists used stencils as a form of political discourse, and the influence of that method remains visible in the early part of this century. However, extensive documentation does not exist.

Even though stencil art's full narrative remains uncertain, recent attempts at developing its background have helped begin analysis. A few people have tried to connect today's stencil scenes to the art form's history. In 1986, the pochoir street art scene in Paris was discussed in Joerg Huber's Paris Graffiti and Guillaume Dambier, Kriki, and Solange Pierson's Pochoir A La Une. In 1996, Peter Walsh wrote an essay on stencils to accompany the Baltimore, Maryland show "On the Street - Off the Street" at the Maryland Art Place Gallery. A year later, Brian Drolet wrote briefly about stencil history when the Cooper Union's "Ambush in the Streets" pochoir photo exhibit opened in New York City.

Since then, authors Tristan Manco, Josh MacPhee, Caroline Koebel, Kyle Schlesinger, and others have added to our understanding of stencil art's story. Recently, internet research has helped in the discovery of other essays, interviews and texts that shed light on stencil art. Museums and arts organizations have begun to seriously reflect upon stencils as an important printmaking medium. For example, San Francisco's KQED television program Spark featured stencil artist Adam5100 in 2007 and included a downloadable "Educator Guide" for teaching students about stencils. Along with the artist's profile, the guide contained an essay about stencils as well as additional resources.

Stencil Nation hopes to build upon this groundwork and present the stencil's history in a clear sequence of time. As the reader can see, gaps persist, estimated dates remain, and some details are anecdotal. However, many new parts of the story have been added which will hopefully create a better understanding of the tool's evolution. This chronology is considered to be a living document that will change, grow, and amend as art historians continue to piece together the amazing story of how an ancient art form has re-emerged as a popular form of expression in the early 21st century.

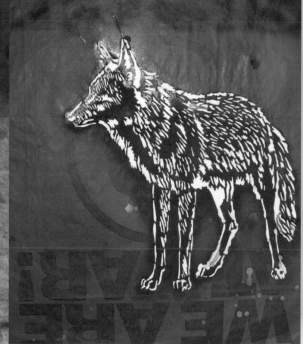

RECORD
HEAT:
FEVER OF A
DYING PLANET

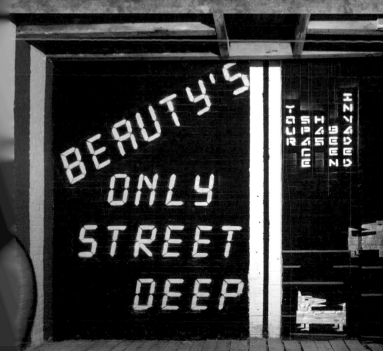

BEAUTY'S
ONLY
STREET
DEEP

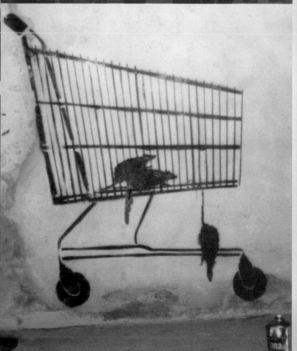

chron

c. 30,000 BCE — Aurignacian Era cave art includes stenciled images in Chauvet cave, France.[1]

c. 27,000 BCE — Gravettian Era cave art leaves stencils created in Cosquer cave, France.[2]

c. 16,000 BCE — Aboriginal cave art stencils painted in Kennif cave, Australia.[3]

c. 2,500 BCE — Aboriginal cave art stencils mouth-sprayed in Cathedral cave, Australia.[4]

c. 2,400 BCE — Stencils commonly used in Egyptian tomb decoration.[5]

c. 1,000 BCE — Tehuelches create hand stencils at Cueva de la Manos, Argentina.[6]

c. 200 BCE — Stencils commonly used in China.[7]

c. 100 B — First cutout shadow puppet appea in China

1941-1945 — Kukriniksy collective uses stencils for TASS Windows Project, USSR.

1941 — Marcel Duchamp stencils famous "Moustache and Beard of L.H.O.O.Q." on 200 covers of Georges Hugnet's pamphletted poem "Marcel Duchamp."[25]

1936 — Stencils used to mark Spanish-anarchist armored cars with "CNT" and slogans.[24]

1933-34 — Protesting the Argentinean dictatorship, muralist David Alfaro Siqueiros makes stencils out of tin sheets and uses keim and nitro cellulose-filled insecticide sprayers to paint the images in Buenos Aires.

1927 — Erik Rotheim uses chemical propellant system to spray fluids via an aerosol can and patents his design.[23]

c. 1925 — Jean Saudé's indepth text on the French pochoir, Traité D'enluminure D'art au Pochoir, published in Paris.[22]

c. 1920 — ROSTA (Russian Telegraph Agency) Windows Post series create with stencil artists Vladi Mayakovsky a Ivan Maliutin, US

1941-1945 — Italian Fascists stencil Mussolini's portrait on walls. Franco's image stenciled in Spain as well.

1949 — Edward Seymour develops spraypaint can in Chicago, IL, USA.[26]

1959 — American artist Jasper Johns appropriates industrial stencil letters for his canvas works "False Start" and "Jubilee."[27]

1960s — Stenciled placards and banners appear at U.S. Civil Rights protests.

1966 — Protesting nuclear weapons, Ernest Pignon-Ernest stencils life-sized, disintegrated Hiroshima victims on the Plateau d'Albion, in Vaucluse, France.[28]

1968 — San Francisco Diggers stencil posters that appear in the Haight-Ashbury neighborhood.

1968 — Richard Artschwager spray paints oval-shape blps, an "act of sustained graffiti," for his 100 Locations installation at the Whitney Museum in New York.[29] Sometimes stenciled, blps eventually leave the white walls to go up on the streets in New York City and elsewhere.[30]

c. 100 BCE

With the development of silk paper, the cut-paper technique, scherenschnitte, develops in China.[9]

c. 500

Ostrogothic King Theodoric signs name with a stencil of gold.[10]

c. 600

Buddhist artists develop "stencil and pounce" technique.

c. 800

Charlemagne observed using a stencil to sign signature.

c. 1000

Chinese refine stenciling to color pictures.[11]

c. 1100

Stencils used at Mogao, near Dunhuang, Gansu province, China.[12]

c. 1300

Bingata (Katazome), resist-dyed cloth made from stencils, develops in Okinawa, Japan.[13]

c. 1450

European woodcut Playing Cards decorated via stencils.[14]

c. 1914

Modern silkscreen technique adapted by John Pilsworth, San Francisco, CA, USA.[20]

c. 1900

Parisian type foundry Deborny & Peignot commissions Georges Auriol to design a stencil-styled typeface.

c. 1900-1930

French develop pochoir (hand-coloring via stencils) into an industry with over 600 workers.[19]

c. 1899

Inventors Helbling & Pertsch create modern aerosol technology using pressurized gases as propellants.[18]

c. 1875

Edison patents the electric pen, using stencil paper to make copies.[17]

c. 1850

Japanese refine katazome, creating kappazuri (stencil printing).

c. 1790

Self-pressurized carbonated beverages introduced in France, beginning the development of aerosol spray can technology.[16]

c. 1500s

Scherenschnitte paper cutting techniques appear in Europe via China.[15]

1969

Juan Carlos Romero's work, "(color stencil)", receives the Grand Prix at Argentina's 58th National Salon.[31]

1969-1974

Taking cues from the 1960s Philadelphia, PA tagging scene, innovative modern graffiti appears on New York City walls and subways.[32]

1974

Gordon Matta-Clark begins to create cut drawings, abstract images with negative space, and eventually cuts out parts of buildings.[33]

1974

Using utilitarian stencil letters since 1961, Larry Rivers cuts his own for the canvas, "The Kiss: Japanese Erotic Art Stencil."[34]

Mid-1970s

Charles "CHAZ" Bojorquez paints a stencil of a zoot suited skull character in LA, incorporating the art form into the Cholo graffiti style.

1976

Grupo Suma forms in Mexico, stenciling public art.[35]

1976

Inspired by Japer Johns, Richard Artschwager, and Robert Smithson's Assemblages, John Fekner begins to stencil "single-word poetry within a site-specific outdoor location" in New York City.[36]

1976-77

Gee Vaucher photographs NYC pavement stencils and uses them in "the first International Anthem 'all men are rapists'". Eve Libertine and Penny Rimbaud, from the CRASS collective, begin to stencil in the UK. Vaucher and the rest join in, mostly spraying "underground lines" on platform advertisements. They eventually stencil large billboards.[37]

1977

Jef Aérosol notices that The Clash wear stenciled clothing, and in 1979, sees anti-nuclear protest stencils on the streets, in Western France.[38]

1979

Street stencils appear in Baltimore, MD.[39]

1978-1980s

Stencils used in resistance movements across the world: South Africa, Basque Country, Nicaragua, and Germany.

1979-1980s

New York City sees stencil graffiti boom: Eric Drooker, Madam Binh Graphics Collective, Michael Roman, James Romberger, Kat P. Sent, Seth Tobocman, Anton Van Dalen, and David Wojnarowizc are among the artists painting.[40]

1979

San Francisco punk band the Fuck Ups stencil their logo on their jackets.

1997

The Cooper Union (NYC) curates "Ambush in the Streets", showing Jules Backus' photographs of 1980's Parisian pochoir art.

1996

Early street stencil gallery show "On the Street – Off the Street" opens in Baltimore, MD, USA.

1994

Art Crimes (graffiti.org), a graffiti photo archive, goes live. At the time, few stencil artists are represented on this traditional graff site.

1992

Artist/author Josh MacPhee paints first street stencil.

1989

Processed World collective puts stencils on San Francisco sidewalks and overpasses.[54]

1989

Many artists collaborate to creat dozens of stencils painted on the sidewalks of New Yo City for The Anti-Nu Port Stencil Projec (organized and execu by Ed Eisenberg an Greg Sholette).[53]

1998

Google search engine goes live. Initial search for stencil graffiti sites brings up a handful of addresses.

2000

Bristol, UK artist Banksy paints his first street stencil.[55]

2002

Stencils become integral part of protests during democratic uprising in Argentina.

2002

Tristan Manco's Stencil Graffiti released, along with a small online archive of book-related photographs.

2002

StencilArchive.org, the first online international stencil collection, goes live. Australian community-driven site StencilRevolution.com soon follows.

2004

Online resourc Flickr, YouTub Blogger, WordPr etc., allow eas posting and sharing of photographs a information. A b in stencil-relat sites begins

1980

Inspired by Cara Crash's stencils the year before, Scott Williams begins to stencil postcards, using skeleton images and cartoon characters, at the Compound in San Francisco, CA.[42]

1981

BLEK (Blek le Rat and Gérard Dumas) begins to stencil the streets of Paris, France.[43] The French street pochoir style soon booms with artists such as Miss-tic, Jef Aérosol, Nemo, le Rire du Fou, Surface Active, and Marie Rouffet.

1983

During the Third Resistance March, siluetazos (silhouette coup), stenciled outlines of bodies, appear to protest the 30,000 who disappeared during Argentina's dictatorship.[44]

1983

Dallas, Texas-based Church of SubGenius provides instructions for a "Bob" stencil that they "don't want you to make and paint."[45]

1984

World War 3 Illustrated #4 publishes Seth Tobocman's famous "You Don't Have to Fuck People Over to Survive" stencil. Seth made his first stencil in 1983 to protest the U.S. invasion of Grenada.[46]

1984

Political Art Documentation/ Distribution launches its anti-gentrification campaign "Not For Sale" in New York City. Stencils are used on the streets and on posters.[47]

1989

Shepard Fairey's OBEY Giant Project begins, including stencils of the iconic wrestler Andre the Giant.

1988

Cars stenciled at the Carmanic Convergence, San Francisco, CA.[52]

1988

After a brief stencil collaboration with Seth Tobocman in 1987, World War 3 Illustrated co-founder Peter Kuper begins to use stencils in his illustrations. He eventually stencils covers for Time and Newsweek as well as Mad's Spy vs. Spy.[51]

1986

Two books on French pochoir street art published: Vite Fait, Bien Fait by Josiane Pinet, Nicolas Deville, and Marie-Pierre Massé, and Pochoir a la Une by Solange Pierson and Kriki. Vite Fait, Bien Fait celebrates its release with a collective show at Galerie du Jour, featuring live stencil painting.[50]

1985

Stencil art used as popular resistance tactic against Chilean dictatorship.[49]

1985

Polish artist Tomasz Sikorski stencils public walls in police-controlled Warsaw. His father painted resistance-themed graffiti during the Nazi occupation in WWII.[48]

2005

Stencil artist Scott Williams receives the Adaline Kent Award from the San Francisco Art Institute.

2006

Individual artists and arts collectives use stencils as a form of visual resistance in the people's uprising of Oaxaca, Mexico.

2006

Blek le Rat's show at Leonard Street Gallery in London sells out on opening night.[56]

2006

Wooster Collective opens huge street art exhibit, 11 Spring Street Project, which includes many international stencil artists.

2007

Banksy's piece, Bombing Middle England, sells at Sotheby's for £102,000.

John Fekner

In New York City, John Fekner began to paint his "single-word poetry" stencils in 1976 at a time when modern graffiti was just beginning to take off.

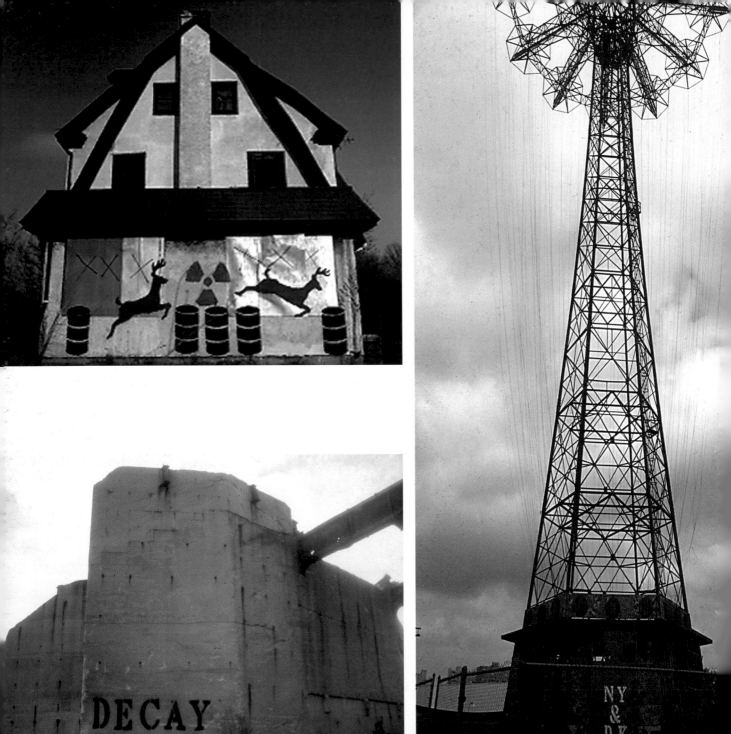

DECAY

NY
&
DK
4 EVER

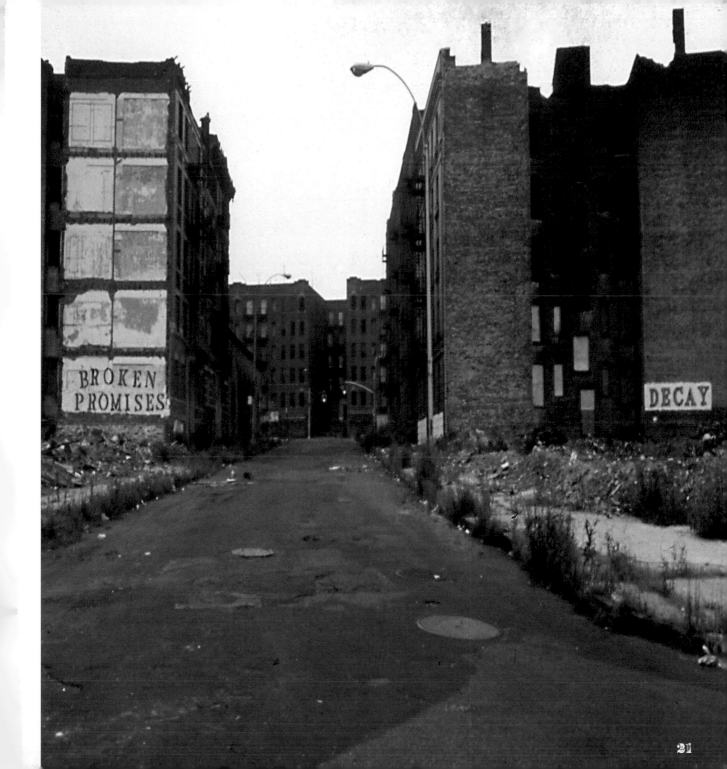

21

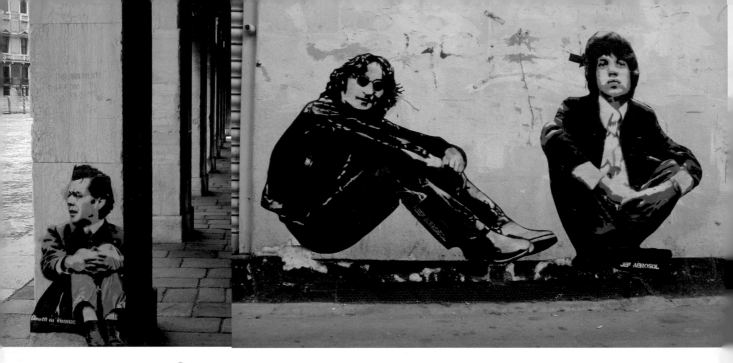

JEF AÉROSOL

BECAME AN ACTIVE MEMBER OF THE AMAZING FRENCH STENCIL COMMUNITY IN THE 1980s, AND HAS CONTINUED TO CHAMPION STREET-SPECIFIC ASPECTS OF THE ART FORM.

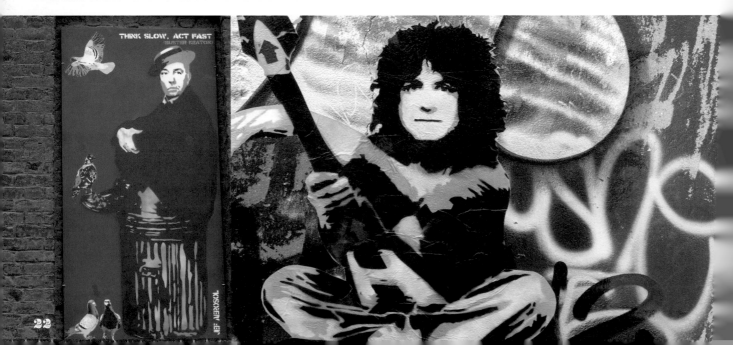

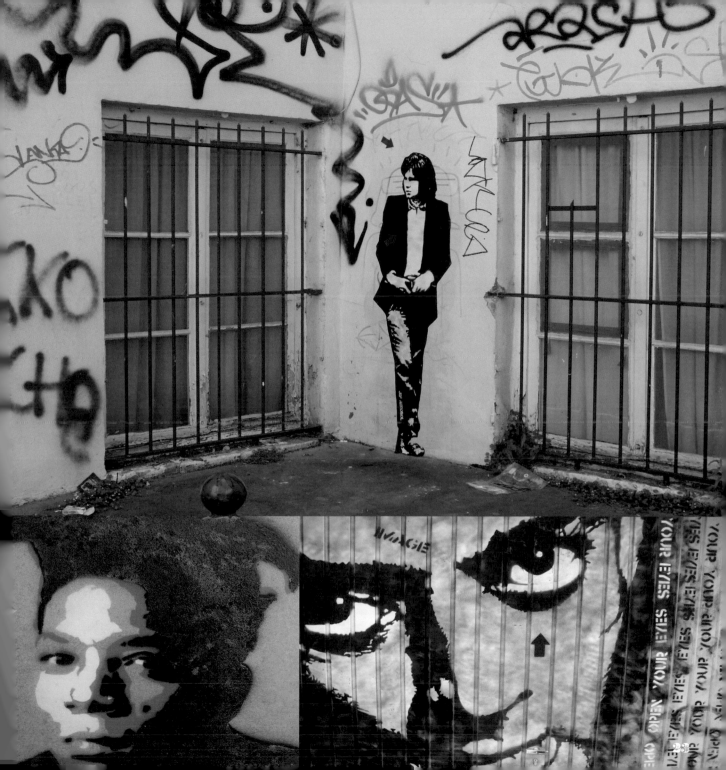

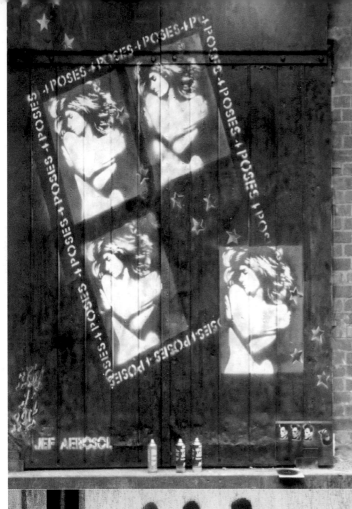

JEF AEROSOL

DÉFENSE D'AFFICHER

POSTE
DE TRANSFORMATION
CENTRE
ACCESSIBLE SEULE
AU PERSONNEL AU

une prochi
de la ma

SLOW DIE
JEF AEROS
198

QUATRE POSES

JEF AEROSOL

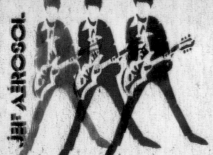

JEF AEROSOL

shake some action
shake some action
shake some action

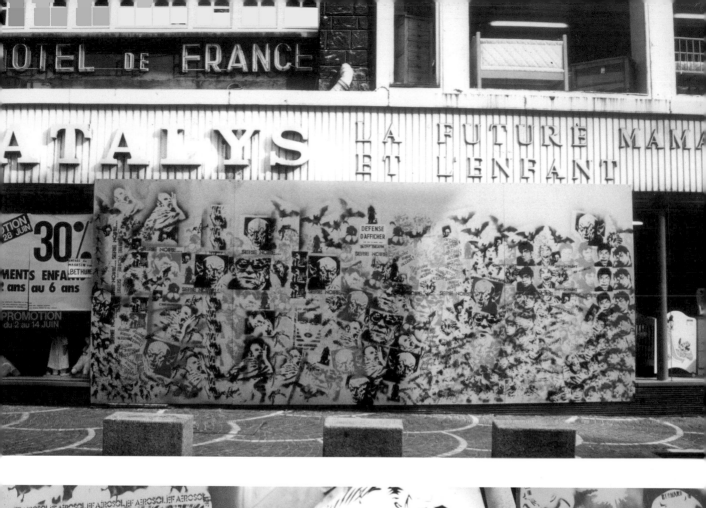

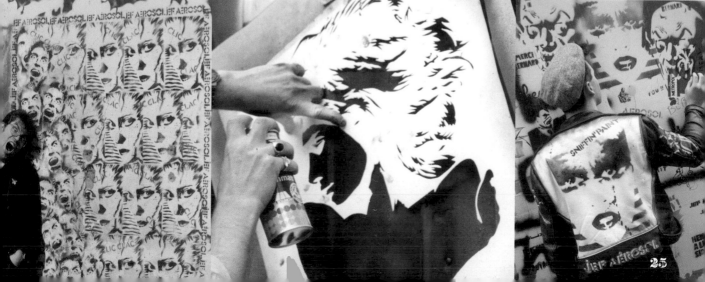

Scott Williams

San Francisco artist Scott Williams created his first stencils in 1980,
eventually developing a deep body of work that continues to the present.

HEALTH through ENTERTAINMENT

scott williams, didier cremieux
scott williams, didier cremieux
scott williams, didier cremieux

dec 9 – 31

SOCIAL ILLUSIONIS

alterpiece 99 VALENCIA

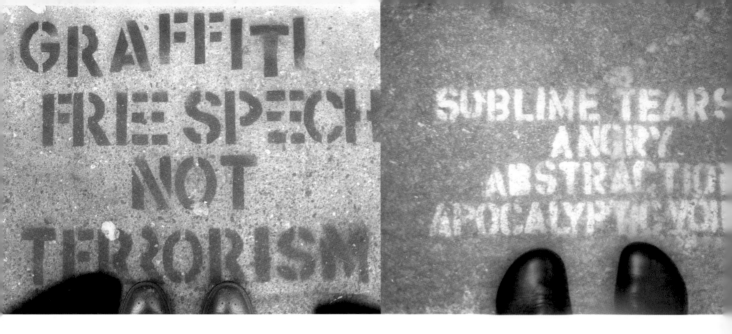

D.S. BLACK

D.S. Black, an early pioneer in photographing street stencils, has a collection of San Francisco-based photos dating back to the mid-1980s. Black's collection may be one of the best documentations of *in situ* street stencils, outside of Paris, from the early era of Stencil Nation.

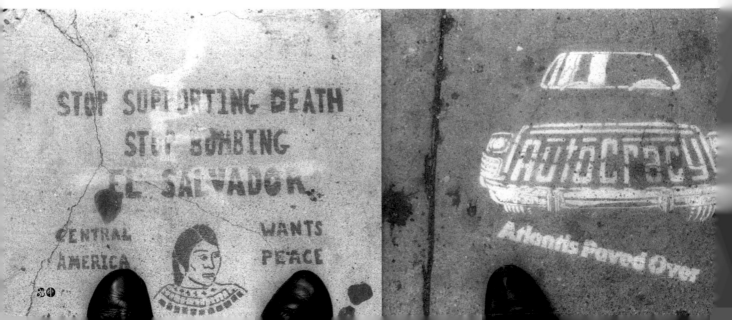

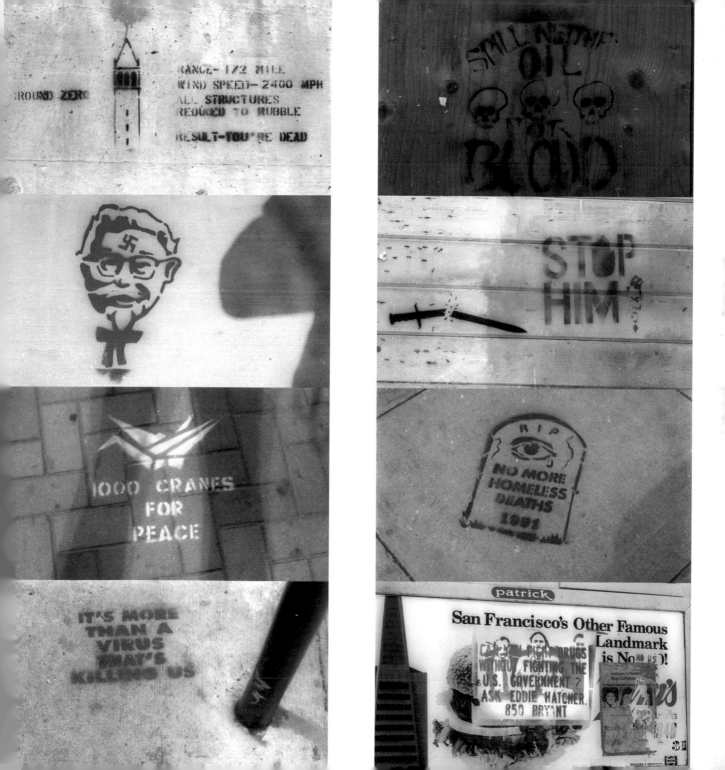

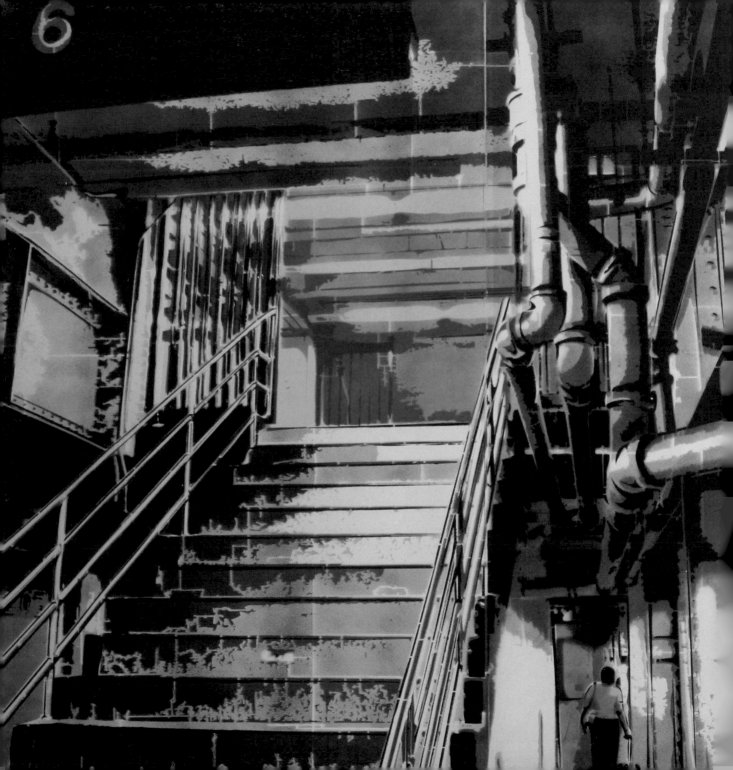

STENCIL NATION CITIZENS:

artists

PIXNIT

Adam5100

Hao

Soule

Janet Attard

Amy Rice

Klutch

Street Art Workers
(SAW)

Arofish

Logan Hicks

Banksy

Swoon

M-City

Chris Stain

Peat Wollaeger

Tiago Denczuk

Documentarians

David Drexler

Maya

Duncan Cumming

Thomas Müller / TXMX

Martin Reis

ARTISTS

"For some things, a pencil is better," writes Mark Evanier in Mad Art: A Visual Celebration of the Art of Mad Magazine and the Idiots Who Create It. In Evanier's profile of Spy vs. Spy artist Peter Kuper, the author sums up the complexities of stencil art, as well as the character of most stencil artists:

"The results [of using stencils to create Spy vs. Spy] are wildly popular, though the process does have one drawback. Imagine a gathering of MAD cartoonists in an Italian restaurant.... Everyone's drawing on napkins... and down at the end of the table, there's Peter Kuper, trying to cut a stencil out of his manicotti, which he'll then spray with a mouthful of marinara sauce."

Forgoing the pencil for a technical process like stencil creation draws a certain type of artist to this medium. These artists share the similar fate as Kuper does with his imaginary Italian dinner. They all go through a lengthy process of creating the actual cutout stencil before they even get to paint the image. They all employ the basic items needed to make that cutout image, and they almost always get lost in the detail of the cuts and the control of putting the pigment through the final stencil.

For the more obsessed artists, technique development brings up many problems that need to be solved. Where do the bridges go? How can bridges be hidden to make the image not look like a stencil? How can one make a six-color stencil image with only two cutout stencils? How many layers can be used to create an image?

And, like other forms of spraypaint-oriented art, the artist must also develop spray techniques for their stenciled images. Paint, cap, brand, and color choices add to the process. Spray control and desired effects (overspray, drips, gloss, etc.) become important when artists begin to work on canvas, but also come into play on the streets.

Many other choices must be made as well before the artists paint their stencil. What do you cut the stencil out of? What do you cut with? What do you paint the stencil on? If you're getting up on the street, where will you place the stencil? What image or text do you use as the stencil? What are you trying to say with this stencil? How do you go out and paint stencil graffiti without getting caught?

Stencil Nation's "Artists' Tips: How to Make Stencils" section may help the beginning artist answer some of these questions, but the path to creating stencil art is walked by a person who is willing to take the time and develop the skills necessary to patiently make a piece of art that a pencil may have done in a shorter length of time.

The development of skills through practice may be what drives an artist to take the extra steps in stencil art. It may be the problem solving involved in keeping the image from falling apart, or hiding the bridges. Some artists love using stencils because of the look of the final, painted image. Others like the cheap, mobile, and repetitive ease of the tool. Whatever the reason, artists that begin to stencil usually fall in love with the process as well as the outcome. If not, they'd move on to stencil-like art made from screens or vectors.

What may most often arise for the artist is the fascination of creating and painting an image or message cut out as a stencil. Most artists remember when they first saw a painted stencil. Some first noticed cut-letter stencils while others might have first seen stencils on a piece of clothing that punk musicians wore. Fascinated, they all began to analyze the tool, and how it related to their art. Artists soon found the easy tools to make their first stencil, and began to develop their skills.

Interested in discovering more about the artists' connections to their stencil art, Stencil Nation asked why they used the tool and how it aids their creativity. Other questions came up: Do the artists see a difference in location of stencil art, i.e., on the gallery walls or in the streets? As the community grows, and the art form drifts into the mainstream, will it be co-opted? Are they even bothering to think about these things?

Simply put, why are people taking time to cut an image out of their "pasta" when they could be doing art a different way? Their answers vary like their stencil styles. This diversity of voice, vision, and style can only strengthen the art form and benefit the community. The ongoing dialog will keep the stencil's mostly punk, hip-hop, and on-the-streets roots alive for future artists who discover the joy of making their first stencil.

PIXNIT

With increased surveillance in cities today, I started using stencils as a way to bring multiple highly detailed images to the street and lessen the risk of being caught. As a formally trained painter with a background in graffiti, I can design a piece for a specific building, install it and go in less than a minute.

Stencils have a close relationship to screen-printing and painting, so it was a natural step in the evolution of my work to incorporate them as part of my painting process on the street and off. As an artist I use whatever tools are available to me to get the desired results and don't believe that bringing my work into a gallery diminishes it's cultural relevance. Showing art in multiple venues allows the work to be accessible to a wider audience and shifts its content so that the image itself is the focus rather than the action of painting it on the street.

HAO

I use stencils as a street art for several reasons. In a city like Paris, where streets are busy night and day, a stencil enables me to put up a picture or a message in a few minutes. In the street, to be faster, I only use monochromes. That is why I mostly choose drawn stencils that have an almost comic-strip style graphic. Besides it is "cheap" art; with a spray can and a piece of cardboard, you can put your picture or caption onto many places.

For the last three or four years, in almost every country, there has been a huge stencil art craze! It's great! About changes in the stencil world, according to me, the main one is about the drawing technique. The whole new generation now uses Photoshop or Illustrator. With these applications, the result may be amazing for multi-layer stencils. Personally, I've never used a computer to make my stencils. I still draw with a pencil and an eraser!

I think that multilayer stencils made with Photoshop and Illustrator are better for pieces shown in galleries. In the street you don't always have the time to spray a multi-layer stencil, so you have to put the emphasis on the rightness of features and shadows. You try and make the bridges disappear. For a result as best as possible, nothing will outdo a hand-drawn stencil.

Stencil graffiti is a way of life above all. Some enjoy it for fun, others stencil to become well known, but for some of us it is part of our lives.

Stencils in galleries? As long as it is occasional: let's not forget that stencil art is mainly street art. For me, it is 85% in the street, 10% in spots/waste grounds, 5% in galleries.

KIM MCCARTHY AKA SOULE

Stencils are a great way to reproduce your art onto any surface. They're also very versatile as a way of being able to take them to the streets and mass produce one image in many places. I do my art because it's something fun for me to do. I like to see and hear the responses that I get out of it.

Recently, artists are making more elaborate and detailed stencils. In the past artists would just make a one-layer image, but now you might see a stencil that has twenty or more layers. They just keep getting better with time. Artists refine and fine-tune their work all the time.

Walking down the streets, alleys, and anywhere else, and seeing stencils that artists have sprayed up, makes me happy. It inspires me. As for stencils in galleries – why not? I show my work in galleries. The public is starting to look at stencils and all other street art as a real art form, so maybe we, street artists, will finally get the recognition we deserve.

Everything goes commercial at some point, and some artists tend to overdo the commercial aspect of their art. But I suppose if I was making the amount of money they are, I wouldn't be complaining either. I would love to make a living, and more, off my art.

AROFISH
Excerpts from the Scrawls of War

Palestine, January 2004: It crossed my mind that perhaps they [Israeli soldiers] were trying to bounce rounds in at us, but as I looked, I saw that there was some graffiti sprayed on the wall right where the bullets were hitting. It was just basic-written Arabic words which I couldn't read. I don't know if it was Anti-Jewish, Pro-Intifada or whatever. But the gun was shattering and blasting at the stone, purposely erasing the words with bullets.

Baghdad 2003-2004: This one [Arofish's Carpet Bombing stencil] earned me three days detention, courtesy of the American military, for trying to spray it on the concrete "T" barrier outside the Baghdad Hotel – one of their compounds. The cage I got put in, by a tall, black corporal who'd seen too many prison movies and was married to his baton, had about 15 Arab guys in it. Everyone had a sticker on their chest describing personal details and circumstances of their arrest. Their stickers said things like "I.E.D. material." Mine said "anti-coalition graffiti".

Anyway, there I was in central Baghdad in the middle of the night with Tom, a young journalist and flat-mate who came along perceiving some story value in the expedition, all ready to go with stencil, spray cans and duct tape. I see a silhouetted figure on the roof of a nearby building, which also hosts a sangar (improvised guard post shelter fortified with sandbags). It occurs to me that my rolled up, meter-long stencil might look like a rocket launcher, so I walk behind a building to unroll it.

TIAGO DENCZUK

I started using stencils about six years ago, in my hometown of Curitiba, Brazil, mostly creating art for chicks I hung out with. I made cards and posters that were multi-layered cutouts of portraits and such. Once I moved to San Francisco and got exposed to the City's stencil graffiti, and saw the StencilArchive.org table at the Anarchist Book Fair, I decided to start making and painting stencils myself. I first made stencils as graffiti, and then as paintings on canvases and found materials.

Since stencils are no more than a technique, co-opting is not a possibility. If commercial

enterprises try to imitate some style or aesthetic derived from what creative people are doing as only a form of expression, that's just as far as they can go as imitators. Creativity and originality are the keys for genuine art, and having the goal of making something look good so you can sell it for more than it's worth makes it impossible for someone to have the real artistic creative inspiration. Therefore, they create pieces that are already obsolete. Being afraid of having some style co-opted is believing, wrongly, that artistic creativity is limited.

As graffiti, I see stencils as one of the best tools for certain places. The result of speed, discretion, quality, and longevity is incomparable. And, I believe that everyone that works with stencils should, at least, consider painting out. The evolution of the technique came more from information being exchanged in the walls than in galleries or art school.

Janet "Bike Girl" Attard

I use stencils to make my art because I love stencils. They allow me to do everything by hand: designing the image, cutting the stencil, and hand printing. We live in a world of mass production; my stencils are the opposite of this world.

My bicycle inspired me to use stencils. I started making bicycle stencil art in 1995. I thought I would try to make a record of every important bicycle frame in the history of bicycles, and little did I know that there are so many designs. So, what I thought would be a small project has turned into my life's work. Recently, the great people in history who rode bicycles have inspired me, and I am now starting a new series called Cycling Legends.

The current state of stencil art is amazing. There are so many stencil artists around the world. So many examples of individual creativity. The public has more respect for stencil artists. Web sites, such as StencilArchive.org , JustSeeds.org and StencilRevolution.com, have helped educate the public about stencils. There are also stencil books, stencil curated art shows, stencil festivals... Australia... on and on.

Stencil graffiti is great! Stencils in galleries, should also be celebrated. Stencils on the street or in a gallery do the same thing in a different way: both give a stencil artist a place to show their stencil work to the community.

If a stencil artist is so good that they can get paid for their stencil artwork, from a commercial enterprise, I think that is great. So few artists are able to support themselves from their artwork, I think we should be happy for the few stencil artists who might be earning a living.

Chris Stain

My work reflects where I'm from, Baltimore, and the impression it left on me while growing up there. Originally, lack of money for screenprinting equipment forced me to use stencils. Now I really enjoy the process.

I like stencil graffiti and stencils in galleries, but I'm partial to the street because it's more of a surprise for the viewer. Everyone can also view street work.

Stenciling hasn't really been about commercial enterprise for me. It's more of a personal

form of self-expression. If your heart's not in what you do, and you are just trying to make a buck, then it will show in time.

AMY RICE

I was initially inspired to create stencils after my exposure to them through street art. I immediately saw the potential for pushing and expanding the medium into something that may be thought of more in terms of "fine art," and it was a challenge I was up for.

It is absolutely astonishing how far the medium has come. In the early days of the Stencil Archive and Stencil Revolution Web sites, multi-layer stencils with good cuts and little-to-no overspray were blowing us all away. There was a lot of focus on technique; there was a general lack of diversity in subject matter, theme, and cultural representation. On StencilRevolution. com, where there was a public rating system, works were getting top ratings and overall "oohs and ahhs" that, while groundbreaking in their time, now look fairly generic.

There has been a real sense or community that has grown out of this stencil renaissance. The combination of the afore-mentioned Web sites, the willingness of some of the ground-breaking artists to share their techniques in forums or in interviews, the street art connection (with its own sense of history and community), plus the ease of reproduction leading to DIY stencil group shows all over the world have assisted in developing an art medium with a sense of international community like no other art form I can think of.

I love a well-placed stencil in the public realm, but I have had less tolerance for ill-thought placements that ultimately have wrecked someone else's day (like on a tree, or some well-maintained garage in a modest neighborhood).

KLUTCH

I use stencils because they are a cheap, easy, and a populist means of making images. I did stuff on jackets, skateboards, ramps, speakers, etc. back in the early 1980s hardcore punk scene but didn't think of them artistically until APE7 from Sydney showed me the bigger picture.

Stencils are just another form of mark making and are as appropriate in galleries as an alley wall. It's what you do with it that counts. The same printing press can print advertisements, political banners, lyric sheets for anarcho-crust metal, or art prints. Ask yourself realistically why you are considering commercial work. If you choose to do so then clearly know what your intent is, and then believe in your actions. I know that I need to pay studio rent, eat, and keep the lights on, and I do what I have to so I can. I feel safe knowing that my heart is never going to let me do anything too embarrassing.

If your scene can't withstand some mainstream exposure then it is more likely a trend rather than any real movement. Just like with skating or punk, I may not always understand, agree with, or enjoy the directions where stencil art evolves but I am stoked to be involved in something that isn't just sitting still.

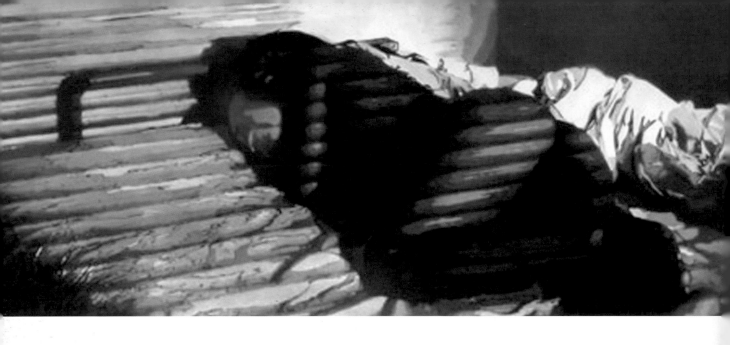

Adam5100

San Francisco, CA

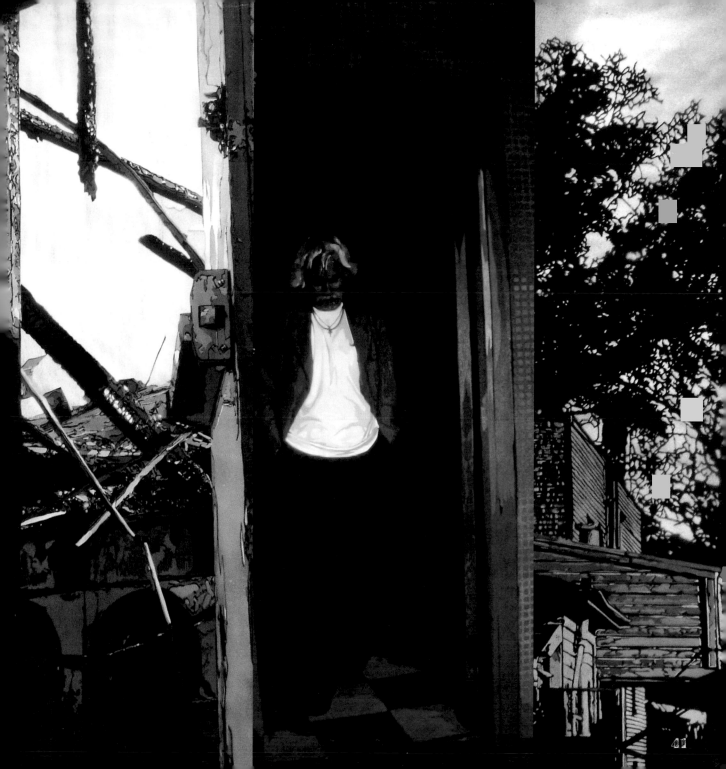

Amy Rice

44

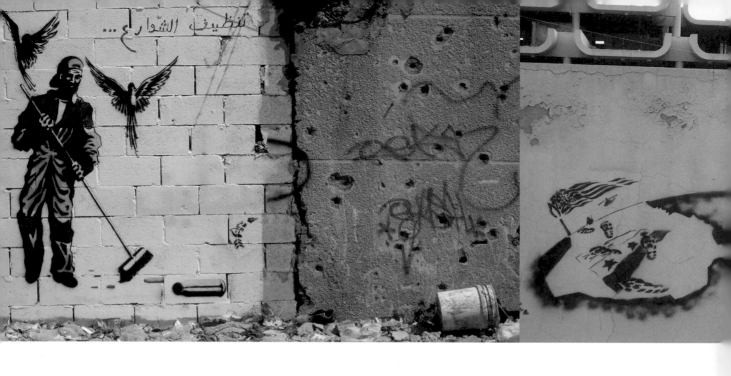

Arofish

London, UK

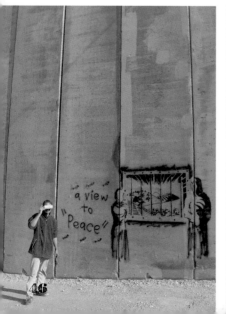

a view
to
"Peace"

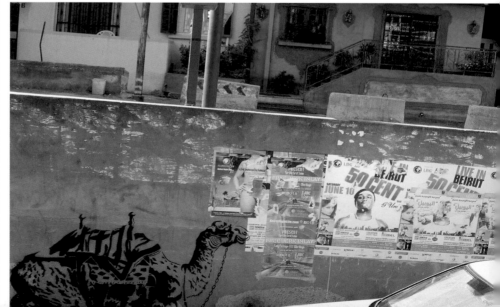

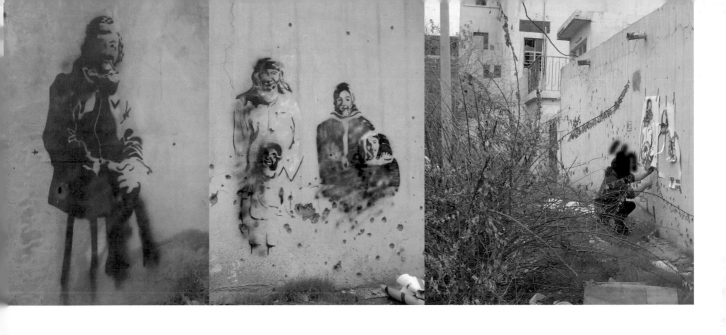

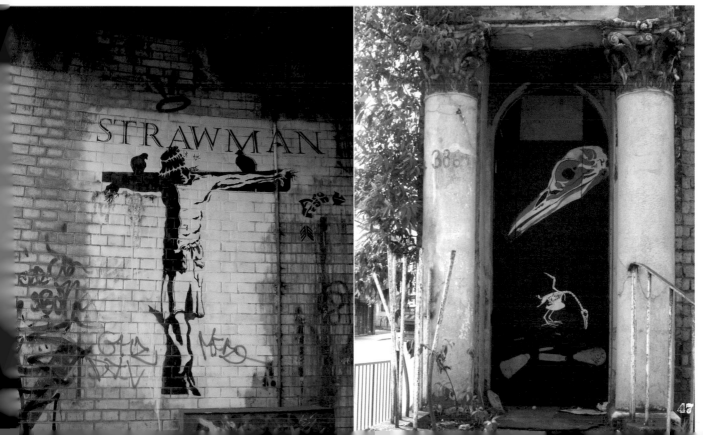

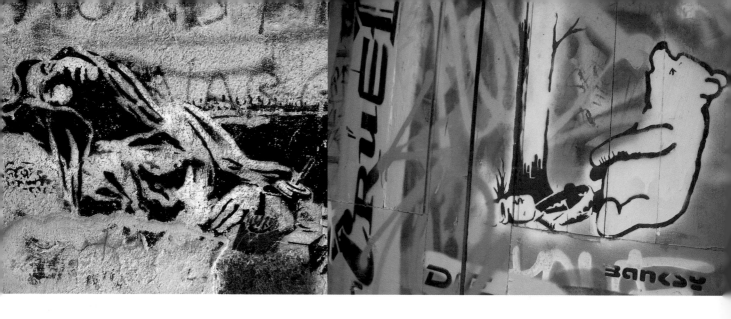

Banksy

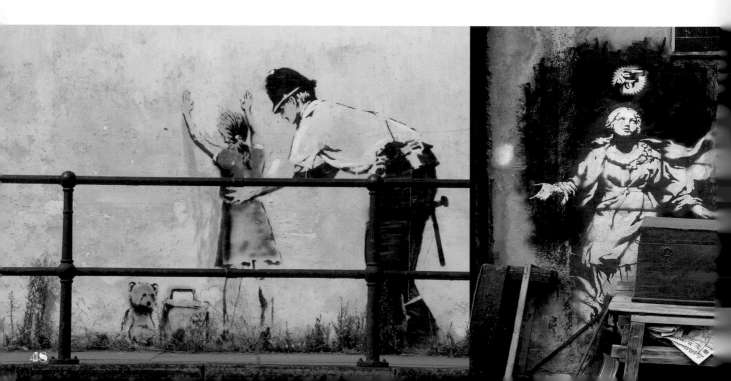

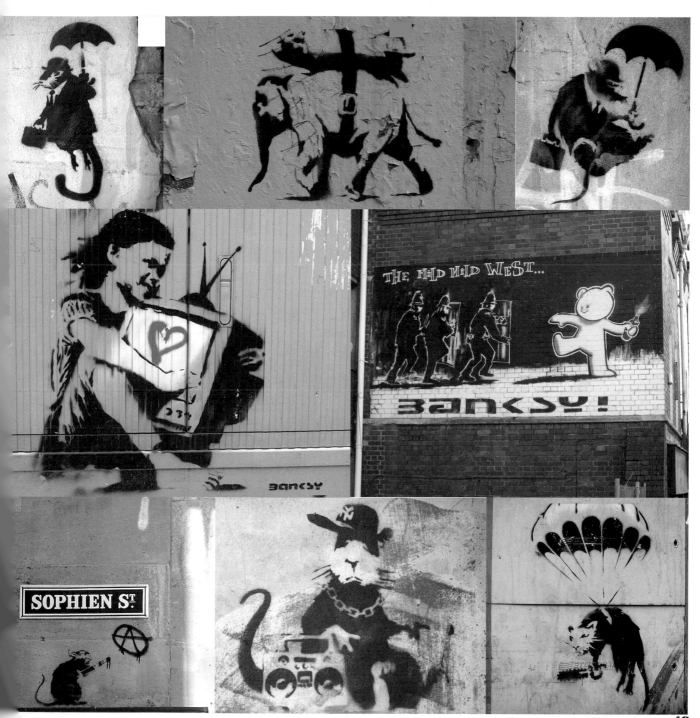

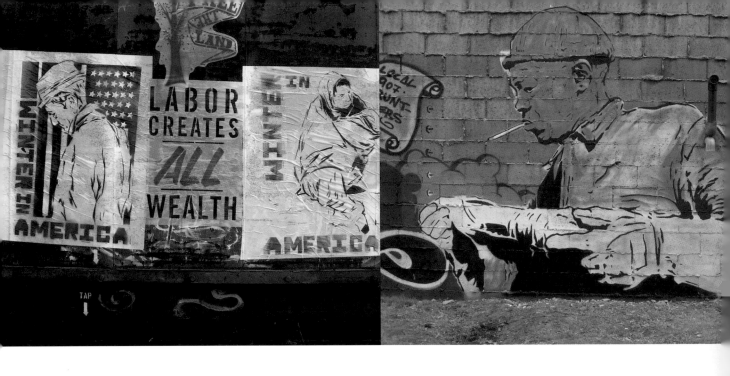

Chris Stain

New York, NY

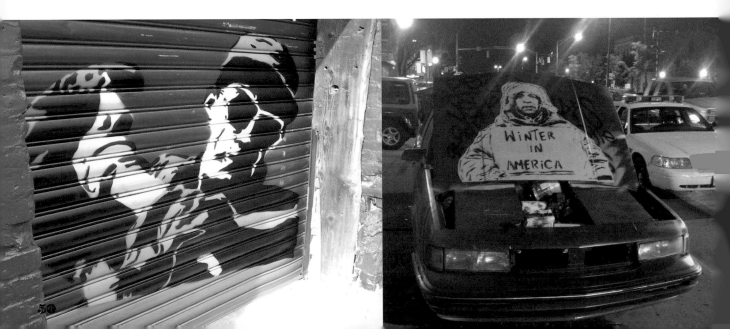

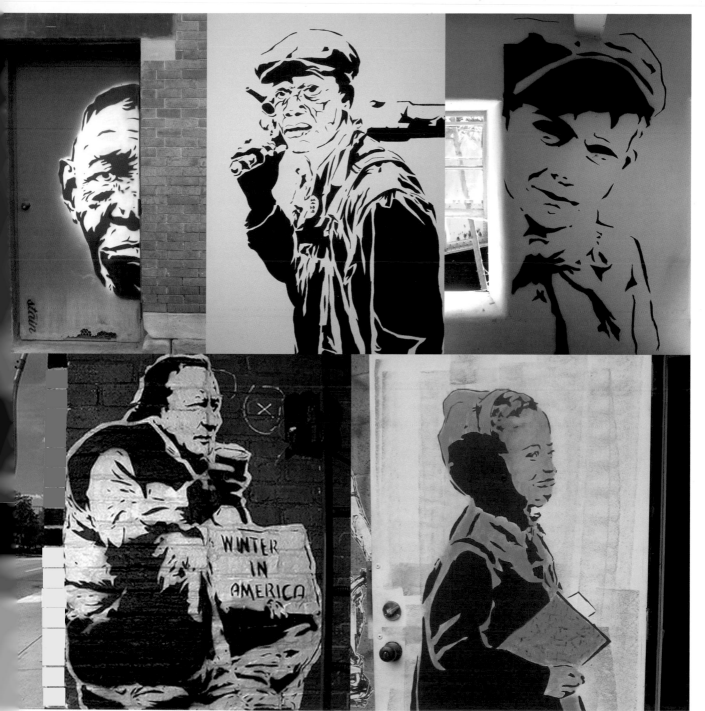

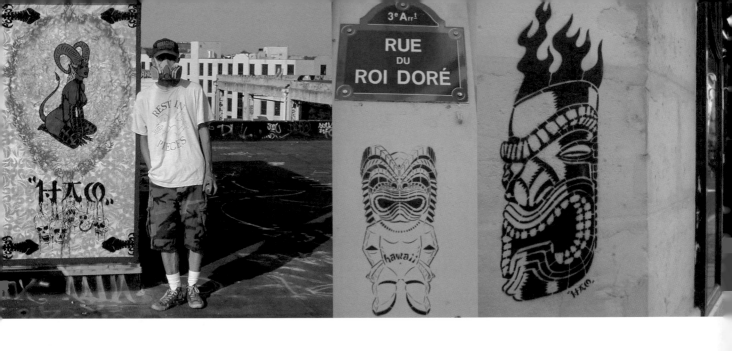

H a o

Paris, Franc

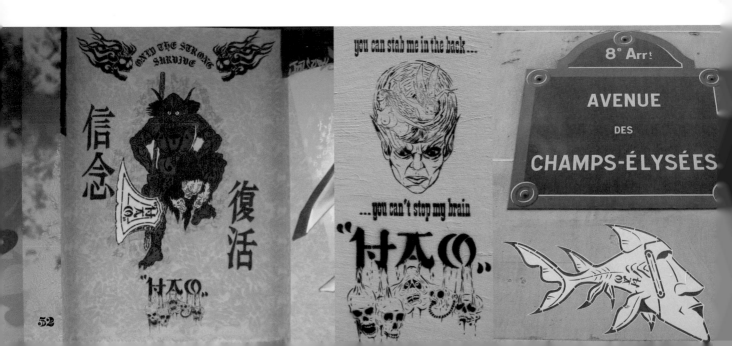

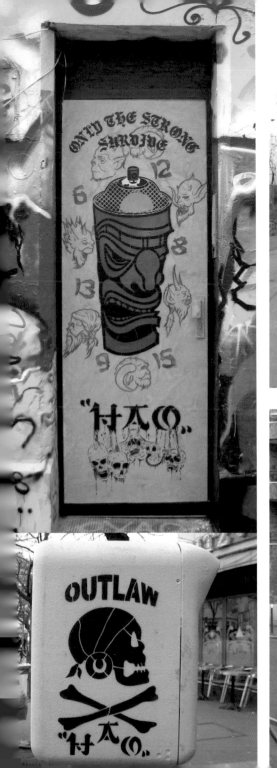

ONLY THE STRONG SURVIVE

6 12
8
13
9 15

"HACO"

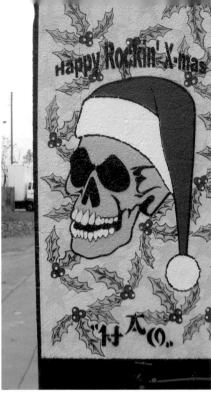

Happy Rockin' X-mas

"HACO"

HACO

"HACO"

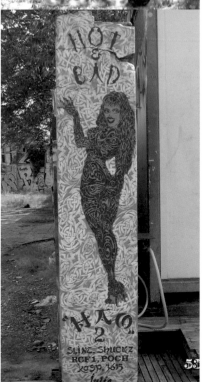

NOT BAD

Julie

HACO
2
SLINT, SHUCKZ
RCF1, POCH
KaSp 3615

53

OUTLAW

"HACO"

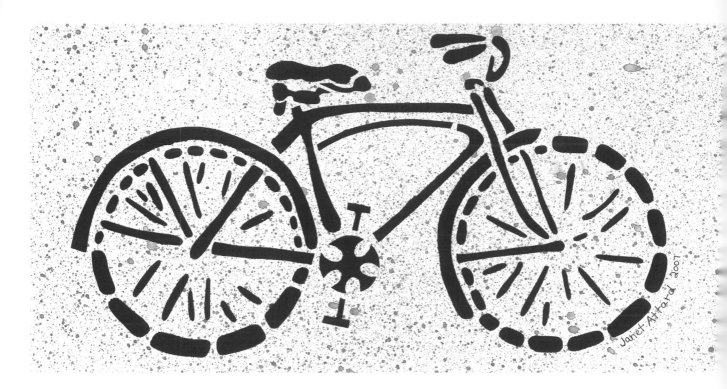

Janet Attard

Toronto, Canad

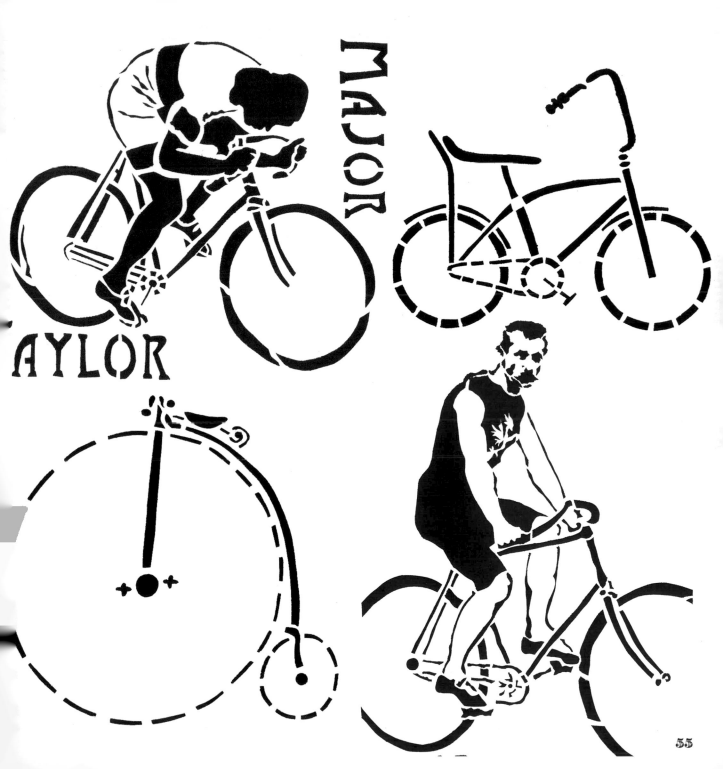

MAJOR

AYLOR

55

Klutch

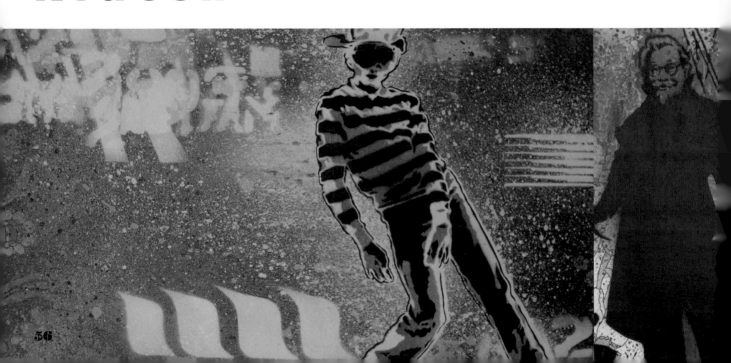

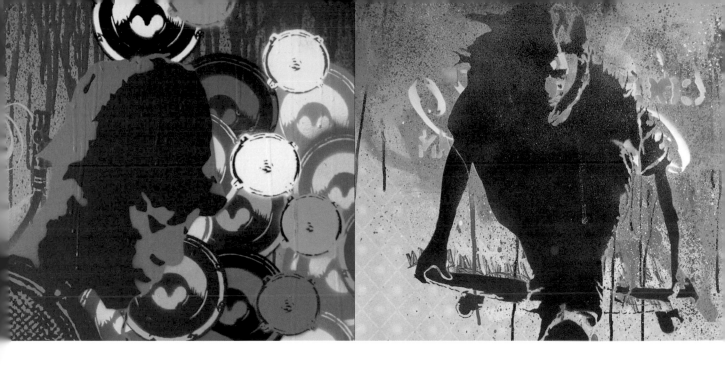

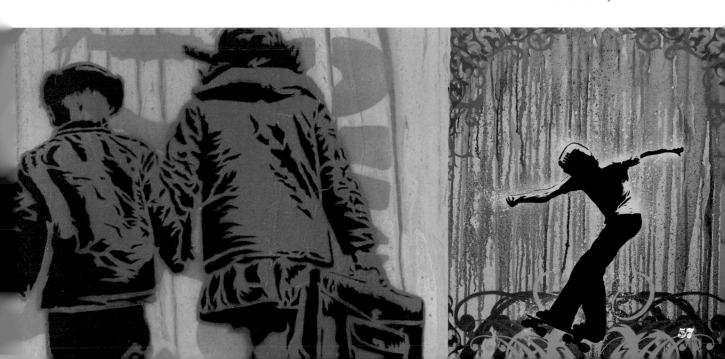

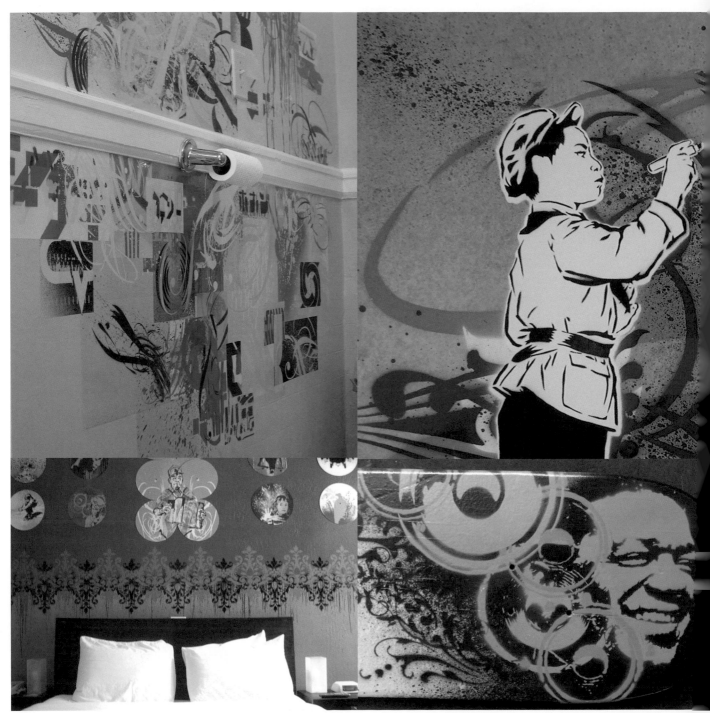

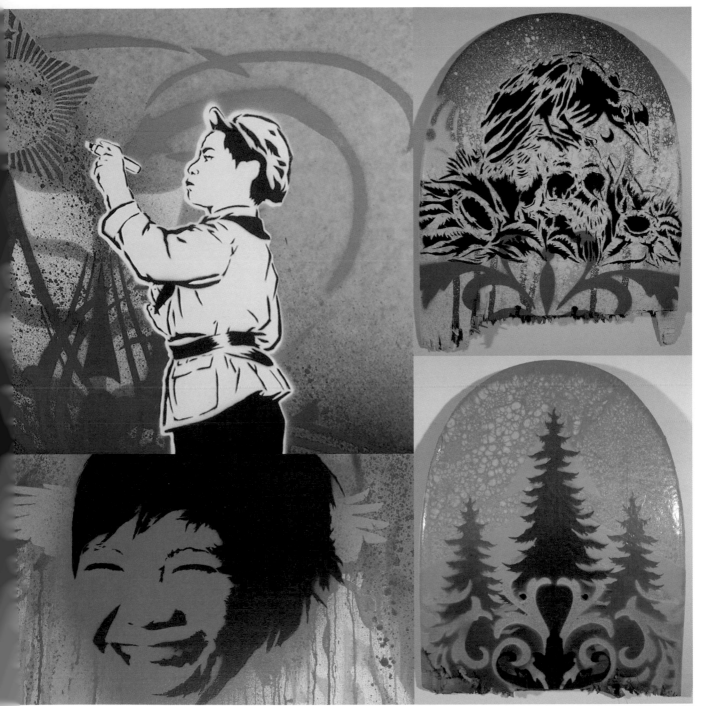

Logan Hicks

New York, NY

m-city

P olan

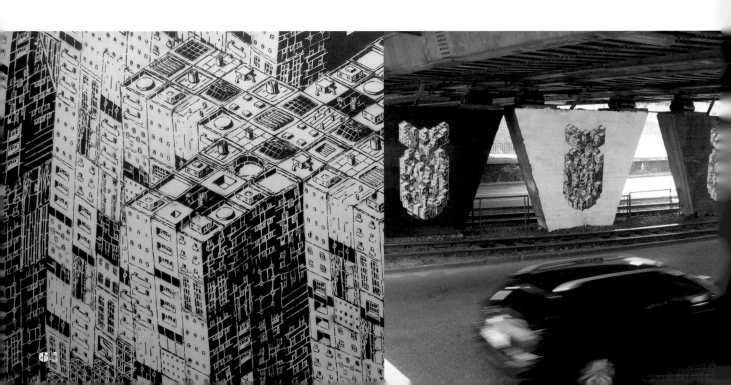

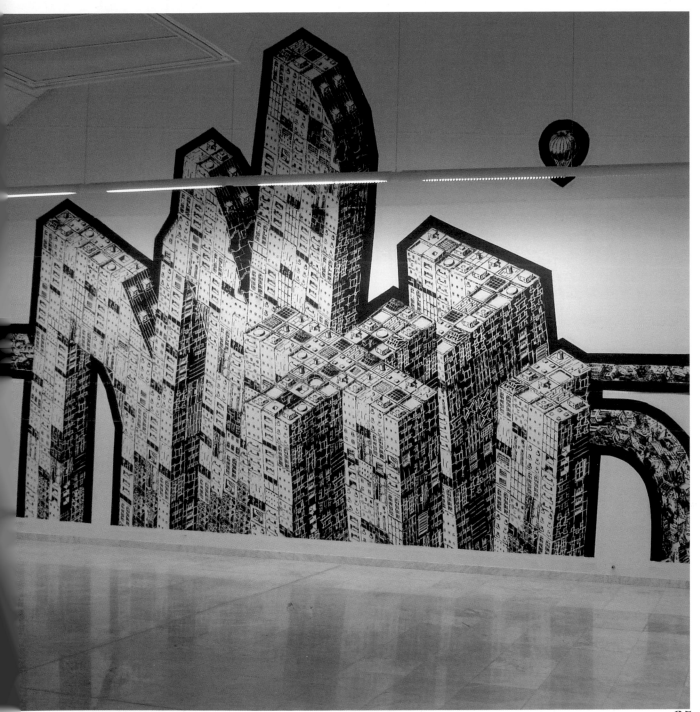

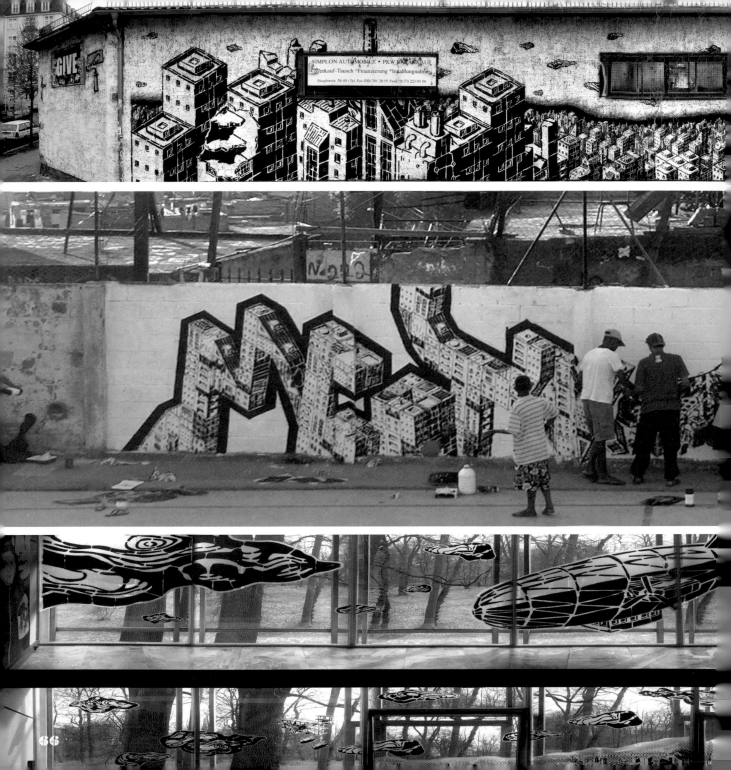

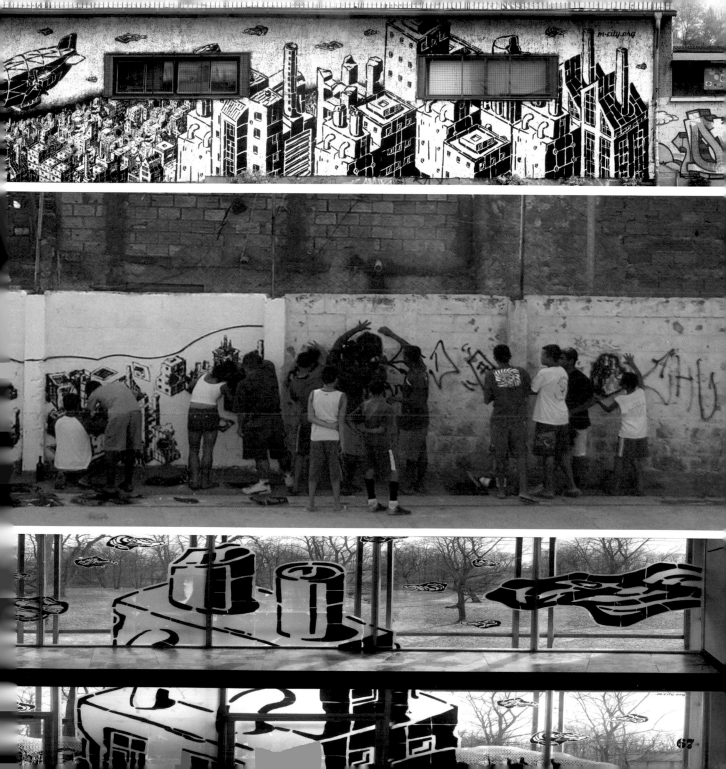

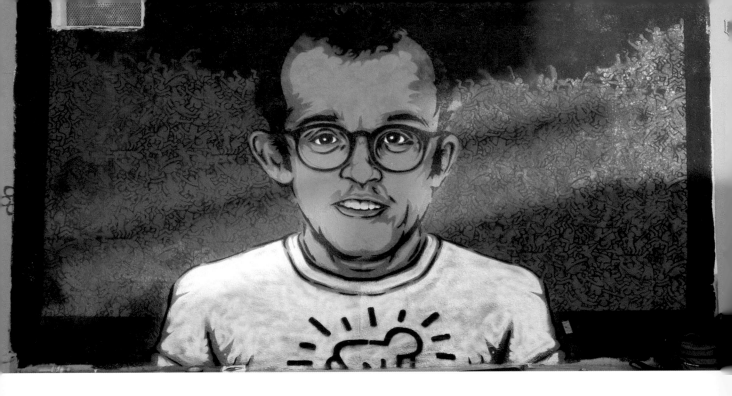

Peat Wollaeger

St. Louis, MO

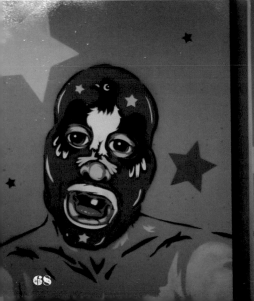
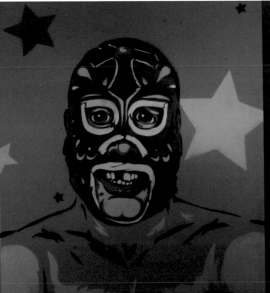

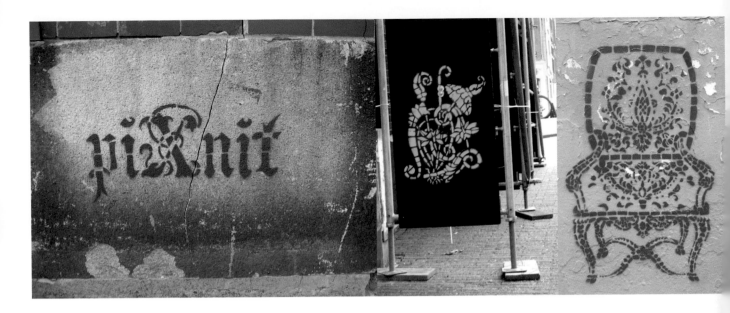

PIXNIT

Boston, MA

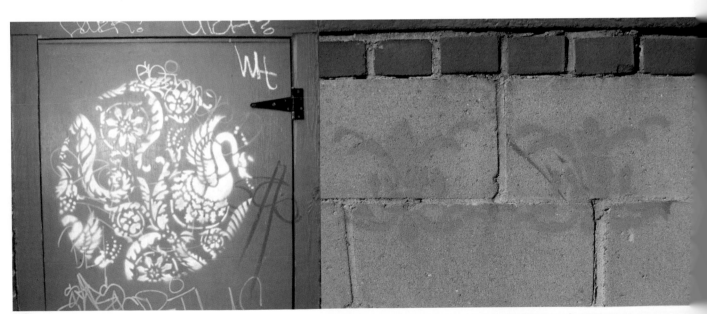

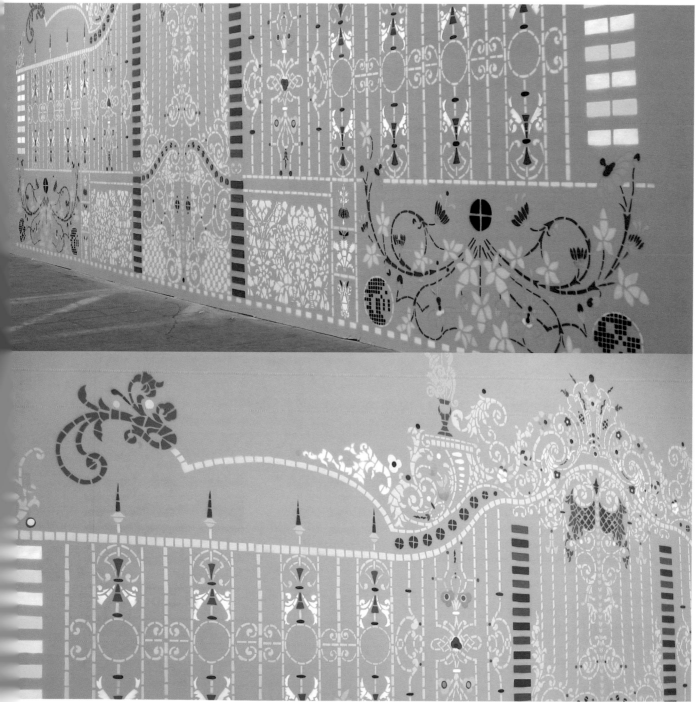

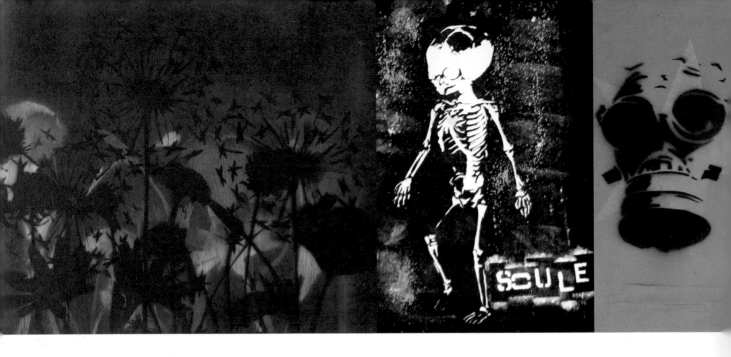

Soule (KiM McCarthy) Seattle, WA

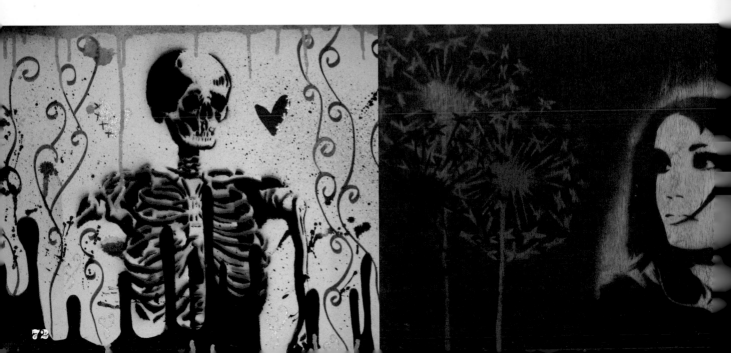

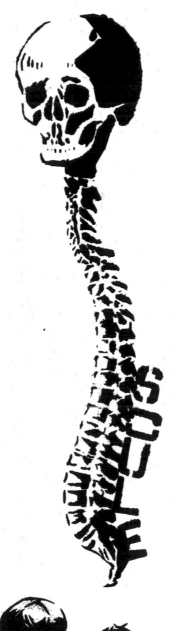

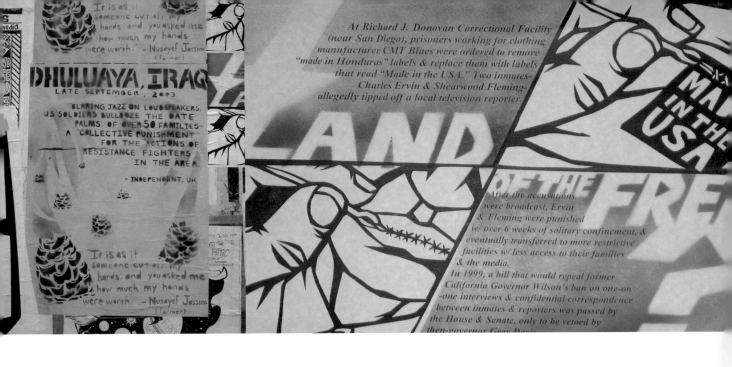

"It is as it someone cut off my hands and you asked me how much my hands were worth." – Nusayef Jassim (farmer)

DHULUAYA, IRAQ
LATE SEPTEMBER, 2003

BLARING JAZZ ON LOUDSPEAKERS, U.S. SOLDIERS BULLDOZE THE DATE PALMS OF OVER 50 FAMILIES— A "COLLECTIVE PUNISHMENT" FOR THE ACTIONS OF RESISTANCE FIGHTERS IN THE AREA.

– INDEPENDENT, UK

"It is as it someone cut off my hands, and you asked me how much my hands were worth." – Nusayef Jassim (farmer)

At Richard J. Donovan Correctional Facility (near San Diego), prisoners working for clothing manufacturer CMT Blues were ordered to remove "made in Honduras" labels & replace them with labels that read "Made in the USA." Two inmates— Charles Ervin & Shearwood Fleming— allegedly tipped off a local television reporter.

LAND OF THE FRE

MADE IN THE USA

After the accusations were broadcast, Ervin & Fleming were punished w/ over 6 weeks of solitary confinement, & eventually transferred to more restrictive facilities w/ less access to their families & the media. In 1999, a bill that would repeal former California Governor Wilson's ban on one-on-one interviews & confidential correspondence between inmates & reporters was passed by the House & Senate, only to be vetoed by then-governor Gray Davis.

Street Art Workers (SAW)

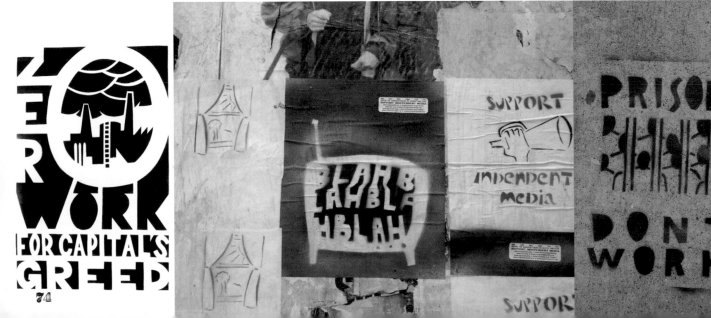

NEVER WORK FOR CAPITAL'S GREED

BLAH BLAH BLAH BLAH

SUPPORT INDEPENDENT MEDIA

PRISON DON'T WORK

SUPPORT

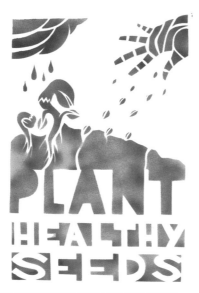

IF THE COPS ARE WATCHING US

WHO'S WATCHIN' THE COPS?

PLANT HEALTHY SEEDS

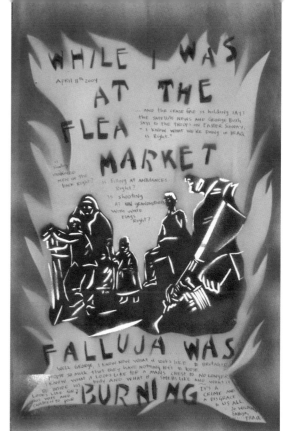

WHILE I WAS AT THE FLEA MARKET

APRIL 11TH 2004

FALLUJA WAS BURNING

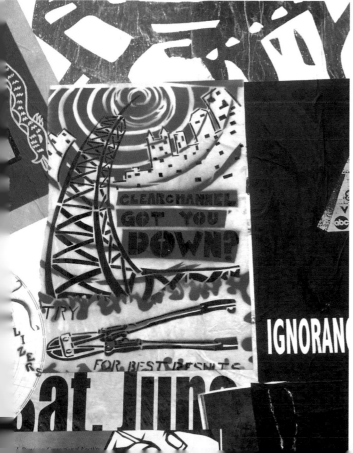

CLEAR CHANNEL GOT YOU DOWN?

IGNORAN

FOR BEST RESULTS

Sat. June

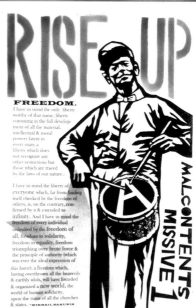

RISE UP

FREEDOM.

I have in mind the only liberty
worthy of that name, liberty
consisting in the full develop-
ment of all the material,
intellectual & moral
powers latent in
every man; a
liberty which does
not recognize any
other restrictions but
those which are traced
by the laws of our nature.

I have in mind the liberty of
everyone which, far from finding
itself checked by the freedom of
others, is, on the contrary, con-
firmed by it & extended to
infinity. And I have in mind the
freedom of every individual
unlimited by the freedom of
all, freedom in solidarity,
freedom in equality, freedom
triumphing over brute force &
the principle of authority (which
was ever the ideal expression of
this force); a freedom which,
having overthrown all the heavenly
& earthly idols, will have founded
& organized a new world, the
world of human solidarity,
upon the ruins of all the churches
& states. —MIKHAIL BAKUNIN

MALCONTENTS MISSIVE 1

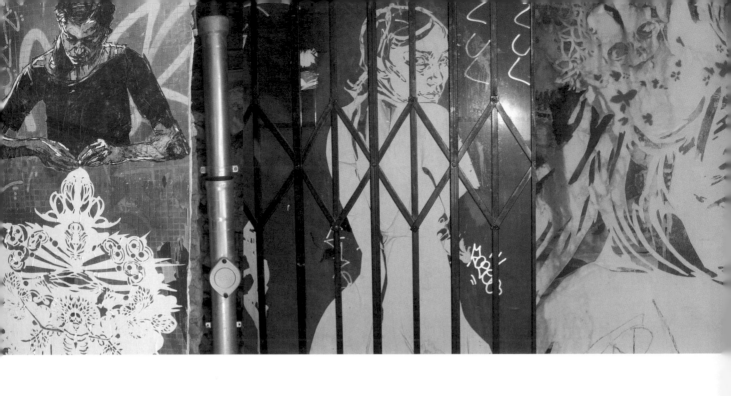

Swoon

New York, NY

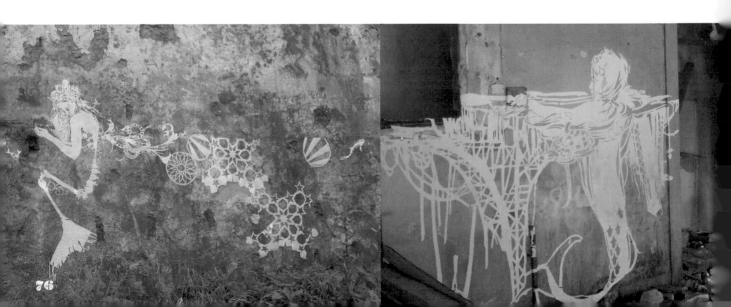

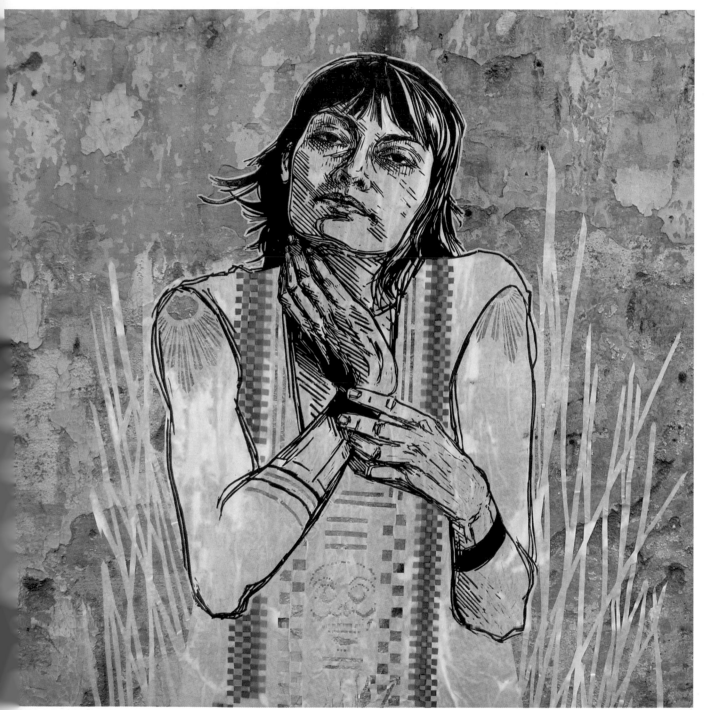

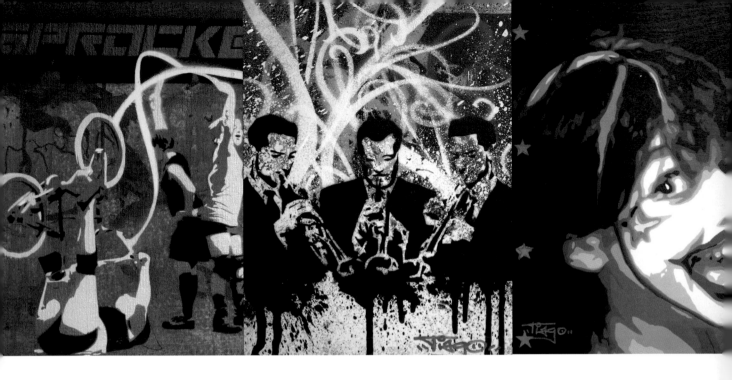

Tiago Denczuk

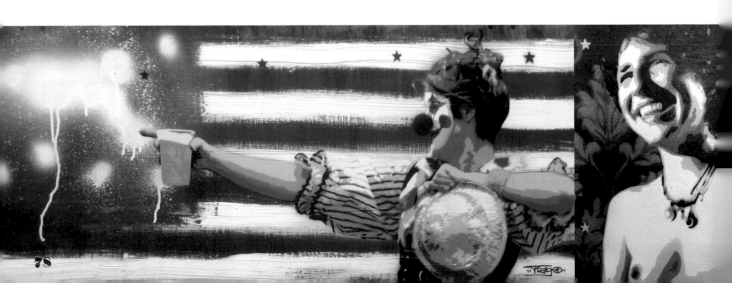

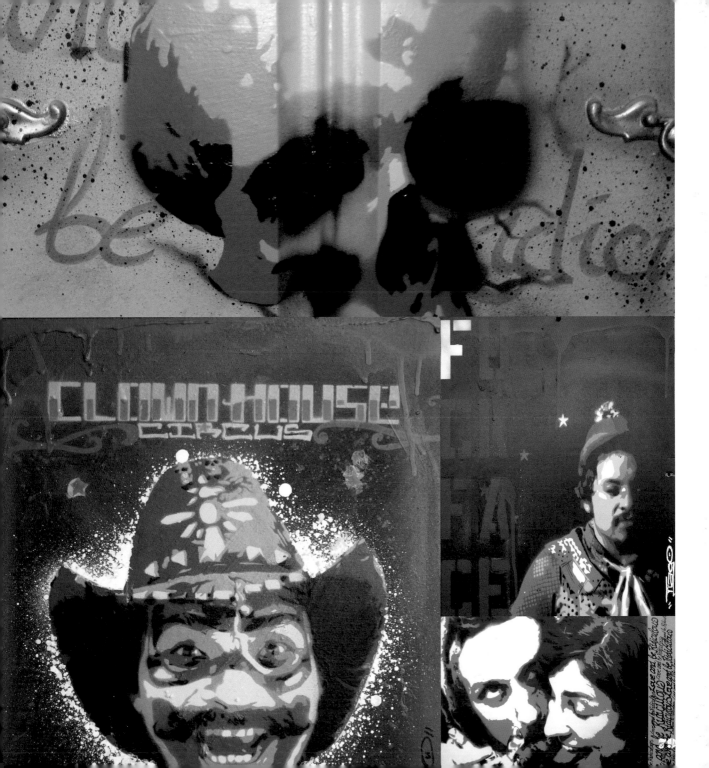

DOCUMENTARIANS

The culture artifacts of modern society will be recorded, photographed, posted online, and made available for others to experience as long as the technology used to document is cheap and easy to use. Go to a rock concert, and instead of lighters, cameras and cell phones light up the venue. Newsmakers falling into the spotlight of corporate media must accept that their every public move will be recorded, documented, and most likely end up archived on the Internet for posterity.

People have the ability to instantly capture each moment's history, now more than ever before. The research company, Strategy Analytics, reports that three million camera phones were in use in 2001, 500 million in 2006, with expectations of over one billion in use by 2007. This wave of citizen-created history sparked Time magazine to name "You" Person of the Year in 2006, stating that the web is a "tool for bringing together the small contributions of millions of people and making them matter…. It's really a revolution."

Another thing that "You" have recently done is to change your typical daily routine. The Situationist concept of psychogeography, where pedestrians are encouraged to break predictable routines and rediscover their urban surroundings, easily fits city dwellers' new modern lifestyles. Walking around with personal technology suddenly breaks the old way of obliviously heading to work. Advancing this concept, the changing atmosphere of public space has become more personal; the impersonal media advertising that bombards people from billboards and passing buses begins to lose potency. With a wandering eye and a camera in tow, today's citizen begins to notice other visual stimuli around them, and photograph it.

For the people who become drawn into Stencil Nation, this ease of and access to technology has allowed global awareness of local stencil art. Before this revolution, an artist's work could go unknown unless other, more difficult means of promotion were used to get the word out. Now, a simple profile on Flickr allows artists and their fans to post new work and discoveries. A public stencil, likely to be painted over, will be digitally photographed and posted as a small contribution to the collective archives serving an appreciative audience around the world.

The impermanence of the art form adds another layer of speed and necessity for documenting the works on streets and sidewalks. Graffiti is seen as a threat: those who do not view it as art seek to erase or buff the public text and images. Some municipal governments go so far as to create laws to make graffiti an illegal activity.

The battle over the buff may seem endless and useless for some, and though millions of dollars are spent erasing all styles of graffiti, more usually appears. For people who see street art as a viable form or expression, some of this art shouldn't be buffed. To document the work before it does disappear, some fans take it upon themselves to collect images of the artwork.

As far back as the 1980s, stencil art caught the interest of people who had decided to change their regular habits and hunt for various kinds of street art with their analog cameras. These early documentarians dropped the film off at stores so that negatives could be developed and the photos printed, and paid a good bit of money to do so. These early photographers didn't have the Internet as an organizational and communication tool, so they often didn't find other people who had similar collections unless mutual friends connected them.

Stencil graffiti images only began to be collected in earnest once the technology allowed easy use and posting of the "flicks" that began to accumulate around the world. The more obsessive documenters bought the early digital cameras, and began to digitize their photos. Somewhere around 2003, personal web sites began to show the growing influence of stencil art. Sites such as Flickr, WordPress, MySpace, and Blogger have widened the flow of images from all corners of the planet. Where only a few web sites showed the way as early as 1996, dozens of locations in as many languages now allow artists, fans, and collectors to share and appreciate both local and international creations.

The importance of documentarians hasn't gone unnoticed in the community. The symbiotic relationship between documentarians and artists is a must in today's urban environment. Some become art form historians after photographing their first piece of art. Others took photographs when they discovered the joy and spontaneity of finding random unexplained images and text appearing in their local environment. Still others added stencil art to their list of things worth photographing. Whatever their reasons, these documentarians fit an indispensable piece of the community into the larger puzzle of Stencil Nation.

Curious as to why these citizens make photographing stencils a part of their lives, some of the documentarians that contributed to this book answered a few questions about their connections to the art form.

D.S. Black
scribbler, shutterbug, and a self-style "entropologist" fascinated by the decay of human systems, Berkeley, California, USA

I first photographed a stencil in San Francisco in 1984. I had been shooting graffiti for a few years, and began to notice that text and graphic cutouts were being used to help with inscribing sub- and counter-cultural messages on the cityscape. I see stencils as comments and critiques sketched in the margins of everyday life. Establishment media give the point of view from above.

To find out what your neighbors are thinking, you have to be receptive to what you see and hear on the street. In a visual form, they give voice to an invisible and otherwise silent population that is encouraged, increasingly, to find self-expression in consumerism. These street messages are a necessary antidote to omnipresent advertising, and serve as a reminder that more important freedoms exist than the right and requirement to shop.

I have been intrigued to find multiple manifestations of the same image – Minimal Man, for instance, appearing in the Mission and on the Berlin Wall. Also in the 1980s, when fears of a superpower showdown were probably most acute since the Cuban missile crisis, the stencil of a broken sword, which was an icon of the peace movement, appeared in many cities. I photographed it both here in San Francisco and in Toronto, Canada.

David Drexler
musician and IT worker, Madison, Wisconsin, USA

Photography has been a hobby of mine for several years. I always enjoyed the whimsical stencils that showed up around the University of Wisconsin campus, and I started taking pictures of them in Fall of 2006. Stencils range from funny to thought-provoking to sometimes a bit disturbing. The artists take a bit of a risk to put their art in a public space where it provides an unexpected experience for passersby. Search flickr.com for "madison wisconsin stencil," and you'll find my photos and many others.

Maya
Barcelona, Spain

I am a fan of stencils and almost always have my camera with me when walking around the city. I noticed stencils for the first time in 2002 in Dublin, Ireland but only started taking photos of them in Barcelona in 2004 when I started my blog. I like them because they are different than graffiti. A lot of them have a message, and by taking photos of them, I try to "immortalize" them before they are erased from their locations. The great thing is that after a while you recognize the works of different stencil artists, and thanks to the Internet, you can exchange information and experiences with other fans or even artists.

Stencils make life more colorful. I love it when I walk in the streets and come across a good stencil that either has a message or is just funny or original. When visiting a city, I actually scan the walls hoping to find a stencil. So far, I've found them in Dublin, Ireland; Paris, France; Hamburg, Germany; Porto, Portugal; Rome, Italy; and Barcelona, Spain.

My favorite city for stencils is definitely Lisbon, Portugal. The walls of some parts of the city, such as the Bairro Alto, are completely covered with stencils. I just can't stop being amazed and taking one photo after the other.

THOMAS MÜLLER / TXMX
painter, Hamburg, Germany

I photographed my first stencil in 1990 in Hamburg, because it was also the first public stencil I made. Finding a stencil is like finding a delicious mushroom in the woods! In the real world, I have a few regular routes, long and short, that I take to find stencils. The route depends on my mood, the time, the weather, etc., and includes St. Pauli, Altona, Karolinenviertel, and Schanzenviertel (all in Hamburg). I know the places and hot spots, and sometimes get a hint from my network of informants! In other cities I always spend a day or so hunting for all kinds of graffiti and street art. My favorite is Barcelona in every respect!

JNJ GRAFFITECTURE
Japan

I photographed my first stencil in Shibuya, Tokyo, about five years ago, when going to work. I like to discover other people's creativity at unexpected places. It is fun to look for it, but it is also really exciting when you just find it by chance. My favorite places to look for stencils are the unspectacular ones where people are just passing by. I also visit places with stencil concentrations. Online, I usually look at stencils via the Flickr community.

PAPERMONSTER
scientist, Newark, NJ USA

One of my major passions is stencil art and how it fits within the spectrum of street art. I began my first documentation of stencils during the summer of 2005 on a street art research trip to London and Paris. The first stencil was in Paris and it was of a man holding a balloon by Nemo. It was the beginning of an exciting connection/interaction with the streets as my environment that opened up a whole new visual world.

Stencil art, a therapeutic form of self-expression, begins as an idea and ends with a beautiful image created from delicately cut slips of paper. Stencil art creates the environment for an active interaction between the street and the individual that can impact and inspire. As a stencil artist, it is the time where I feel relaxed and satisfied as a producer of something powerful and beautiful.

Becoming involved with stencil art opens up a visual gate in your mind that enables your eyes to train themselves to see the world in a completely new and interesting way that no person can ever take away from you. Sharing and passing this gift on to others can change the lives of how those around you interact with their physical surroundings on a daily basis. Teach and learn from others.

David Drexler

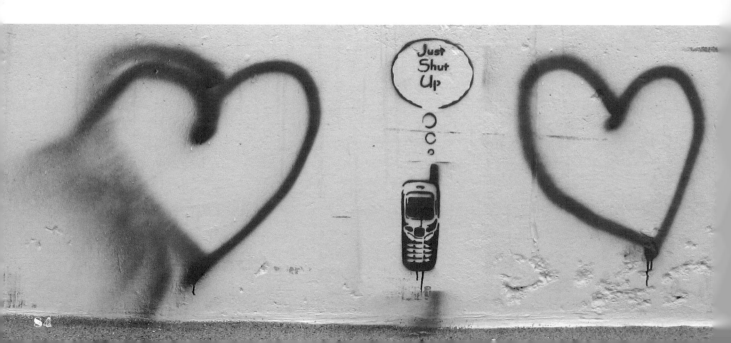

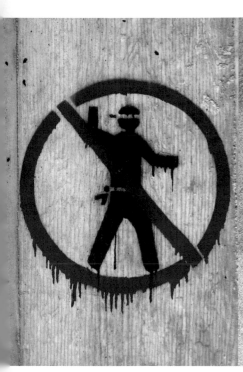

WELCOME TO
THE
JUNGLE

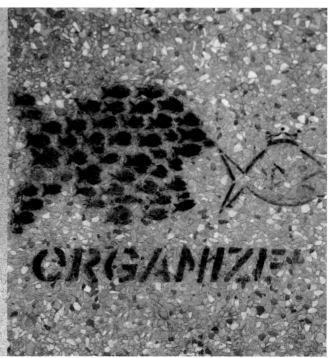

ORGANIZE

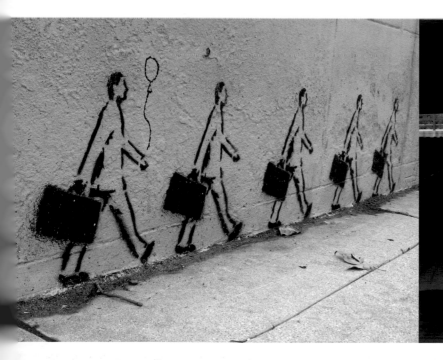

Duncan Cumming

Glasgow, Scotland

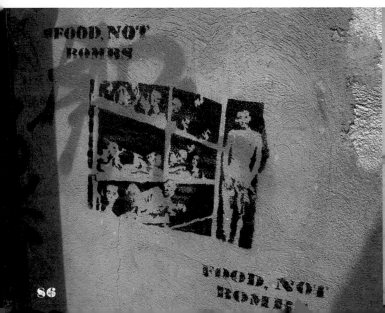

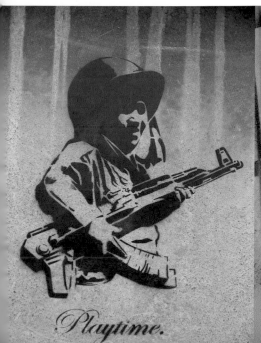

Playtime.

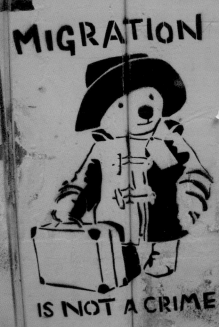

MIGRATION

IS NOT A CRIME

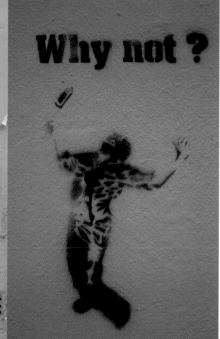

Why not ?

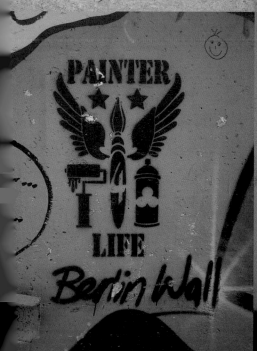

PAINTER

LIFE

Berlin Wall

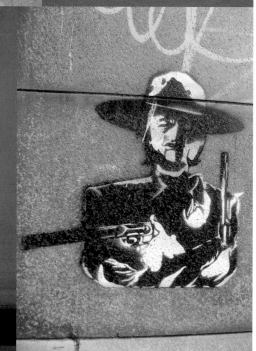

Martin Reis Toronto, Cana

COOLTURE

GIVE IT AWAY ITS ONLY LOVE

WE ARE
WE ARE
WE ARE
INVINCI
WE ARE I
TOGE

Maya worldofStencils

sten-

Thomas Müller

Hamburg, Germany

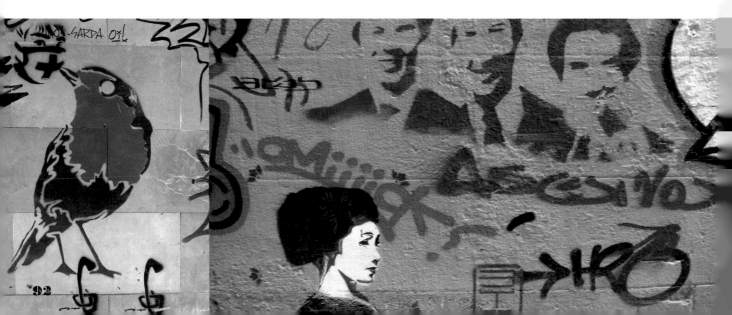

'92

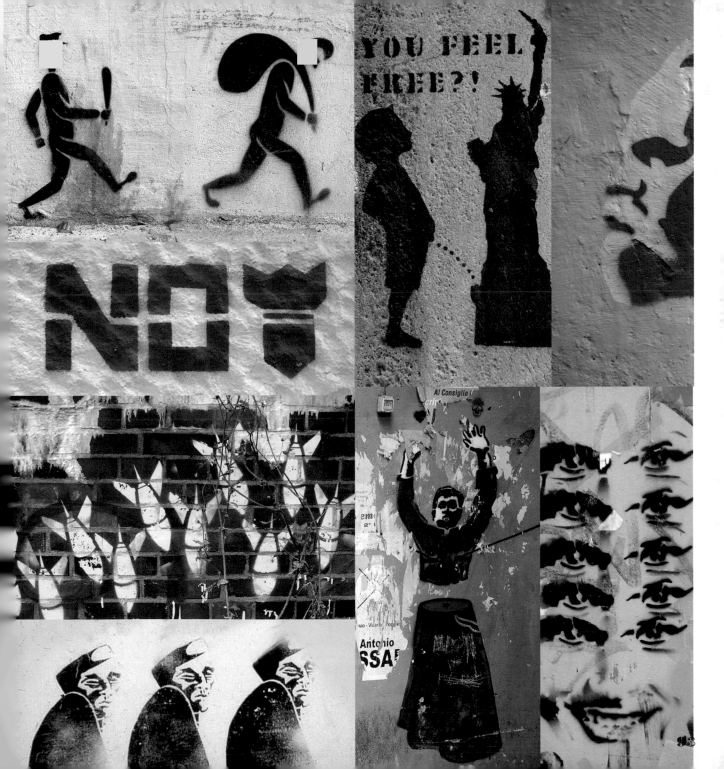

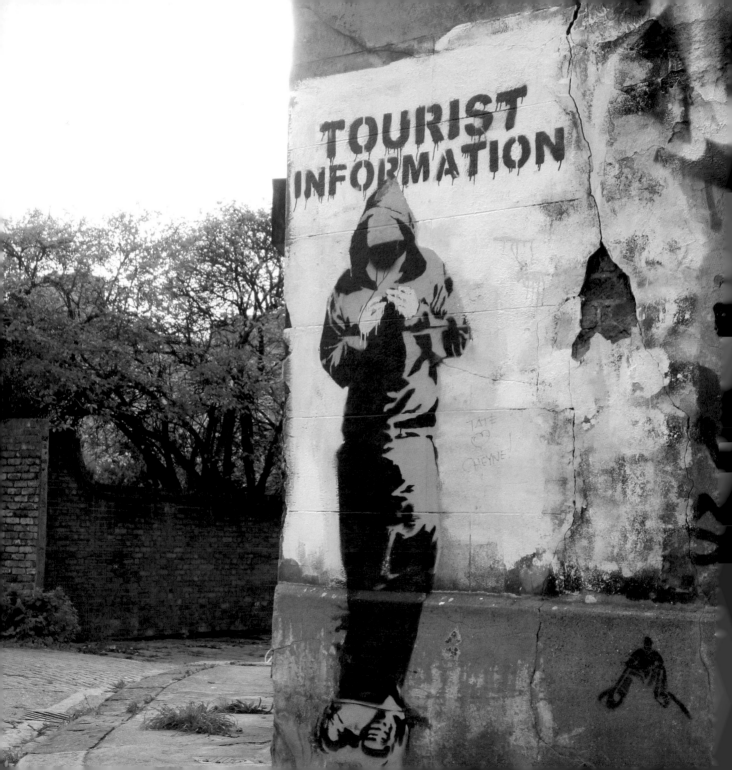

GALLERIES SHOWS GATHERINGS

DIFUSOR

NEGATIVE SPACES

VINYL KILLERS

GALLERIES, SHOWS, GATHERINGS

Stencil painters traditionally get together so that they can create, celebrate, and share this form of artistic expression. Since the art they create goes up in public, grouped artists share their stencil works with one another, random viewers, and even the opposing legal authorities. An openness to collaboration, skill sharing, and constructive criticism has allowed stenciling to flourish and has created a need for meeting up to keep the form evolving. True to its origins, the current growth of shows and festivals is deeply rooted in the tradition of creating community.

The communal spirit among stencil artists became evident during its modern development. In 1934, Mexican artist David Alfaro Siqueiros worked with local Argentineans to create public stencils that protested that country's ruling dictatorship. Many of the street stencils painted in the 1970s and 1980s were done by groups, collectives, or individuals as part of a larger group. Group Suma's mural work in Mexico, and the Crass Collective's billboard jams in the UK exemplify group collaborations in stencil art.

Stencilers also took the aspect of working as a crew from traditional graffiti and built on the foundations of that concept. Traditional graffiti often goes up when crews—a group of artists—work on creating and painting a communal piece. Over time, this hip-hop writing concept merged with stencil art's politically collective angle and helped create diverse groups of people and artists who work within the art form. The blending of punk, activist, and hip-hop influences has generated a scene that stencil artist Flipa describes in Overspray Magazine #3 as "more heterogeneous than... traditional graffiti" adding that "[heterogeneity] has forced tolerance on" the international stencil community.

This tolerance has grown proportionately as new people take up knife and paper, thanks in part to the ease of sharing information on the Internet. Posting photographs, videos, tips, tutorials and ongoing discussions about the scene and art form has fostered Stencil Nation's desire to gather together art, fans, and artists in the physical world. Before museums, galleries, and corporate creatives noticed stencils, artists and fans were sending out online calls for art and curating their own shows and exhibits.

The history of public stencil exhibitions and gatherings held prior to 2002 remains fragmented and is gathered from limited information. They did exist, as the 1986 book release of Vite Fait, Bien Fait at Paris' Galerie du Jour demonstrates. Most of the book's French pochoir artists hung their art on the walls and did live stencil collaborations during the opening party. In 1996, Western Cell Division's group exhibit "On the Street - Off the Street" opened at the Maryland Art Place in Baltimore, Maryland and included many of the United States' early street stencilers.

As early as 2002, individual artists and groups began to collaborate on collective projects via new and old methods of communication. With the theme "Art vs. Prisons," the Street Art Workers (SAW) used traditional mail as well as email and online postings to make a call for art. The result was a small amount of art mailed around the United States, stenciled, and wheat-pasted in at least ten cities. SAW has since done several other similar art actions across North America.

In August 2003, over a year after the launch of StencilArchive.org, curator Russell Howze teamed up with stencil artist Steve Lambert and his Budget Gallery project. The result was "Stencils: The Art of Negative Spaces," a pioneering international exhibit. Presented at CELLspace's Crucible Steel Gallery, a collectively-run art space in San Francisco's Mission District, the show included a group mural, a DIY stencil-making station, a buffed phone booth to stencil on, and a Question & Answer session prior to opening. More than eighty artists submitted art from three continents, and many visitors left with cheaply purchased stencil paintings via the budget-level silent auction.

Well before the San Francisco "Negative Spaces" show, Melbourne, Australia's stencil scene had become a strong community. Frequent stencil exhibitions went up, and StencilRevolution.com became a popular online meeting place for sharing photos, calls, and information. Inspired by "Negative Spaces" and the growing number of Australian community shows, Portland, Oregon stencil artist Klutch launched his first Vinyl Killers exhibit in November 2003. According to Klutch, it was "the perfect vehicle to bring everyone together and showcase stenciling as an art form." With sixty-three artists from a dozen countries participating, the event almost completely sold out. Still going strong, and holding on to its do-it-yourself ethic, Vinyl Killers had its fifth run in late 2007.

As Melbourne's community grew, the first ever Stencil Festival was held there in February 2004. According to its web site, the four-day event featured "200 paintings by 19 featured and 30 open expo artists... a film night, panel discussion, live spraying and an auction of unique artist collaborations." Garnering corporate sponsorship and city grant funding, the organizers turned what they thought was a one-time event into an annual gathering. The Melbourne Stencil Festival grew large enough to take the event to other Australian cities, listing Sydney and Perth as hosts for the 2007 Stencil Festival.

As gallery shows caught on across the world, many stencil artists began to gain wider recognition for their works. Logan Hicks went on an international tour sponsored by fashion manufacturer K-Swiss, stenciling gallery walls as well as collaborating with other artists in shows across Asia. In 2006, Blek le Rat's London show at Leonard Street Gallery sold out on opening night. UK artist Banksy's canvas works became hot items, selling recently for up to £102,000 at auction and garnering international media attention.

In 2007, Barcelona, Spain hosted its first ever stencil gathering. Difusor, an "international stencil meeting," opened June 29 for four full days, encouraging stencil-based community. Eighty different artists from nineteen countries gathered to paint indoors and out, show their cut work, and meet one another. Talks, video screenings, and workshops also filled out the event, but the highlights were clearly the amazing murals and large stencils that went up across the city.

The community and tolerance that Stencil Nation values will hopefully lead it into the future with a willingness to discuss the issues that arise and potentially need to be worked out. As artists and fans continue to gather around the art form, homegrown as well as sponsored events will make the space that is necessary for the movement to grow and mature. The different influences that Stencil Nation shares, the new traditions that are being created via the shows and gatherings, and the desire to keep the art's style and form moving and improving will continue to define the scene now and in the future.

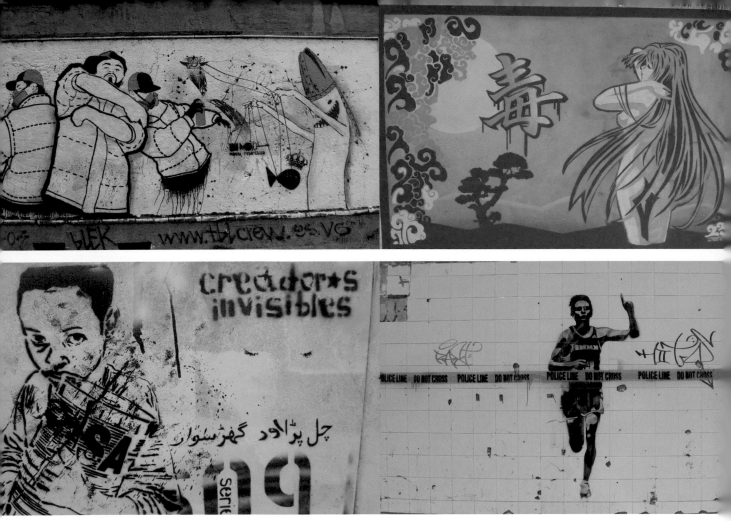

Difusor

Barcelona (2007)

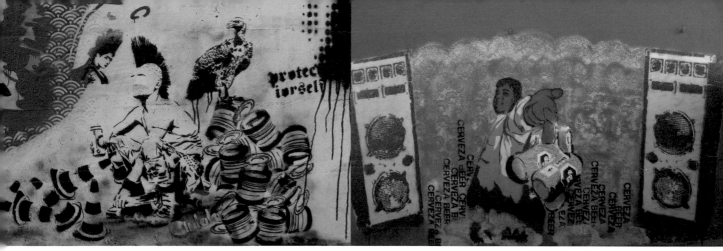

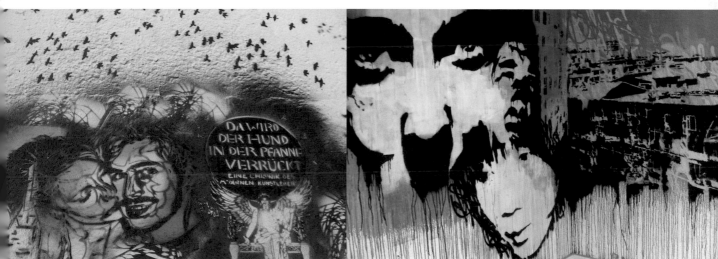

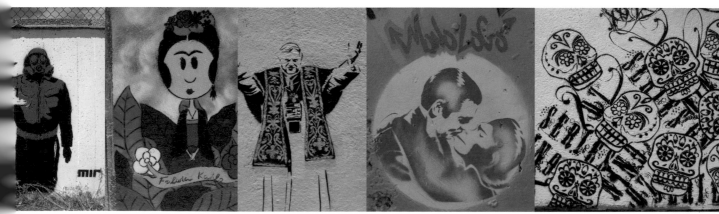

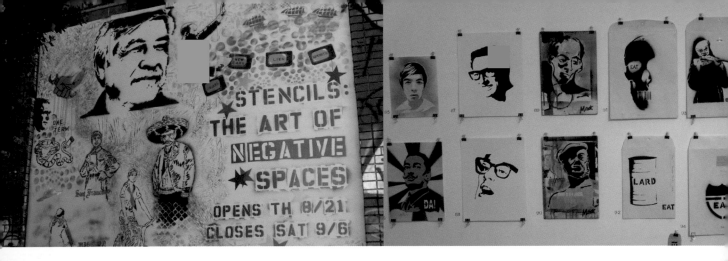
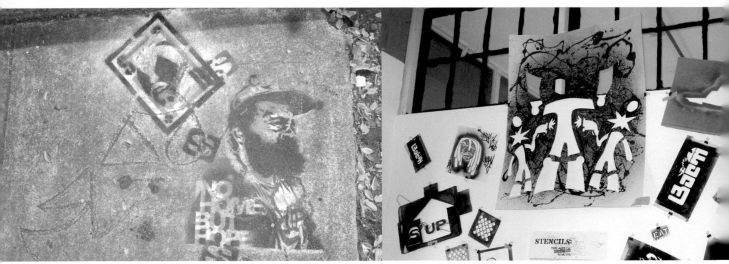
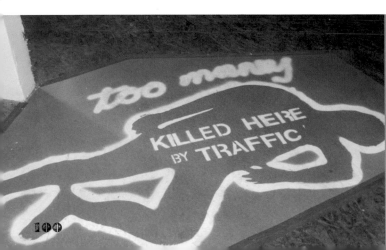

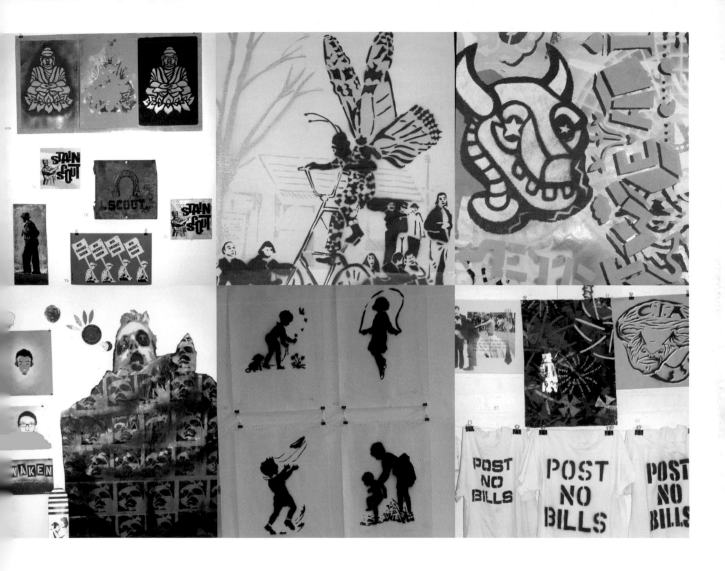

Negative Spaces

San Francisco (2003)

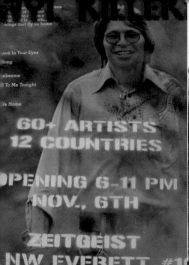

60+ ARTISTS
12 COUNTRIES

OPENING 6-11 PM
NOV., 6TH

ZEITGEIST
NW EVERETT #1

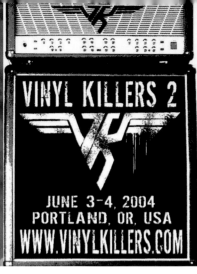

VINYL KILLERS 2

JUNE 3-4, 2004
PORTLAND, OR, USA
WWW.VINYLKILLERS.COM

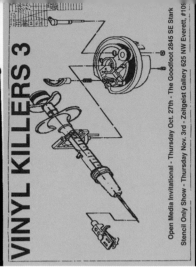

VINYL KILLERS 3

Open Media Invitational - Thursday Oct. 27th - The Goodfoot 2845 SE Stark

Stencil Only Show - Thursday Nov. 3rd - Zeitgeist Gallery 625 NW Everett, #10

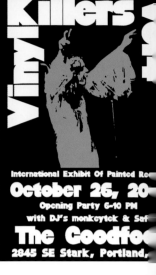

Vinyl Killers

International Exhibit Of Painted Rec

October 26, 20

Opening Party 6-10 PM
with DJ's monkeytek & Saf

The Goodfo

2845 SE Stark, Portland,

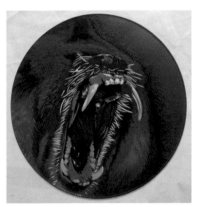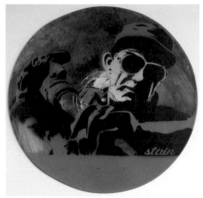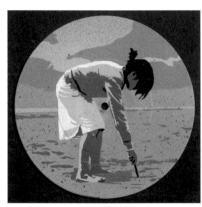

Vinyl Killers

Portland, OR and San Francisco, CA
(2003 - present)

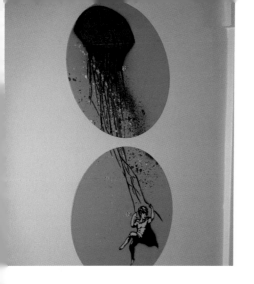

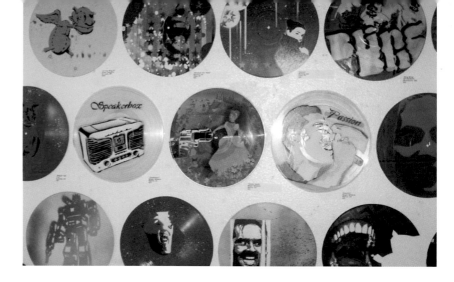

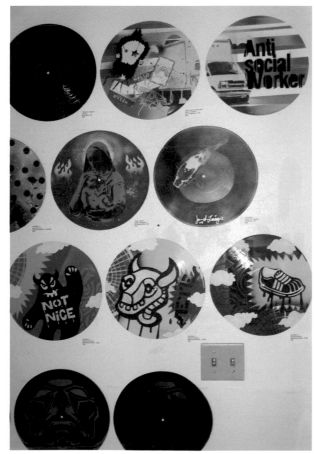

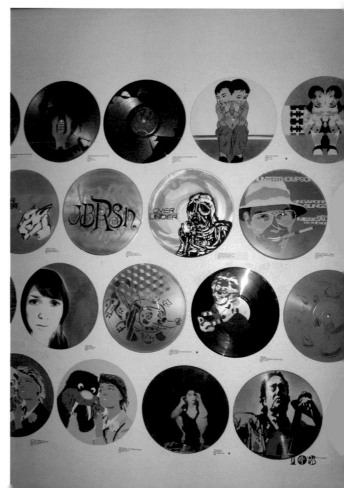

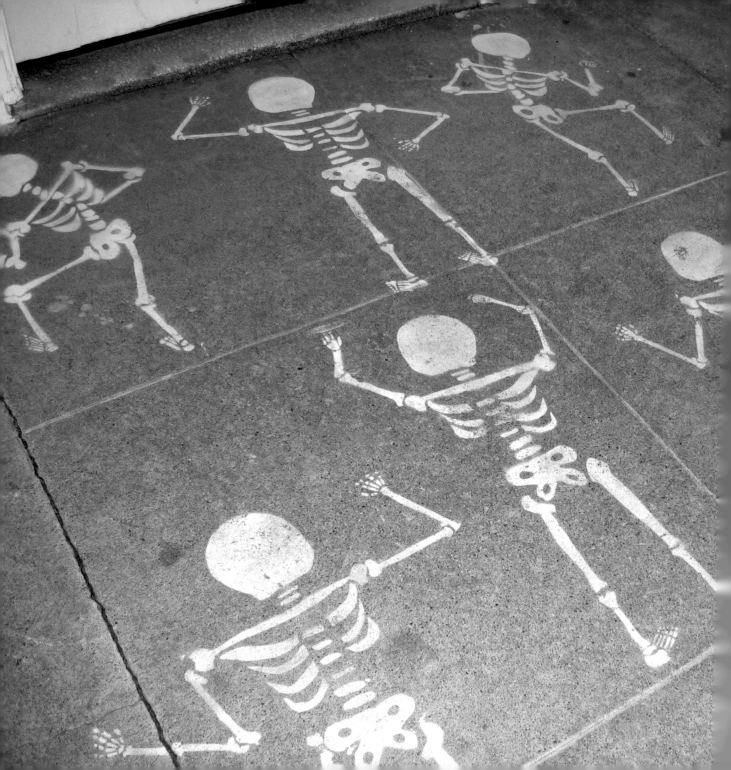

IN THE STREETS

Buffed, Covered, Crossed, & Ripped

Conversations

Horizontal and Vertical
Stencil Image Placement

IN THE STREETS

Just what is a painted stencil found on the city streets across Stencil Nation? The answer depends on whom you ask. Some call it "vandalism" or "defacement," while others call it "art" or "the voice of the disempowered." Citizens may see it as art, but only if it is painted on certain surfaces – maybe the sidewalk, or perhaps on a derelict building in an empty part of the city. A street stencil may be seen as an example of the Broken Windows theory: a 1990s belief that a small amount of graffiti would lead to a larger amount, and eventually other forms, of heinous crime. Are stencils a valid form of expression or do they solely exist to annoy property owners who have to paint over the visual pollution?

The debate may never come to a conclusion because stencil graffiti will continue to perplex those who create, view, and eradicate it. For some municipalities like San Francisco, official advice is offered for property owners who have graffiti on their buildings: "Paint over graffiti within 48 hours whenever possible and advise your neighbors to do the same. Vandals will move along to a different neighborhood if their vandalism is abated quickly." That other neighborhood will have to do the same; instead of going somewhere else in the city, the art may just move to the next block.

Most property owners (and the government institutions that protect their interests) forget that graffiti evolved from early humans' desire to leave their marks in places where they had been. "Inner city stencil artists and cavemen are conveying the same message: 'I am here,' " state Belén Dezzi and Guido Indij in Indij's book Hasta la victoria, stencil!

Petroglyphs, as well as prehistoric stencils, which found throughout the world marked the beginning of humanity's creative urge. Human markings continued as higher art forms flourished and have been found in first century Pompeii as well as on Paleolithic rock art that was "defaced" by future populations. These types of scratches, paintings, words, and images have become important cultural artifacts in human history.

The original ancient attraction to creativity also developed into what is generally described as "art." For those who decry defacement of private property, art is a specific sect of creativity. Art should be contained inside buildings or constrained by government laws, permits, and bureaucracy. Art hangs on white walls, in private homes, and in huge facilities created by the same people who attempt to control the public visual sphere. In his book Wall and Piece, artist and vandal Banksy nicely sums up what this type of creative expression means to the people who, instead of trying to control the open spaces, express themselves within it.

"The Art we look at is made by only a select few. A small group create, promote, purchase, exhibit and decide the success of Art. Only a few hundred people in the world have any real say.

When you go to an Art gallery you are simply a tourist looking at the trophy cabinet of a few millionaires."

The prehistoric cave stencil began as a public form of expression; the painters most likely shared the art via rituals, stories, or traditions. Over time, the stencil became a tool for easily copying an image, but it still maintained its public characteristic via the temples in China, posters in Europe, and utilitarian usage in America. As ancient graffiti evolved into a modern form of public expression via the convenience of spraypaint, so too did stencils become another means for having a voice where voices otherwise went unheard. The fact that different 20th century artists began to stencil their ideas simultaneously around the world leaves little doubt that the art form is meant to be in shared communal spaces. Stencils and other forms of graffiti have not gone away, no matter how hard the buff hits it, because humans will continue to mark their environment.

Buffed, Covered, Crossed, & Ripped

"It's frustrating when the only people with good photos of your work are the police department," Banksy writes in Wall and Piece, as he logs how long some of his works last after they've been illegally installed in public. Painting over street art and graffiti doesn't happen unexpectedly. Street artists see it as part of the process, moving on when a piece is buffed and celebrating if it has a long run.

For the artist, fan, and documenter, the impermanence of street stencils causes excitement, curiosity, and surprise. A walk through the neighborhood might open up a path to new artwork, and if you've forgotten to bring your camera, you might miss the opportunity to photograph it. Coming back to the point of creation, artists know that the stencil may be gone if they don't get there on time. Like Brazilian stencil artist and photographer Alexandre Orion, many artists see the photograph as another step in experiencing the art form. Text accompanying his 2006 San Francisco exhibit at the 111 Minna Gallery explains:

"[Orion] works by combining painting with photography on the walls of São Paulo City megalopolis into the day-to-day life of passers-by with a photographic eye that captures an exact moment in the real lives of the dispossessed, the ignored, the unimportant and the 'normals.' "

In many cities, public art that has been created without permission is considered illegal, and consequently buffed. Each municipality approaches the "problem" with different tactics. New York removed most of the traditional modern graffiti from its subway cars after the government fenced off train yards, and invested funds into eradicating the art via chemicals. San Francisco has recently made any form of graffiti the problem of individual property owners, threatening them with fines if they don't buff it in a certain amount of time. In 2000, the state of California passed Proposition 21, which connected graffiti with gang-related activities and made it a potential felony-level crime.

Still, other cities see graffiti art as a valid art form. Bristol, UK just gave Banksy's "Mild Mild West" mural the Favorite Alternative Landmark award, and the new owners of the building will encase it in glass. In Melbourne, Australia, Hosier Lane has become a de facto legal alley of stencil

and other types of street art. Festivals like Australia's Stencil Festival and Barcelona's Difusor have received funding from municipalities, encouraging and celebrating the art form rather than seeing it as a public nuisance and seeking to wholly eradicate it.

The buff still hits hard in many places around the world. Some fans and artists play on the themes of this on-going battle. Some artists stencil images of the people who are painting over their art. Seeing the artistic value of a well-composed photo of buffed street stencils, documenters will sometimes photograph the interesting patterns or partially buffed stencils. Filmmaker Matt McCormick even created a short documentary, "The Subconscious Art of Graffiti Removal," where buffed paint patterns are compared to works of Mark Rothko and Robert Rauschenberg. Other times, the buffed paint creates another surface for the artist to stencil on.

Instead of painting over street stencils, other people react in different ways. Wheatpasted stencils on paper, and stencil stickers share similar fates when people attempt to take the art off their applied surface to most likely put them on their private walls or in scrapbooks. Torn and ripped posters and stickers take on new meanings, and create new questions about why someone decided to take the art.

On July 21, 2007, French artist Jef Aérosol pasted two stencils-on-paper pieces in Lyon, France. The images of Jimi Hendrix and the "sitting kid" must have appealed to a passerby, or repulsed them. The next day "someone had already tried to remove the paste-ups," Aérosol writes on his Flickr posting. He saw that "the result of that tearing-off" was artistically appealing, so took another photo of the pieces and posted that image with the one he had taken the day before.

A third form of buffing street stencils is by crossing the piece out. Traditional graffiti consists of crossing out a work if one crew of writers has a beef (an argument or war) with another crew. This can be a simple "X" spraypainted over the other crew's art, a tag (simple writing), or a more-creative cross via a throw-up (a quick one-to-two color letter painting). For stencil graffiti, someone who has decided to respond to the message or image usually draws or scrapes an "X" over the piece. The person who takes the time to cross the image, an illegal act of his or her own volition if they deface the property, disagrees with the message or doesn't like the person or group who painted it.

CONVERSATIONS

Some people take extra steps beyond crossing stencil graffiti, and cross over into their own illegal actions. In San Francisco, shortly after September 11, 2001, someone changed the message of a stencil that said "US Navy Out of Viaques Now" by painting "Bomb Arabs" over it. Though the latter message could have been painted anywhere in the City, this hate-filled person chose this one spot to make his statement.

Other examples of street stencil conversations vary from pen-written scrawls in comic-book speech bubbles to new stencils or artwork that play on the text or image of the older piece. Someone may add breasts to a stencil of a woman, while a stencil that says "No War on Iraq" ends up with several other stencils next to it saying "No Warts on a Rock" and "No Balls on a Chickenhawk."

Turning the Broken Windows theory on end, stencil graffiti encourages a written or painted response. The reply may fall into the same types mentioned above, or may take on different approaches. Broken Windows theory states that unchecked graffiti will bring more graffiti and then more heinous crimes. There is no evidence that stencil art raises violent crime rates, but it does create a new form of publicly expressed language and dialogue.

Along with shorter, quick forms of answering the stencil's message, street work can also take on a viral characteristic. One or two stencils in an area can sometimes cause dozens to appear. Other forms of graffiti and street art may appear as well, adding to the public gallery feel of the area. If left unchecked, the wall can become a mural, and even a multi-year historical document of the art form.

Hosier Lane in Melbourne, Australia runs as a 500-foot public stencil gallery, while Tel Aviv, Israel's Shenkin Street boasts a small unbuffed wall where several dozen artists have gotten up. The long runs of these murals may be because of a lack of funding for graffiti eradication, or perhaps the municipality's open attitude towards stencil art may help some of these locations keep the art up for extended periods. As the free flow of images and text accumulate over time, the walls begin to look similar to ancient cave markings, and tell their own stories about the period in which they where created.

Simple connections of ideas and direct statements represent another type of stencil conversation. In this book's foreword, Chris Carlsson mentions the context of stencil art. A stop sign with President George W. Bush's face stenciled on it needs no contextual discussion. An urban resident who stencils "High Crime Area" on his or her building isn't asking for any deep analysis either.

Possibly the most important way street stencils spur conversation is via the viewer's physical interaction with them. Two sets of feet with the words "Dance Here" stenciled on the sidewalk creates an instant act of spontaneily for anyone who chooses to get close with another person and dance. Two sets of footprints, one with positive messages and the other with negative, asks the viewer to walk both pairs and think about where they're headed. In San Francisco, a group of artists called The Strangers decided to create a stencil story about two people in the neighborhood. The characters may or may not fall in love, because the viewer who follows the arrows and text of dozens of stencils can choose different paths that lead to about four different endings to their romantic story.

HORIZONTAL AND VERTICAL STENCIL IMAGE PLACEMENT

Street stencils fall into two general categories; described simply according to what surface they are painted on. Other than horizontal and vertical placement, Stencil Nation has only broken down stencil work into a few other categories, found in the "Stencil Media" section. Part of the community's interaction with stencil art stems from an initial reaction to a newly discovered piece. Context, questions, and emotions arise and mix for the viewer who takes time to contemplate the art, its message, and the individual who put it there.

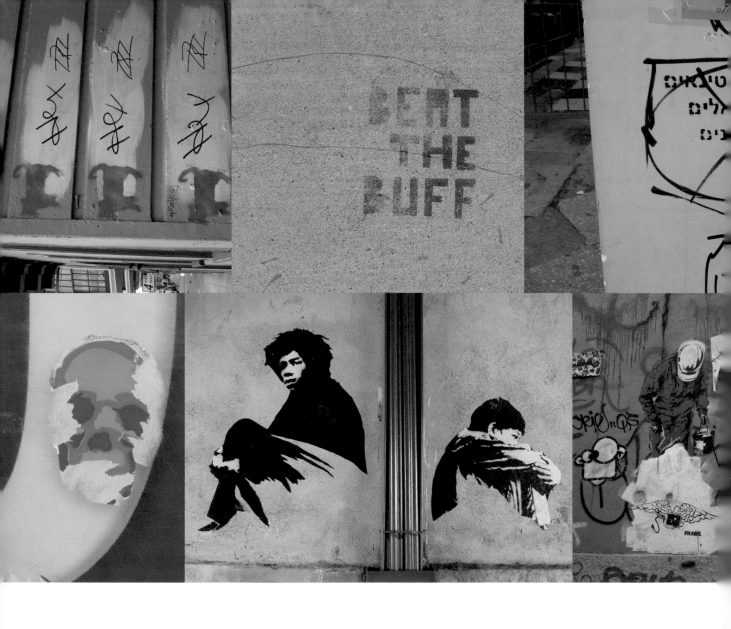

Buffed, covered, crossed, and ripped

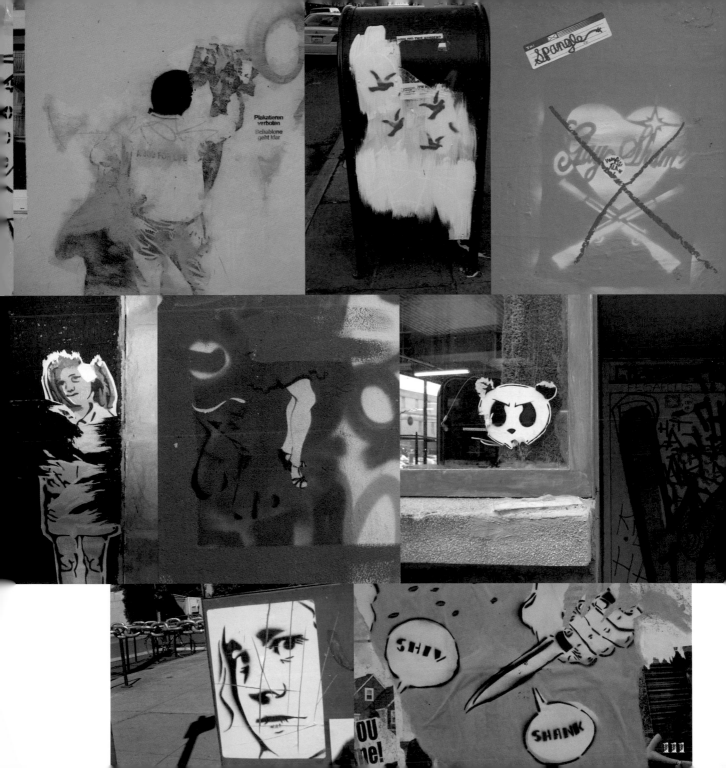

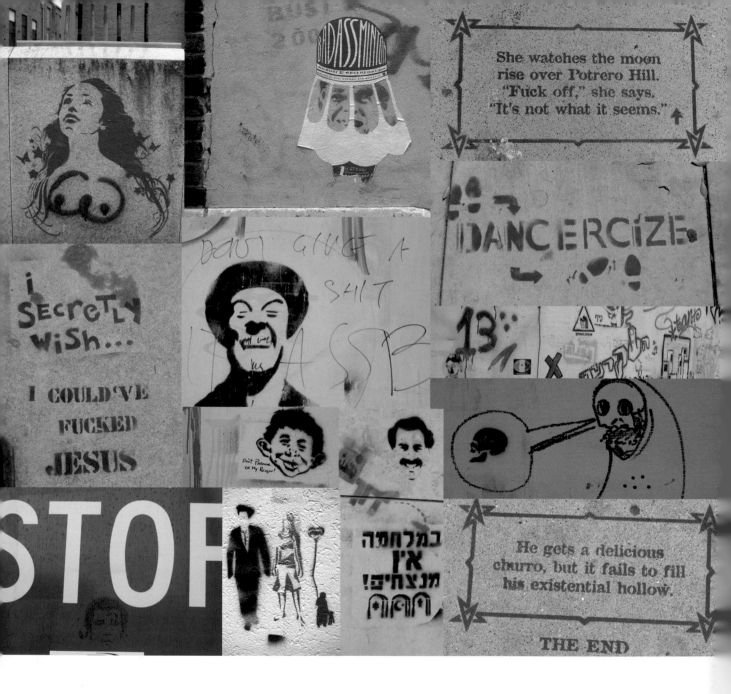

She watches the moon
rise over Potrero Hill.
"Fuck off," she says.
"It's not what it seems."

i
SECRETLY
WiSH...

I COULD'VE
FUCKED
JESUS

DANCERCIZE

STOP

במלחמה
אין
מנצחים!

He gets a delicious
churro, but it fails to fill
his existential hollow.

THE END

Conversations

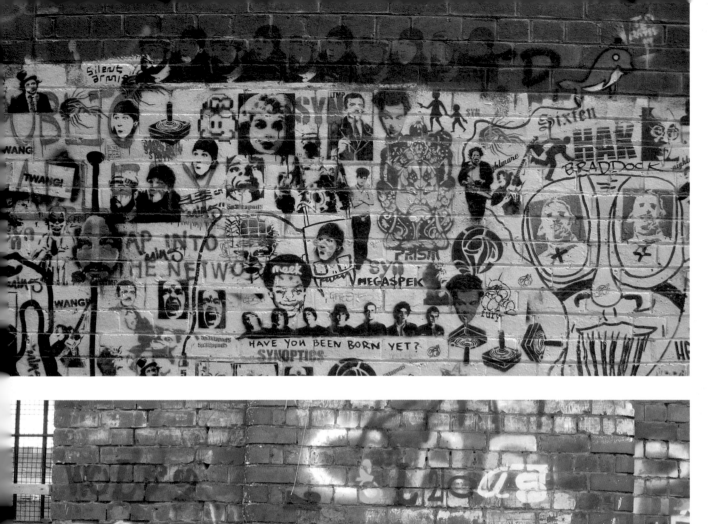

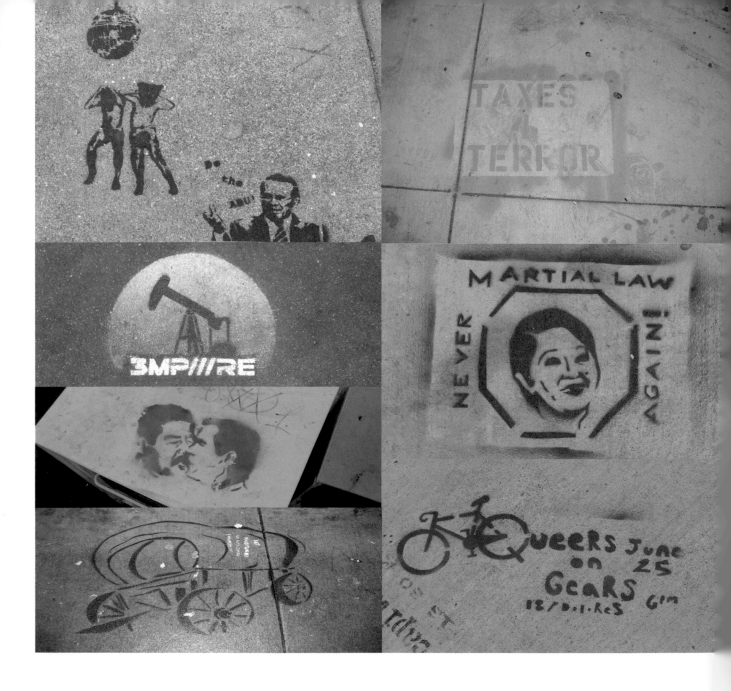

Horizontal Stencil Image Placement

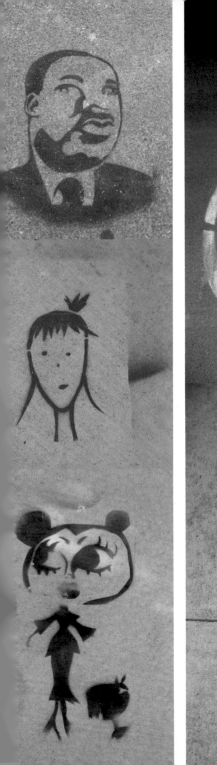
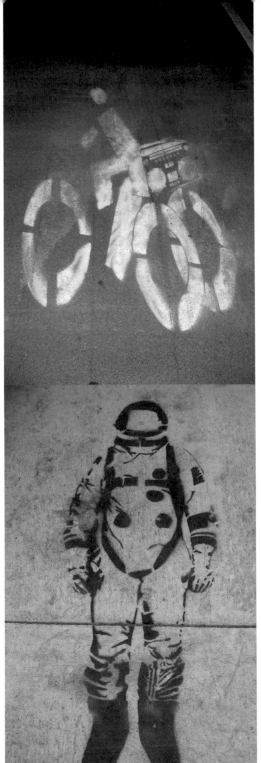
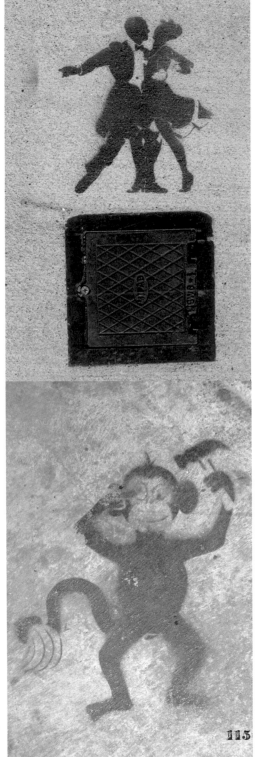

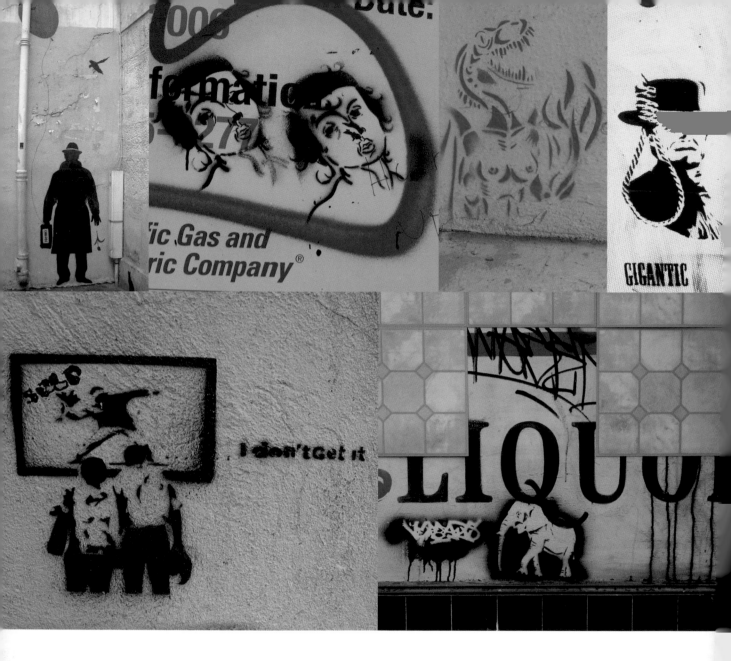

Vertical Stencil Image Placement

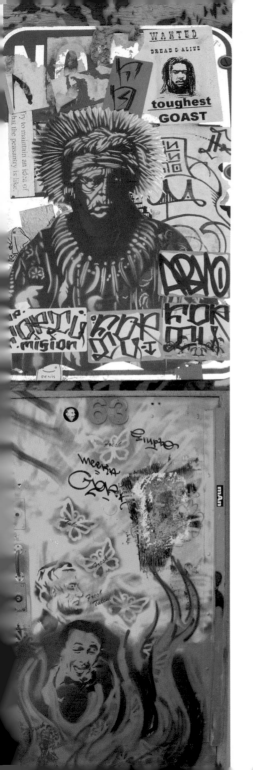

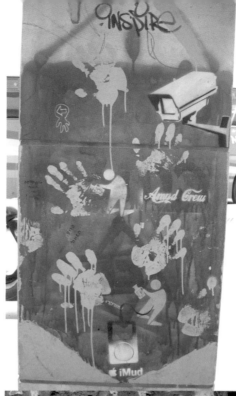

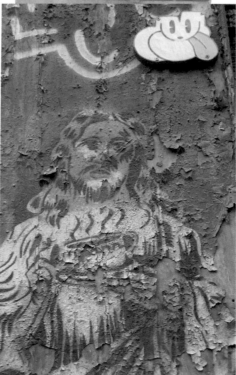

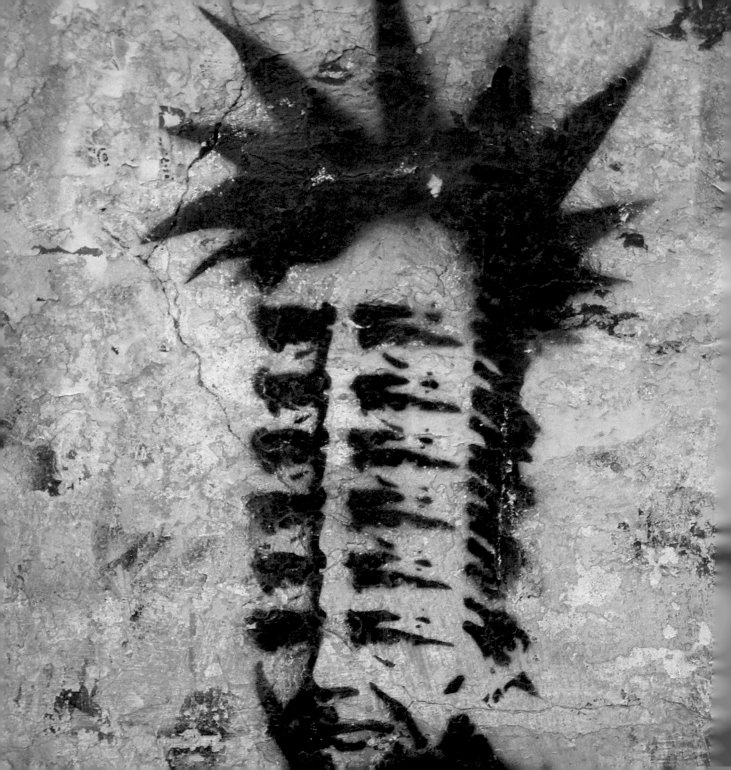

CITIES OF STENCIL NATION

Black Rock City, NV, USA

Oaxaca, MX

Montreal, QC, CA

San Francisco, CA, USA

Taipei, TW

Tel Aviv, IL

Tokyo, JP

CITIES OF STENCIL NATION

Stencil art and graffiti do not appear only in a few urban centers where several artists live. Across the world, stencil art often appears on the streets, sometimes in festivals, and occasionally inside galleries. Street stencil hot spots appear in Paris, London, Melbourne, San Francisco, and New York... but other cities get action, too. Buenos Aires, Cape Town, Tehran, and São Paulo have stencil art, just like other cities across the vast Stencil Nation.

Critical perspectives often classify stencil artists as white, male, and art-school educated, but anyone can easily make a stencil and be a Stencil Nation citizen. The evidence of the tool's history does not show that one type of person holds stencil rights over another. Its ancient roots took soil from caves in Australia, Argentina, and France. In the 20th century, modern stencil roots grew from political movements in diverse places like South Africa, Mexico, and Nicaragua. These roots dug deeper with the punk and hip-hop music movements in the UK and United States, and slowly began to spread.

Over the past five years, traveling artists and homegrown adopters have picked up the tools and painted streets around the world. Instead of criticizing and stereotyping the community, critics should celebrate its scope and diversity. Stencil Nation appreciates the fact that most of this art is painted by unknown people across the world. Thus, it is the mission of this book to give several slices of geographic context to show how easily and quickly tools of communication spread.

BLACK ROCK CITY, NEVADA, USA

For one week out of the year, Black Rock City arises from the ancient desert lakebed upon which it is named. The Burning Man festival creates the basic city infrastructure, and the citizens build the rest. Mostly a festival celebrating fire, large sculpture art, and radical self-expression based upon participation, this temporary city has always been a welcome place for stencil art. Spraypaint and stencils work well in the hot, arid climate, so they have been employed as decorative art for many structures, autos, tee shirts, etc. Now, intentionally blank walls have begun to appear to beckon the growing popularity of traditional graffiti and stencil art, allowing the street art form to flourish in this movable desert art haven.

MONTREAL, QUEBEC, CANADA

Stencils go up all across Canada, so Montreal is no exception. Simple Flickr searches for Montreal, Vancouver, and Toronto stencils (the latter city being featured in Martin Reis's "Citizen Documentarian" section) bring up dozens of amazing pieces. Montreal hosts a community that keeps the art on the street fresh and bilingual, providing another fine Canadian example of how street stencils are at once ubiquitous, informative, and entertaining.

Oaxaca, Mexico

Following in the art form's activist roots, many artists, groups and collectives have reacted to the ongoing oppression of the Oaxacan people. After the fraud-marred election of PRI party member Governor Ulises Ruiz Ortiz, popular social justice movements attempted to demand better treatment. Ortiz refused, igniting a series of occupations, marches, and protests, followed by police repression, gun battles, deaths, and more protests. Amidst this community organizing, stencil art became an important tool of civil disobedience, communication, and expression. Like the recent wave of political stencil graffiti in Buenos Aires, Argentina, Oaxaca saw fresh pieces of all sizes go up quickly in response to Ortiz-backed aggression. If painted over, the artists easily painted the stencils again. The artists also created banners, sand-stencils, and other forms of protest art. Ortiz still remains in office while the uprising ebbs and flows, yet stencils remain a powerful tool for the expression of the people.

San Francisco, California, USA

Since the late 1970s, stencil art has proven to be a powerful art form in San Francisco, California. Aerosol pioneer Scott Williams began using the tool in 1980, developing a distinct pop/punk-infused style. D.S. Black's photographs reveal that stencils were used in the streets to provide commentary on issues, ideas, and thoughts as far back as 1984 (See "Origins" section for Williams' and Black's work). In 1997, the flourishing street stencil art on the City sidewalks inspired the creation of StencilArchive.org, an early online stencil gallery. Today, San Francisco still gets a regular coating of art, now on stickers, posters, sidewalks, walls, tile, vinyl, and other mediums worthy of painting and mounting in public. Gallery shows are frequent, and many local artists continue to find inspiration via the cut-out image.

Taipei, Taiwan and Tokyo, Japan

Asia's cities attract capital investment and architectural wonders as well as stencil art, making them hosts to Stencil Nation's growing population. Like other cities, traveling artists make sure to take their stencils along, and get up like Elik, Faile, and Bäst did in Tokyo. But local artists pick up the knife and cut out and paint their own images, proving that street stencil skills and nerve develop all over the world.

Tel Aviv, Israel

Jewish, Muslim, and Christian, Middle Eastern, Mediterranean, and European: many cultures and influences pass through Israel, making it a unique crossroads for stencil art. As the country continues to build its security wall around Palestine's West Bank, many international artists seek to work on that concrete canvas. On the nation's coast, Tel Aviv's street stencil scene makes its mark as well, displaying art that stands alone in style, content, and creativity. Mostly painted on Shenkin Street, Tel Aviv's artists have created their own politically-charged public gallery along the walls of this trendy shopping area.

Black
Rock
City

NV, USA

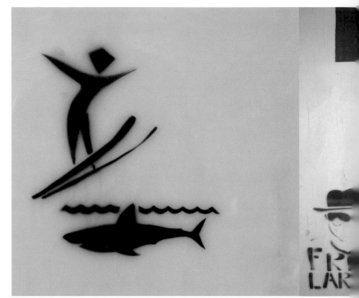

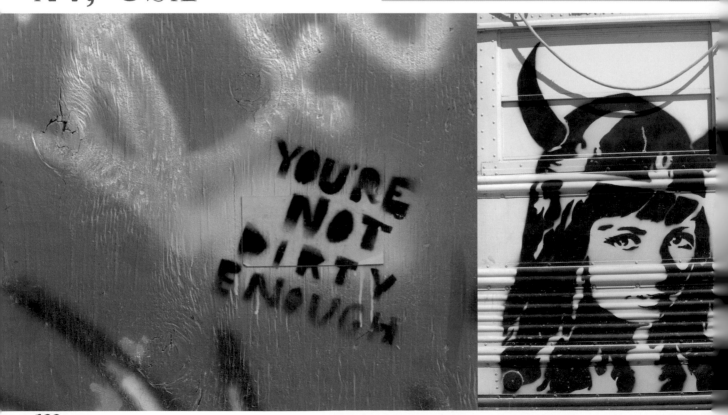

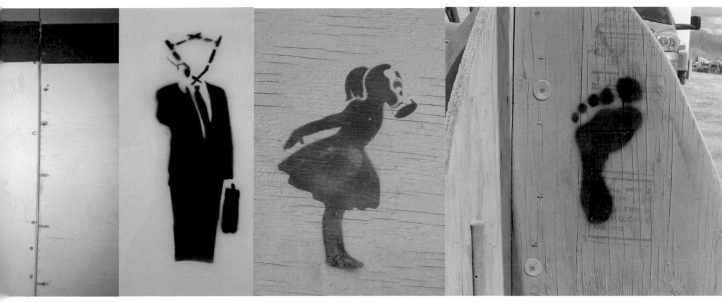

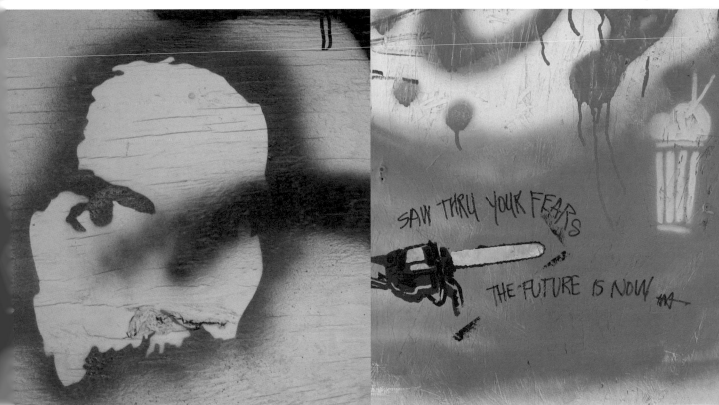

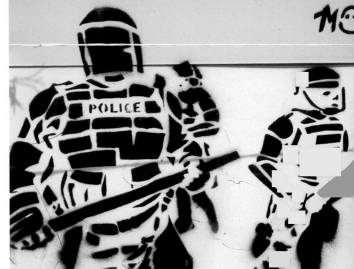

Montreal

QC, CA

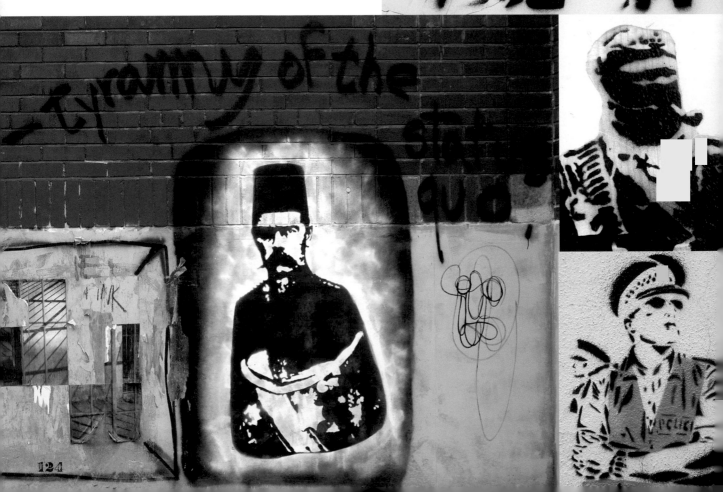

Tyranny of the status quo

124

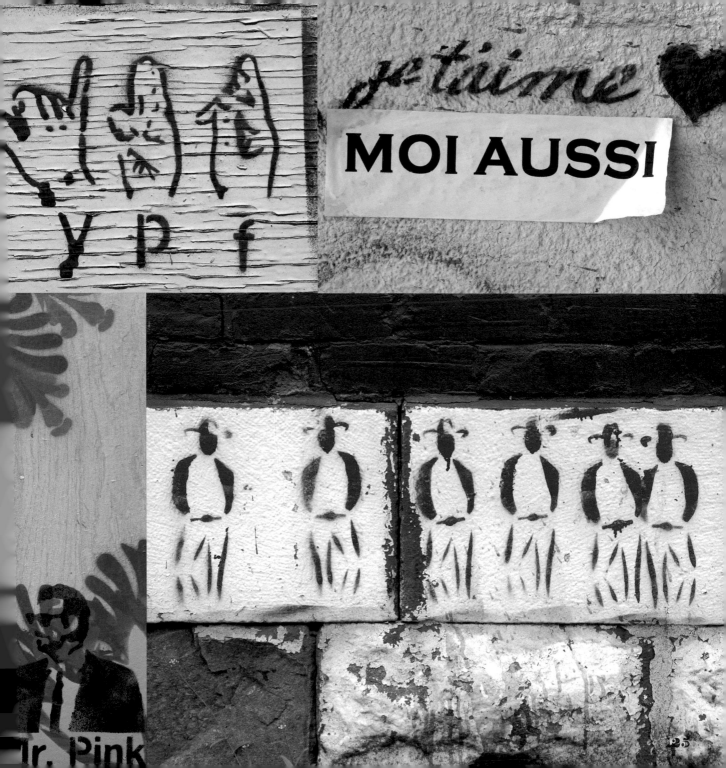

je t'aime

MOI AUSSI

Mr. Pink

Oaxaca

MX

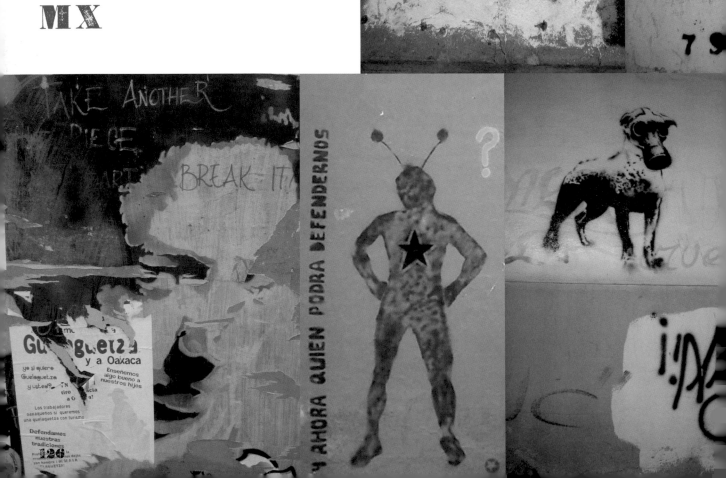

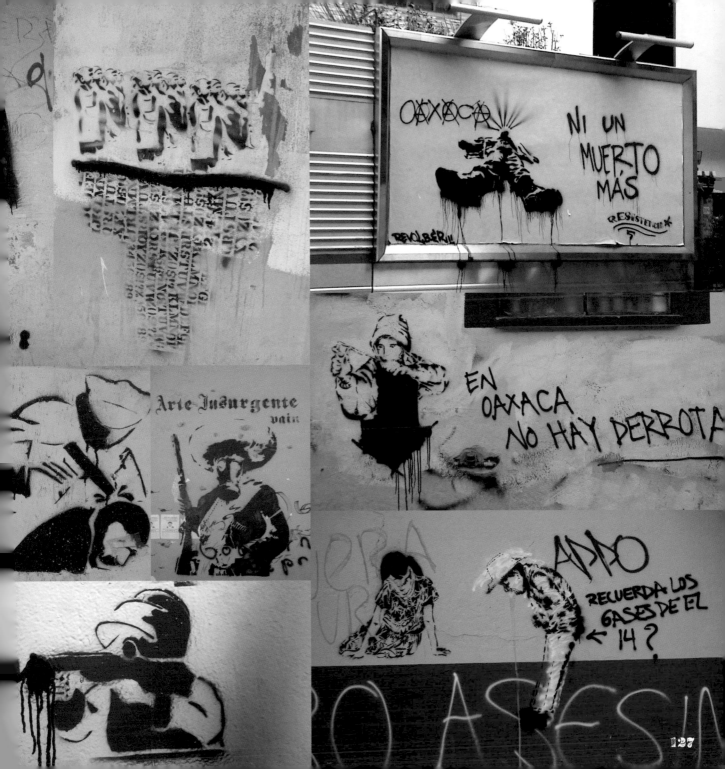

OAXACA NI UN MUERTO MÁS

RESISTENCIA

REVOLBER il

EN OAXACA NO HAY DERROTA

Arte Insurgente

APPO RECUERDA LOS GASES DE EZ 14?

ASESIN

127

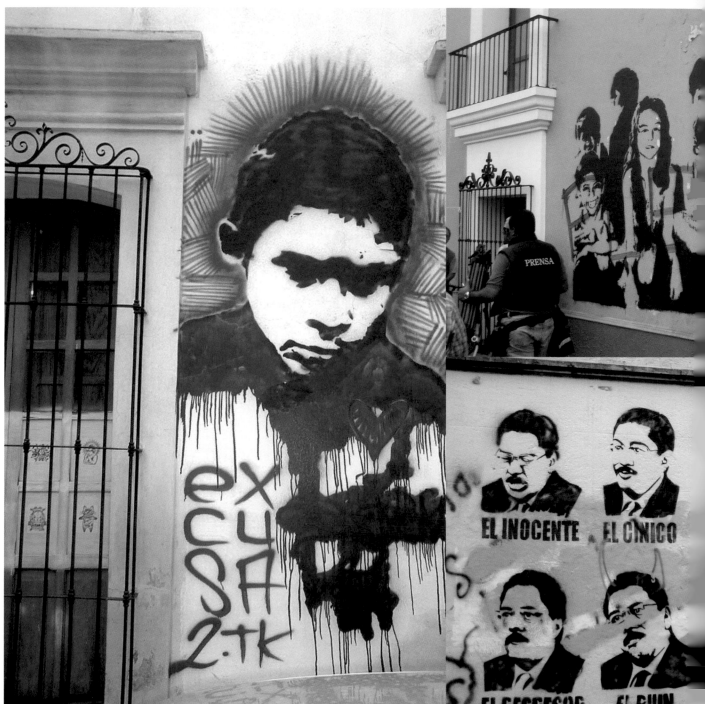

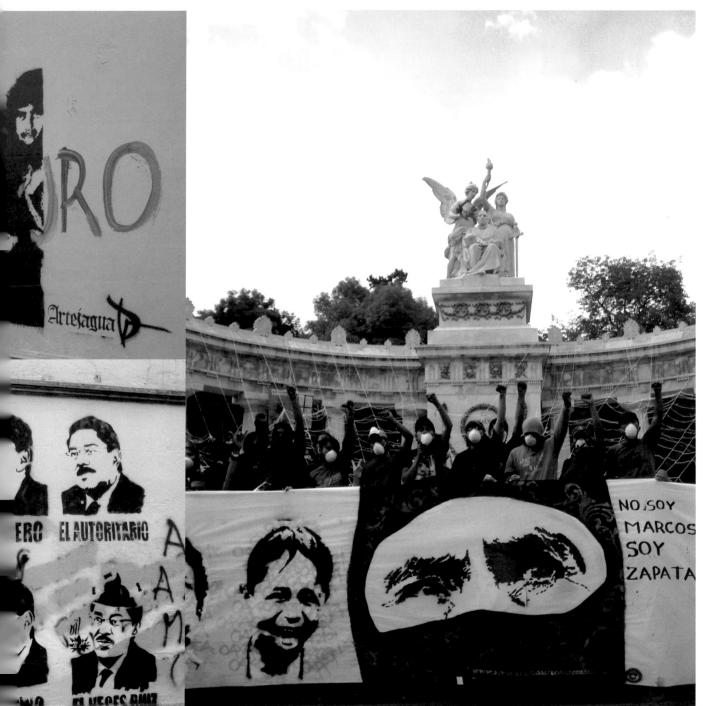

NO ¿SOY
MARCOS
SOY
ZAPATA

San Francisco

CA, USA

I ♥ SF

FIGHT FOR YOUR HOME

let's gentrify like it's 1998!

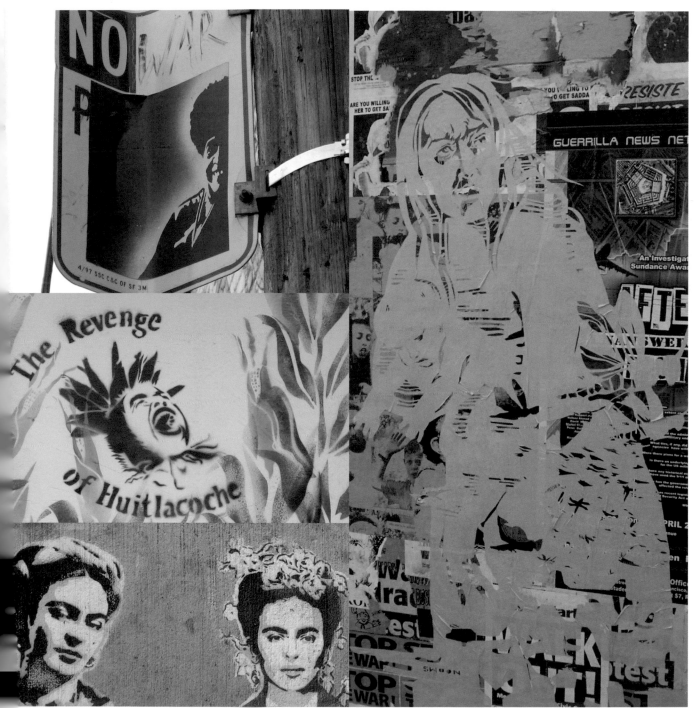

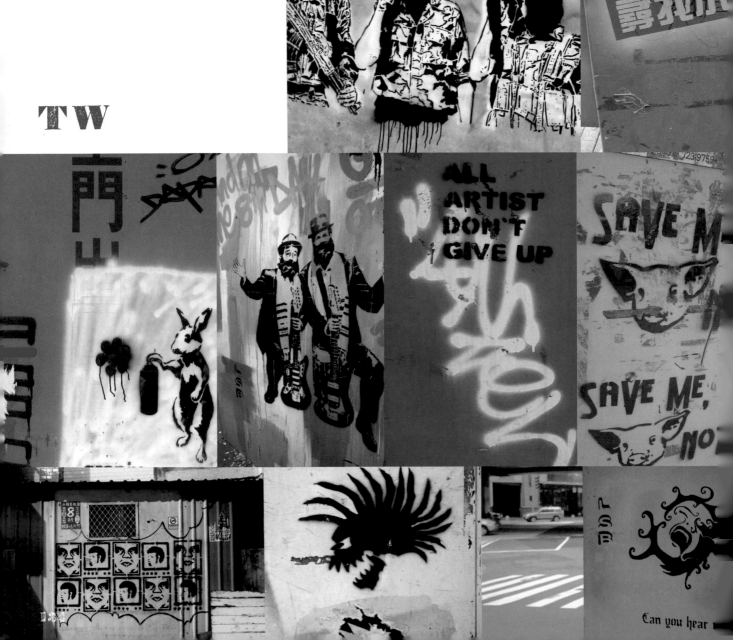

Taipei

TW

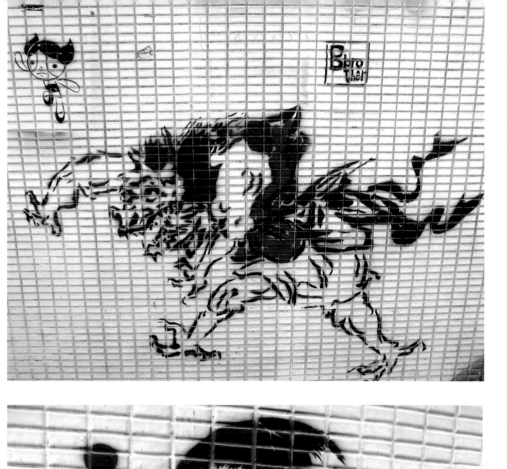

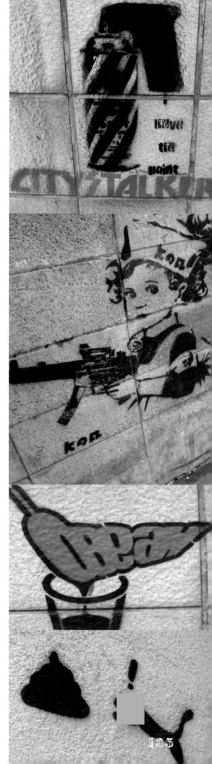

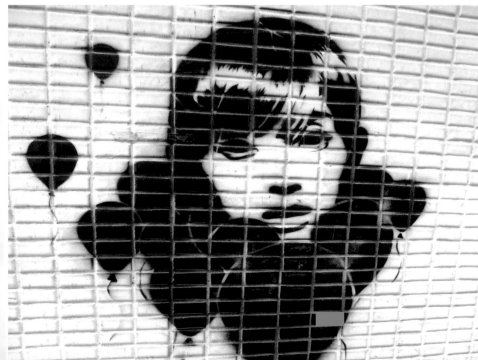

Tel Aviv

IL

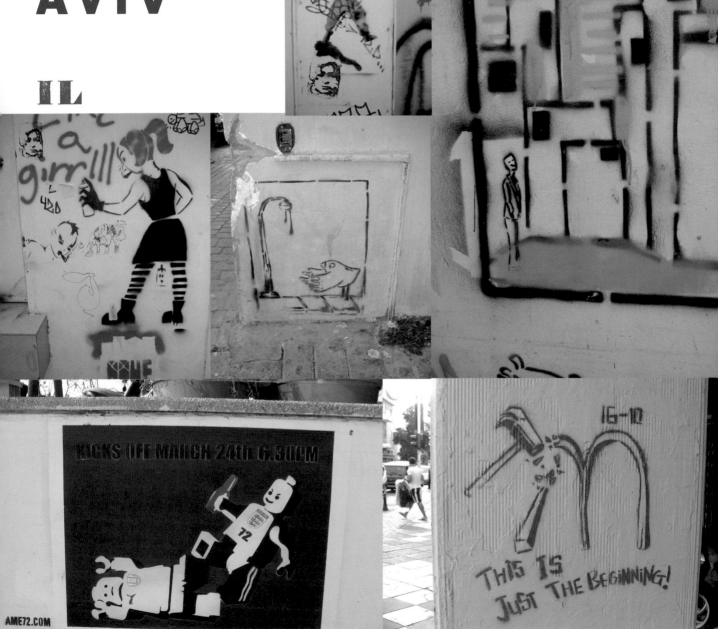

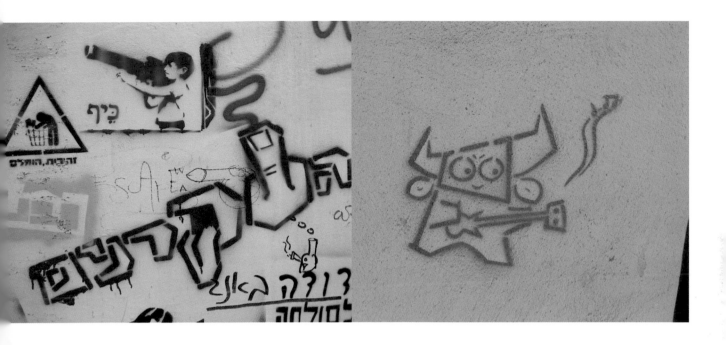

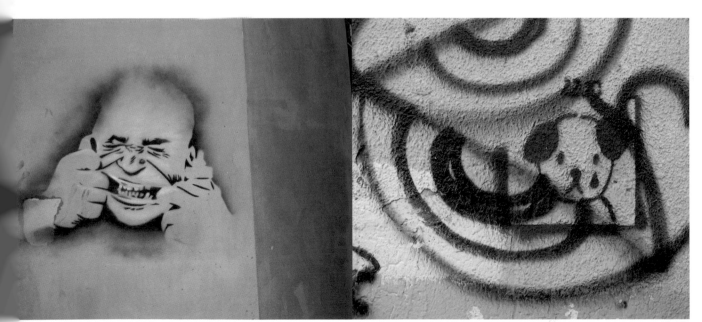

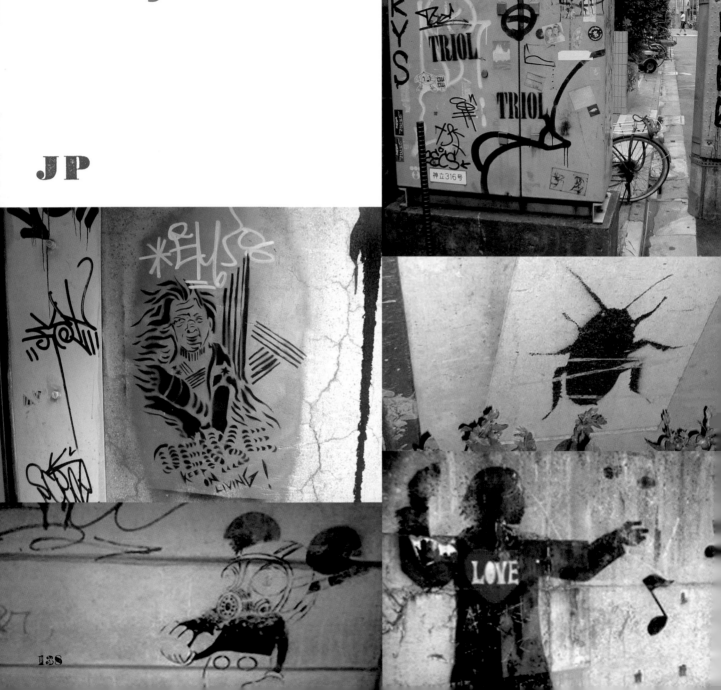

Tokyo

JP

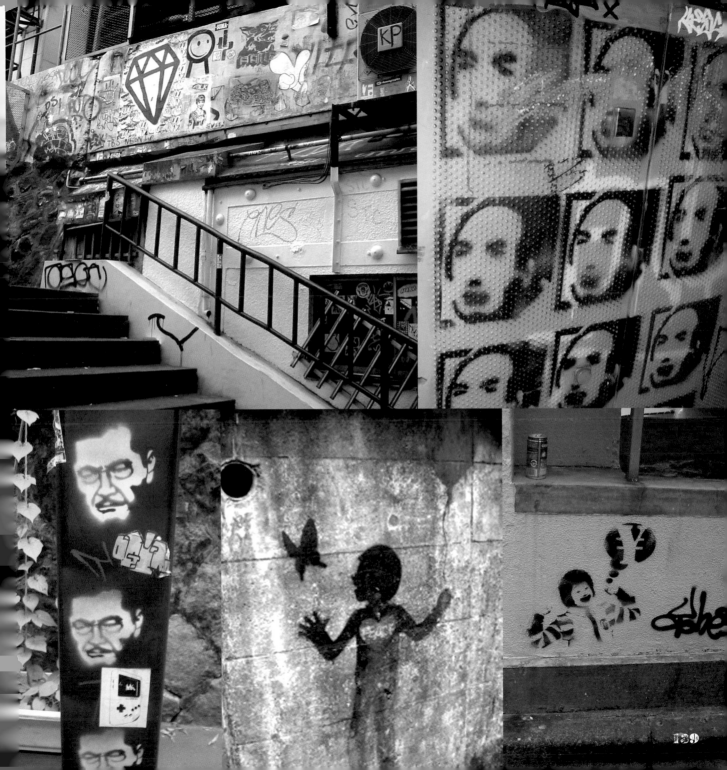

STENCIL MEDIA

Cutout Stencils

Fabric

Found Objects

Murals and Large Stencils

Paper

Vinyl

Stickers

Canvas & Wood

STENCIL MEDIA

Whether out of necessity or as an aesthetic choice, stencils give the artist an easy way to create the same image over and over. If there is no access to screenprinting tools, or if there is only a small run of printed objects, the cutout image allows the artist to create repetitive imagery in a quick, efficient way. And, unlike screens, cut stencils work with many different forms of liquid and spray pigments. Bleach, spraypaint, airbrush, and fabric paint are just a few examples of how the image can be painted onto the desired object.

Stencils allow the artist to easily move their work from one medium to another. Early examples of modern stenciling appeared almost simultaneously on metal, paper, walls, and clothing. As the art form developed, artists began to stencil other objects such as vinyl, found objects, sticker paper, and paper. Murals and large-stencil pieces soon followed.

Other than placement, which was delineated simply to horizontal and vertical in the "In the Streets" section, Stencil Nation has chosen to represent the media that the stencil is painted upon. What stencils look like and what their text conveys creates a list of almost limitless descriptions. Categorizing the work according to what material it is on allows the descriptions to remain up to the viewer's interpretation. Therefore, the following sections represent some of the more widely used media found in the streets and on the gallery walls.

CUTOUT STENCILS

Possibly one of the more under-represented aspects of stencil media, the actual cutout stencil stands alone as a tool that is also a work of art. How the artist attempts to cut the image out of the paper or plastic reveals their creativity and crafting skills. What the artist plans on doing with the cut stencil defines its detail and usage. Works on canvas and gallery walls can be made from many stencils painted in layers over a longer period of time. Stencil graffiti usually calls for one or two stencils that can be painted clandestinely in a short period of time, as well as easily concealed from passersby.

In the streets, cut stencils rarely appear near their painted images but they occasionally end up as street art. In a derelict San Francisco building, the artist Pneu decided to put up his cut out after using it about two dozen times. In the galleries, cut stencils can be displayed beside the finished artwork created from them. Or the cut out can rightfully hang on the wall as an artistic example of the artist's deft tool-making skill.

Fabric

Looking at the history of the tool, Japanese artisans figured out long ago that stenciling on clothing worked well. Their process, katazome, was developed around 1300 BCE, most likely after they picked up stenciling from Chinese artisans. Modern fabric stenciling has been influenced by the punk movement's use of the tool in the 1970s and 1980s.

Portland, Oregon artist Klutch stenciled jackets in the early 1980s hardcore scene. Parisian artist Hao decided to stencil t-shirts of his favorite bands because their shirts weren't available in France, and Jef Aérosol has posted on his website 1970s photos of The Clash wearing stenciled shirts.

Stencils work well with fabric, though spraypaint doesn't always hold up after a few washings. Toronto artist Janet "Bike Girl" Attard doesn't use spraypaint. Since her fabric-painting process is so complex, she has yet to be able to describe how she does it. Other people have found instructions online for, and enjoy using, bleach with stencils to create artwork on their clothing.

Found Objects

Beyond walls and sidewalks, the cities of Stencil Nation provide a treasure trove of objects to paint. Many stencil artists find dumped or abandoned objects on the streets of their neighborhoods and take them home to paint on. Other artists pick up objects at sidewalk sales or flea markets, paying very little, and use them as media on which to stencil their artwork. Objects that are part of public space, such as sewer cleanout covers, will get taken off, taken home, stenciled, and screwed back on the cleanout (or maybe nailed to a tree). Sometimes a stenciled board will appear on a construction wall, screwed in with hex bolts so the art can't be easily removed.

Spraypaint works well on many surfaces, so a rusted metal bucket lid makes a nice canvas for Albany, NY's Mr. Prvrt to stencil on. Designed to stick on almost anything, aerosol pigments dry on wood, polystyrene, furniture, and found art surfaces. Pneu decided to stencil a used plastic laundry basket and hang it on a San Francisco street sign. Mirror, glass, and tile also prove to be good objects to hit and then glue or hang on the street.

Murals and Large Stencils

Inspired by a large Kafka portrait stenciled on the pavement near San Francisco's Tire Beach, artist Claude Moller created a companion piece for the writer's image. At least twenty feet long, Moller's Emma Goldman piece was so large, he had to climb on top of a shipping container to photograph the whole image.

For artists like Moller, the need to go large incorporates a whole new level of artistic intricacies and technical details to work out. If they are painting the images illegally, concealing a huge stencil is next to impossible. Painting quickly also becomes irrelevant when a large piece goes up. But artists find ways to get their large works into the urban environment.

The stencil mural has become a popular medium, appearing in diverse styles. Collaborative murals, incorporating different artists' images, usually happen on legal walls. They can contain smaller pieces or larger ones, like the murals that went up at Barcelona's Difusor festival. Single-artist created murals represent the other style found on the streets. Kontra's work shows a definite singular style, as does Scott Williams' murals. Works created by one artist can also go smaller and get painted more quickly when done without permission of the authorities.

PAPER

Stencils on paper come in many forms. When he can't travel with his cut stencils, Jef Aérosol stencils paper and then wheatpastes the images on the walls of other cities. Other artists stencil small-run concert posters and hang them in windows around their neighborhoods. If someone is having a garage sale, a paper stencil may appear announcing it, stapled to poles near the house. And, from the Civil Rights movement to the protests of today, many signs have been stenciled en masse for upcoming marches or rallies. Then protest groups pick the stenciled paper signs from a pile, march with them, and then return them to one of the organizers at the end.

Wheatpaste has become a genre of street art, with a long history, and stencils have always been part of that style. Unlike stencil graffiti, where a few colors need to be quickly painted on the streets, stenciled posters can have as many colors that the artist desires. They get painted in the home or studio, and then the artist simply goes out with a brush and a can of paste to put them up on the streets. Los Piratos do a good job of making multi-color stencils on paper and then pasting them out.

VINYL

Along with found objects, an old-fashioned 12-inch vinyl record creates a perfect medium to stencil on. Spraypaint covers and dries well on the flat vinyl surface, and the center hole is perfect for screwing the final work on a wall. The fact that records get thrown out, or can be bought cheaply at thrift stores, make them easy to find and collect for future use.

Working within a circular image also creates potentially new avenues of creativity. And the modular versatility of combining more than one record together in different shapes adds to the fun of painting on this medium. It is no surprise that Portland artist Klutch's international vinyl art show, Vinyl Killers, has just had its fifth show with dozens of submissions.

STICKERS

In lieu of sending computer files to a screen printer 500 miles away, or buying screenprinting equipment, artists have become accustomed to cutting out stencils and painting sticker-backed paper. The stickers chosen are usually of a small size so that the artist can easily conceal them while hitting the streets. When the buff heats up in their city, artists have an easy-to-make, slip-in-your-pocket alternative that they can use to continue to get up. Stickers are not above the mighty scraper tool, but the fact that an artist can go out with dozens of stencil stickers and quickly put them up in many nuanced locations – high above arm's reach – allows longer run-time in heavily buffed areas.

Stickers also open possibilities for other types of stenciled street art. Skipping the painting step, Salt began to cut out sticker paper and put it up in San Francisco. Other artists like Orchid took the modular concept and used more than one sticker to create a larger piece. And, like paper, stickers can be custom cut to different shapes appropriate for the work that will go on them.

CANVAS AND WOOD

Like traditional painting, some stencils end up on framed canvas. These pieces appear in many of the indoor gallery exhibitions, are sold, and in turn are hung on the walls of their new owners. Stencil artists also use plywood as a similar medium. Both can be bought in the store, but sometimes wood can be found as scrap while used canvas can get painted over and reused. Their natural, flat surfaces enable easy priming, painting, and hanging.

On occasion, stencils on wood and canvas get hung on the streets. These pieces are usually secured to the outdoor vertical surface via bolts, screws, or nails. Wood is easily pre-drilled and can sometimes be bolted onto street sign poles if the pole has holes available. Like other portable media, painting on canvas and wood allows the artist to work at a less hurried pace, and use multiple stencils and colors for the final piece.

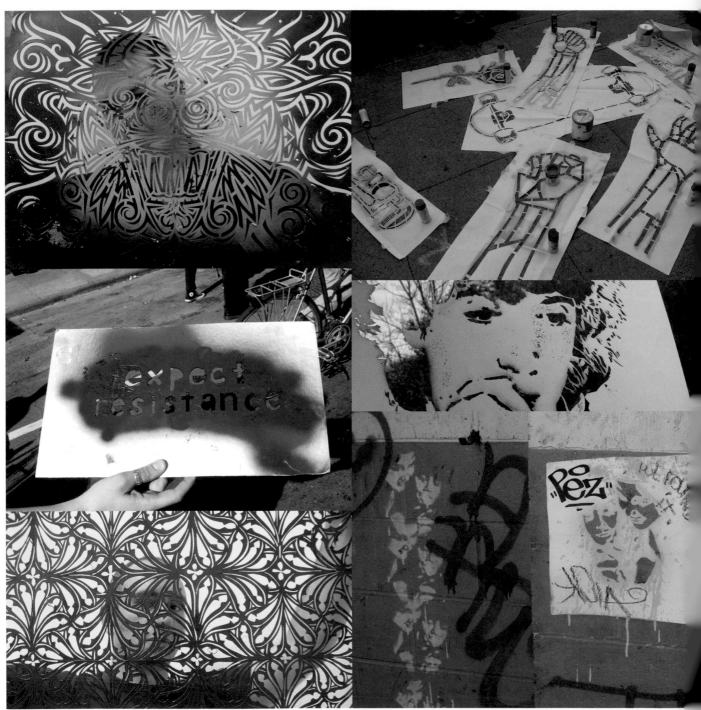

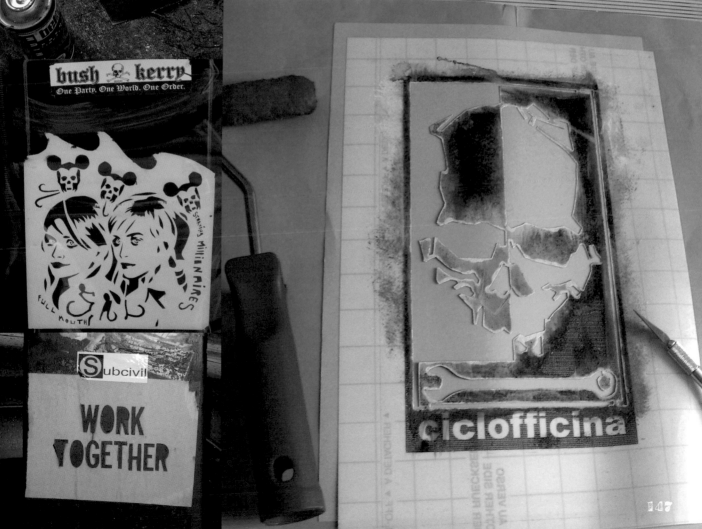

Cutout Stencils

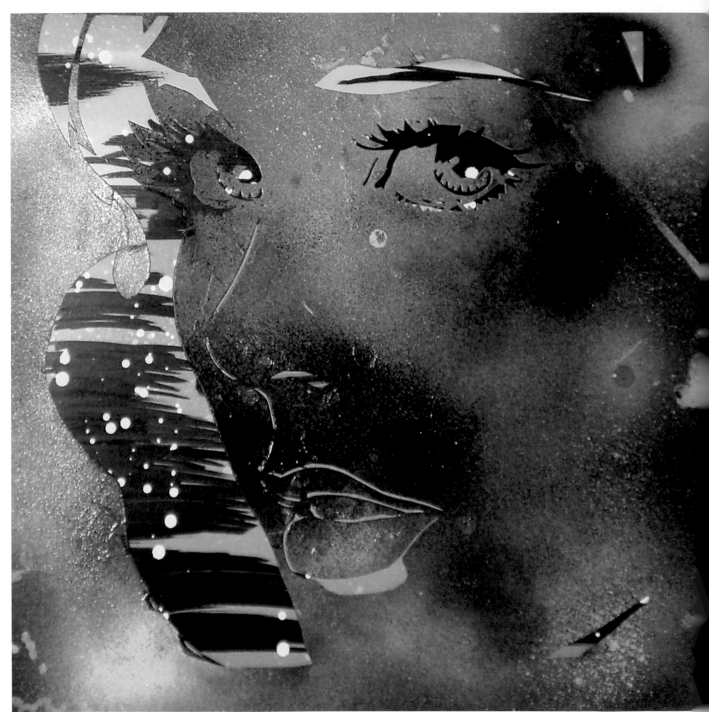

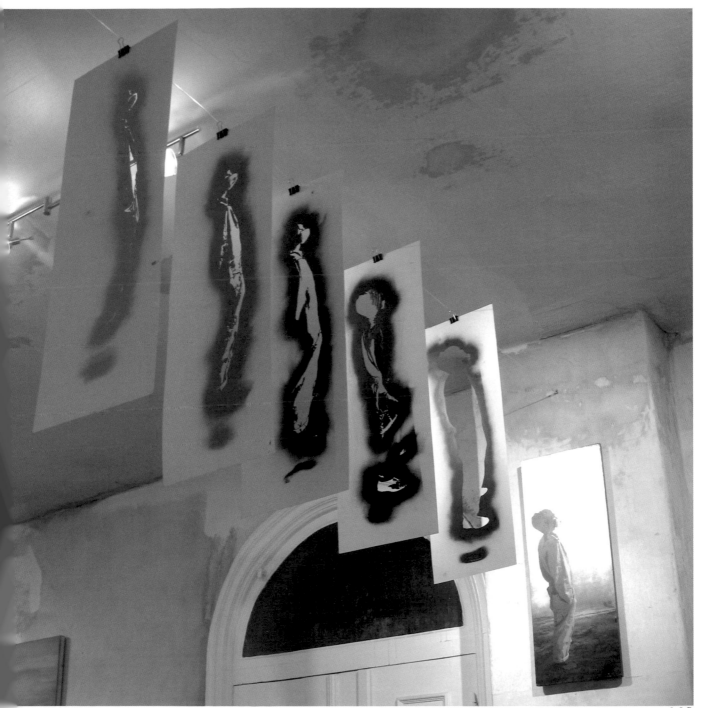

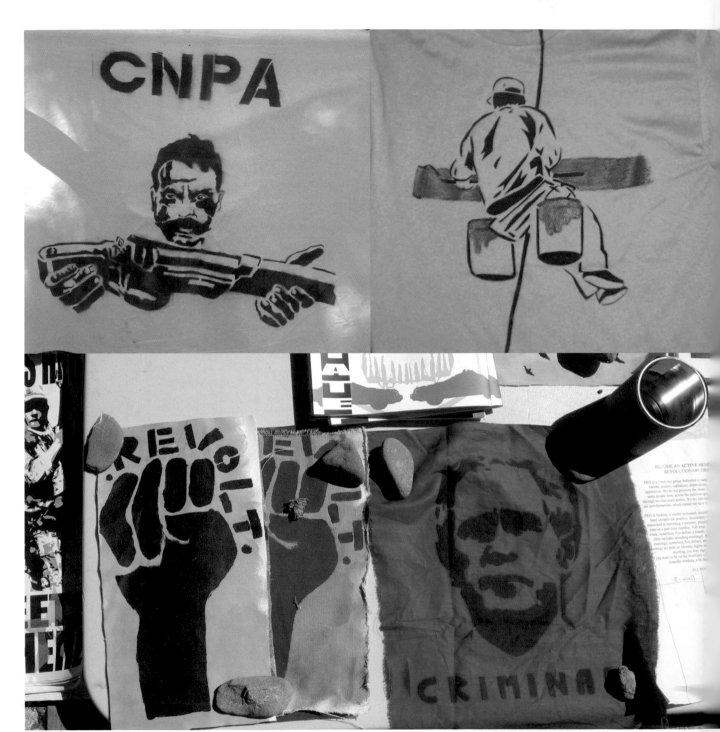

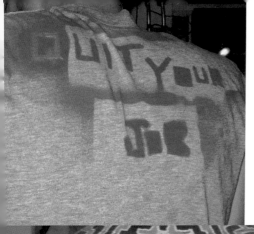

Fabric

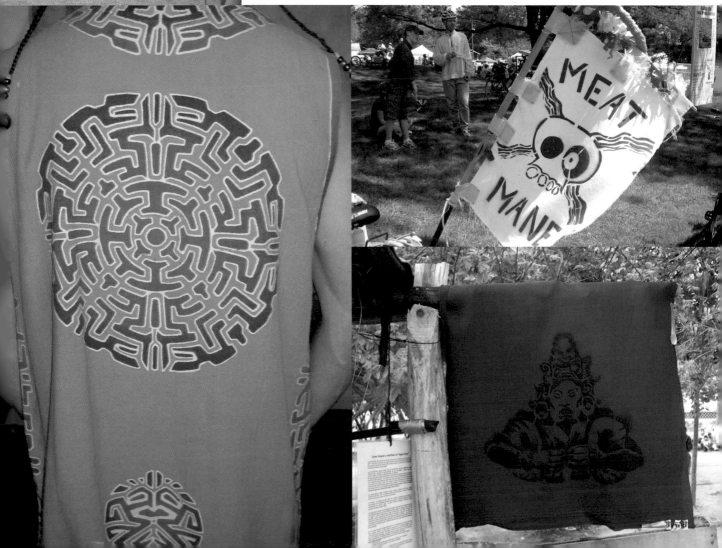

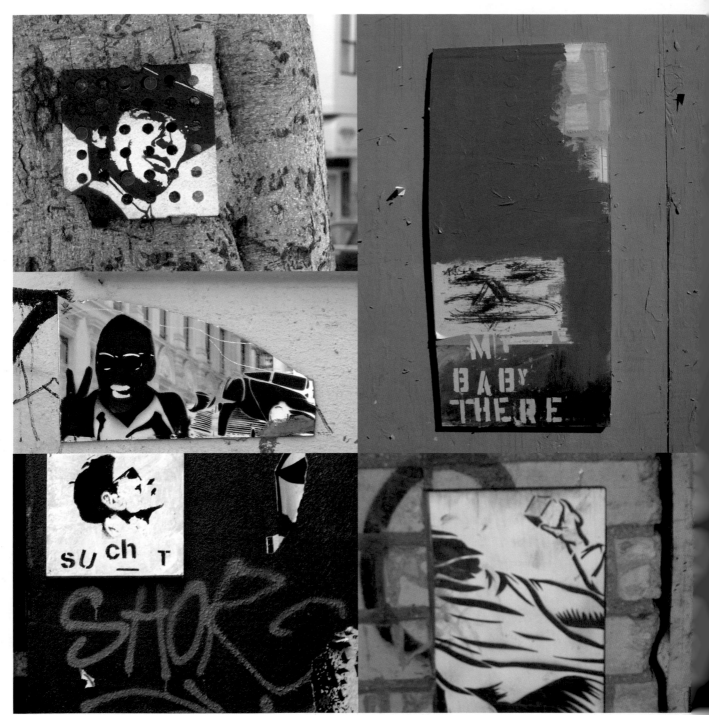

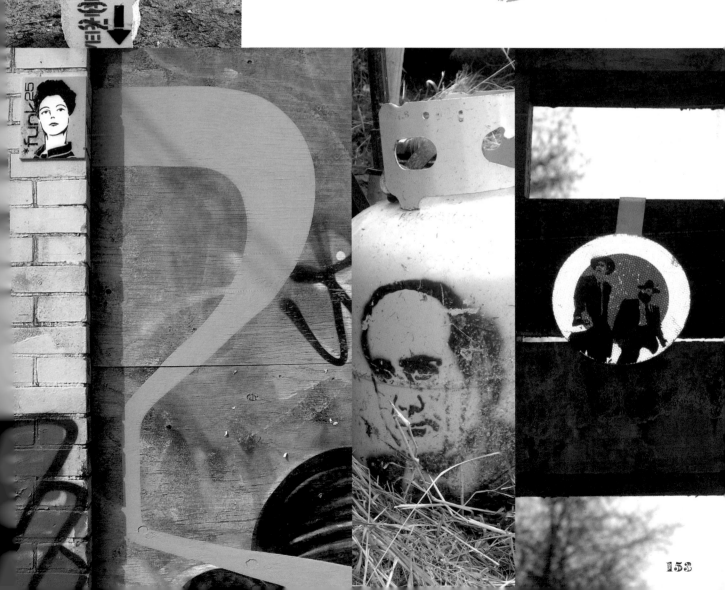

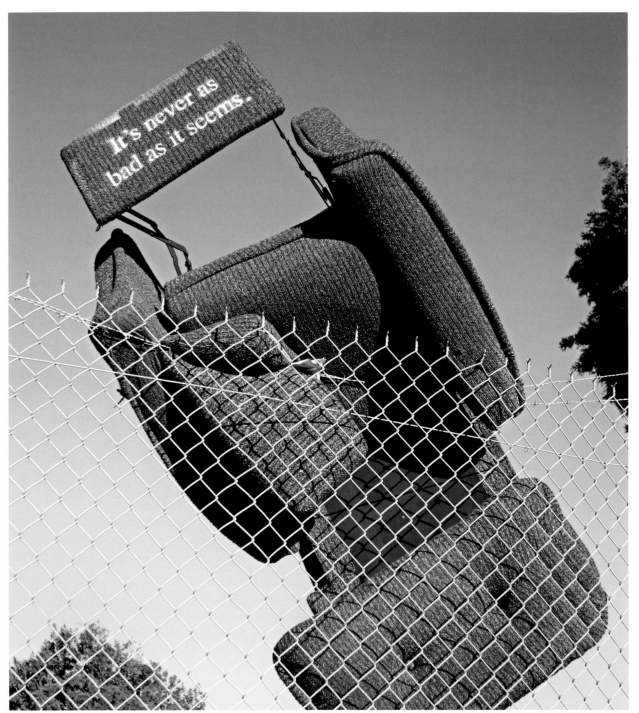

It's never as bad as it seems.

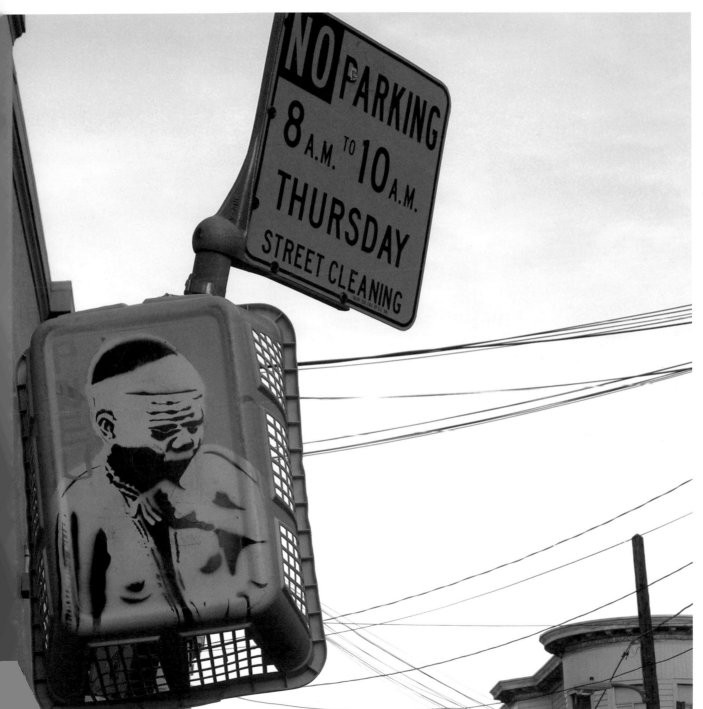

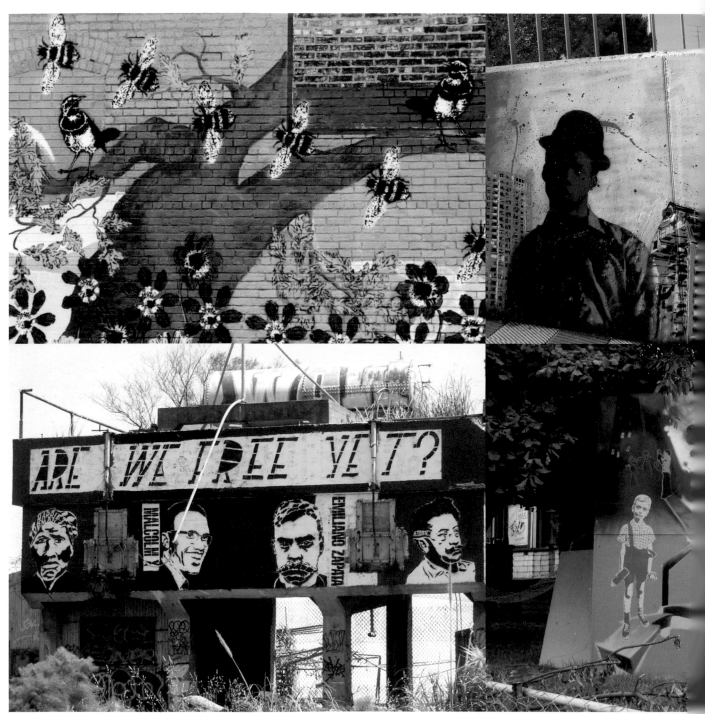

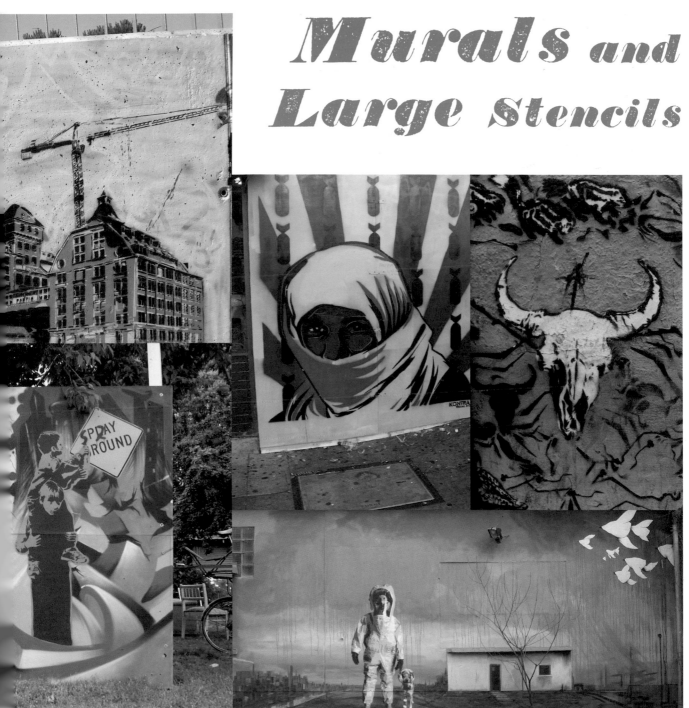

Murals and Large Stencils

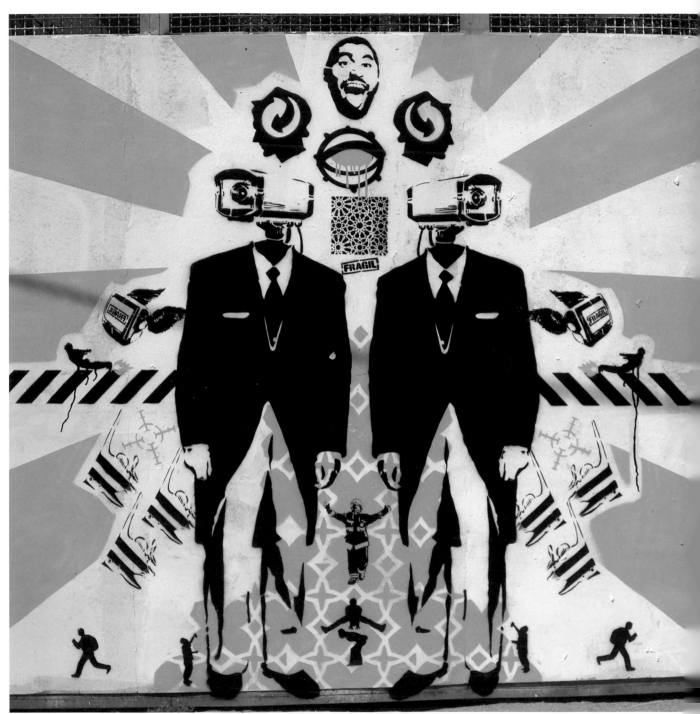

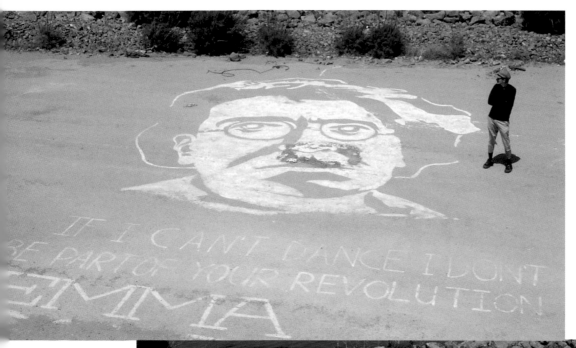

IF I CAN'T DANCE I DON'T
BE PART OF YOUR REVOLUTION
EMMA

KAFKA

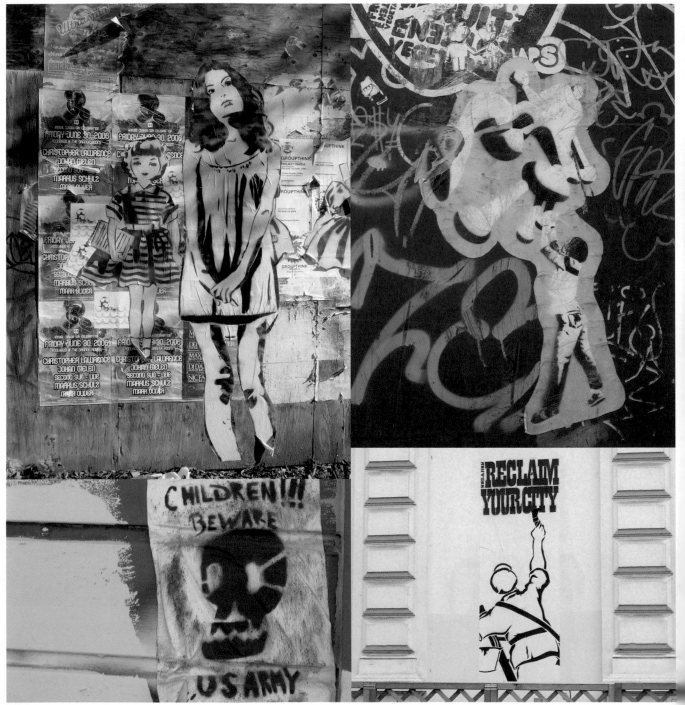

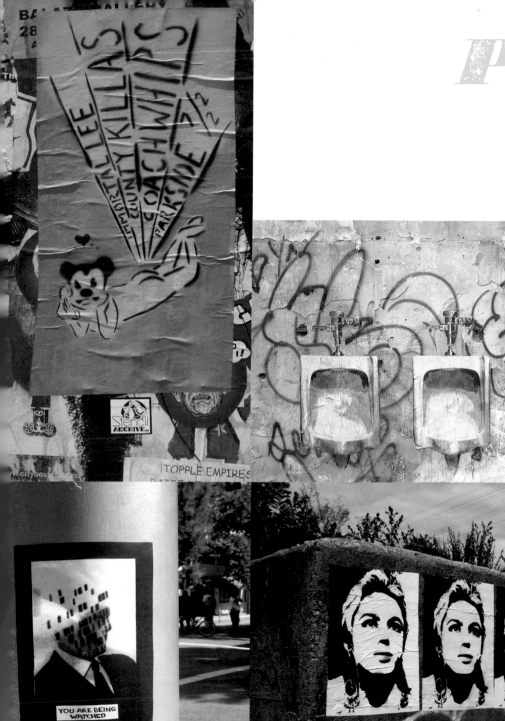

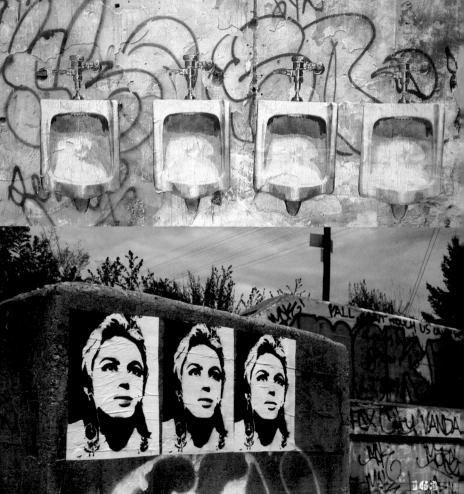

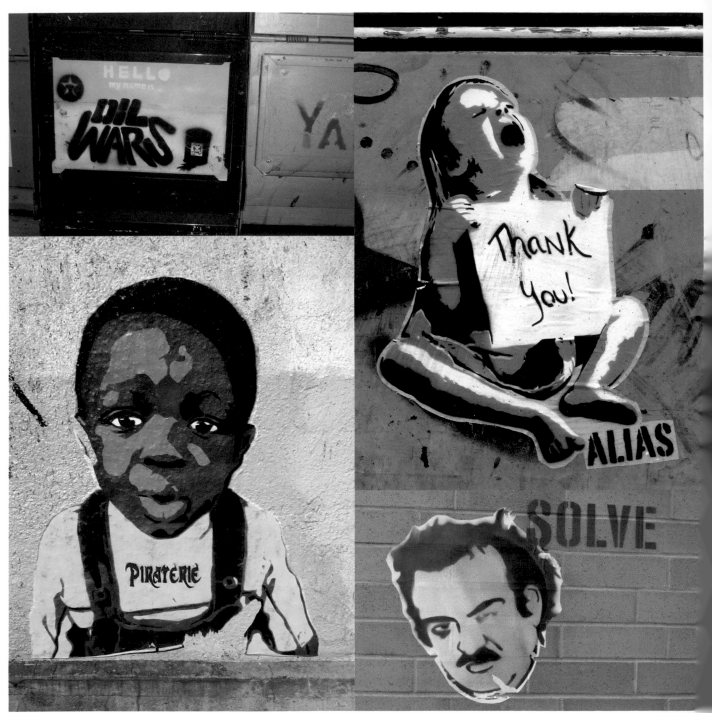

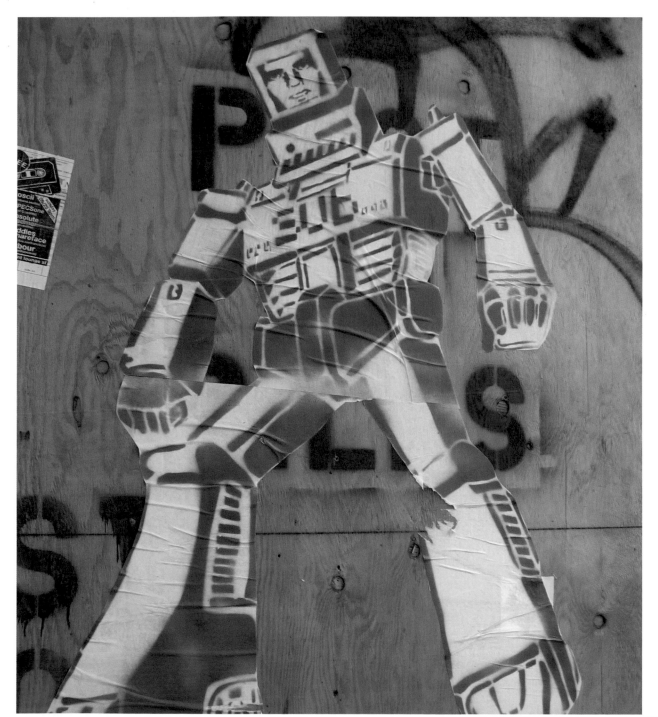

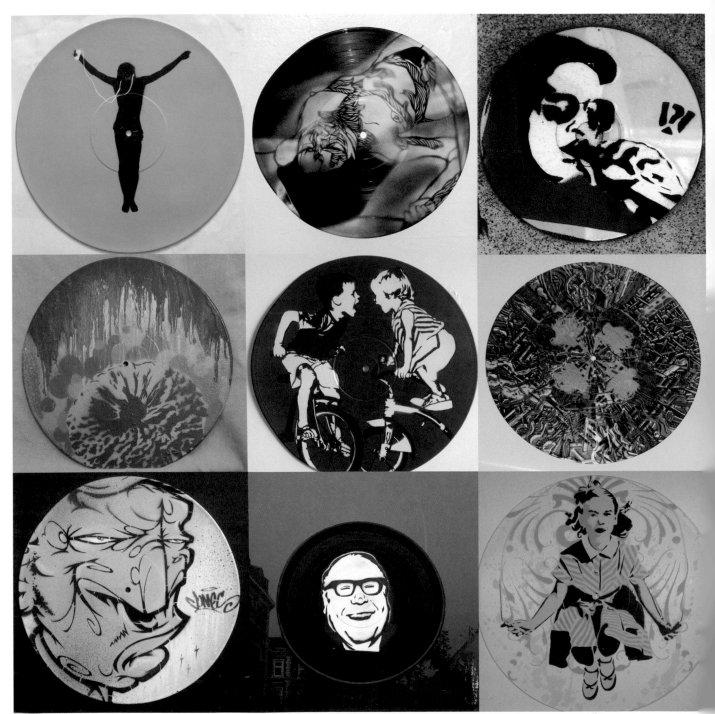

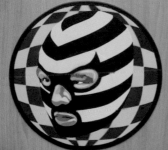

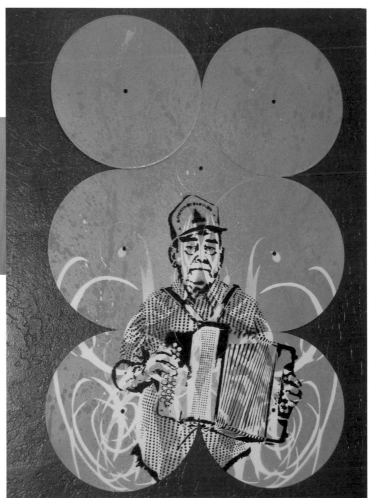

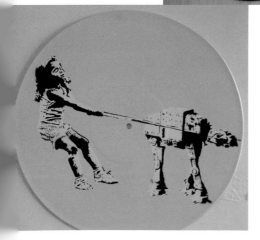

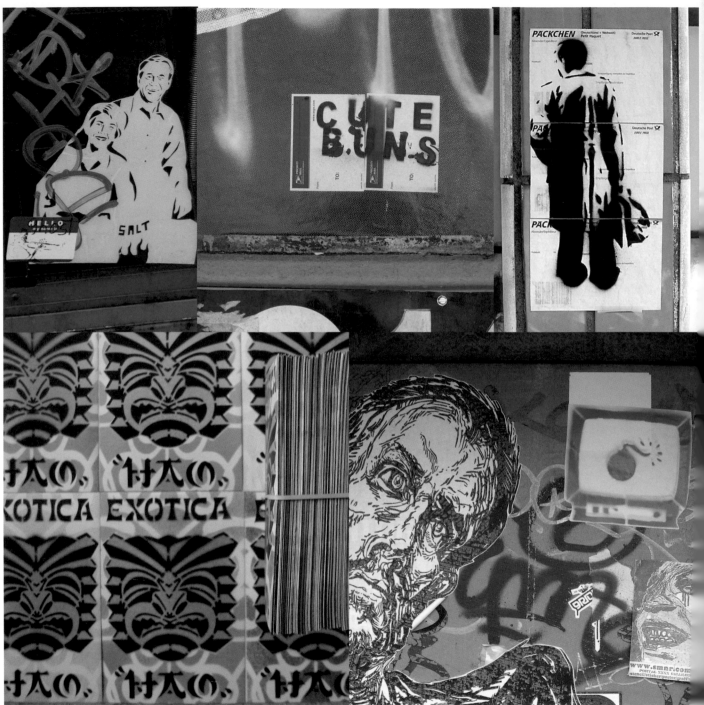

Stickers

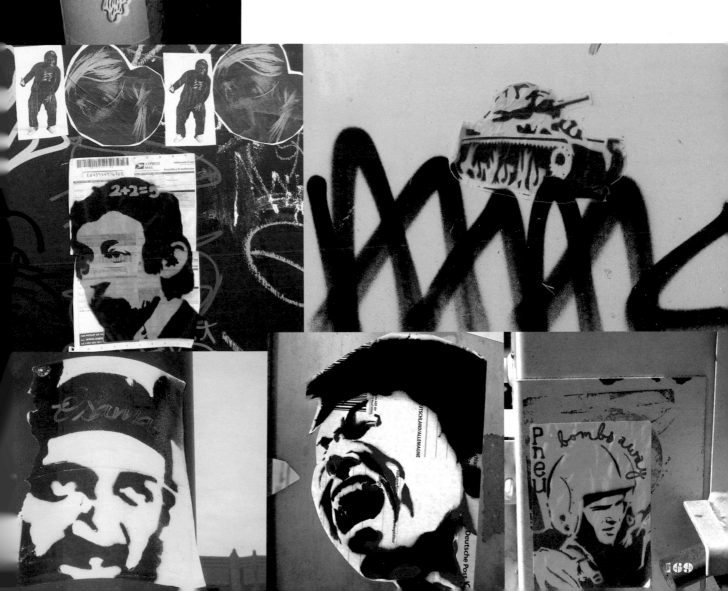

From:

Dancehall

Label 228 July 2002

KFUE
KRUZ

HEY REDUS
2 DOLLARS

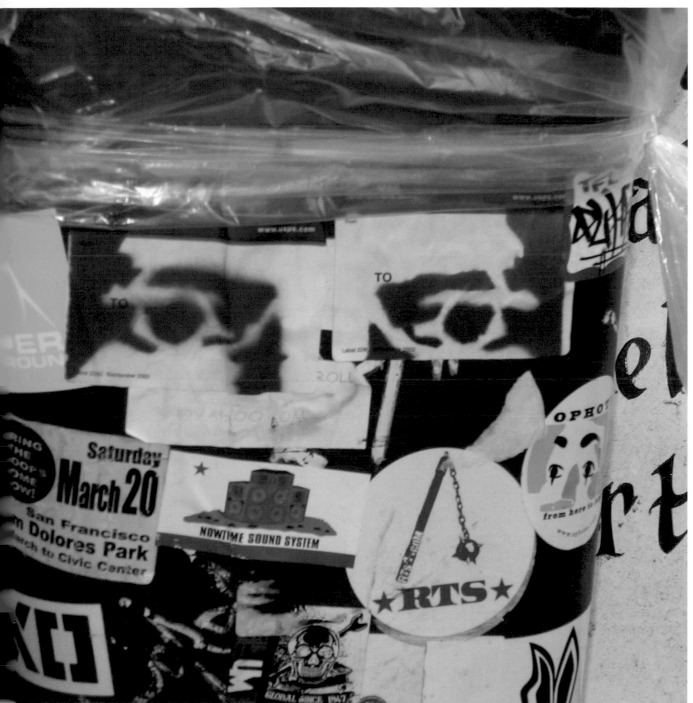

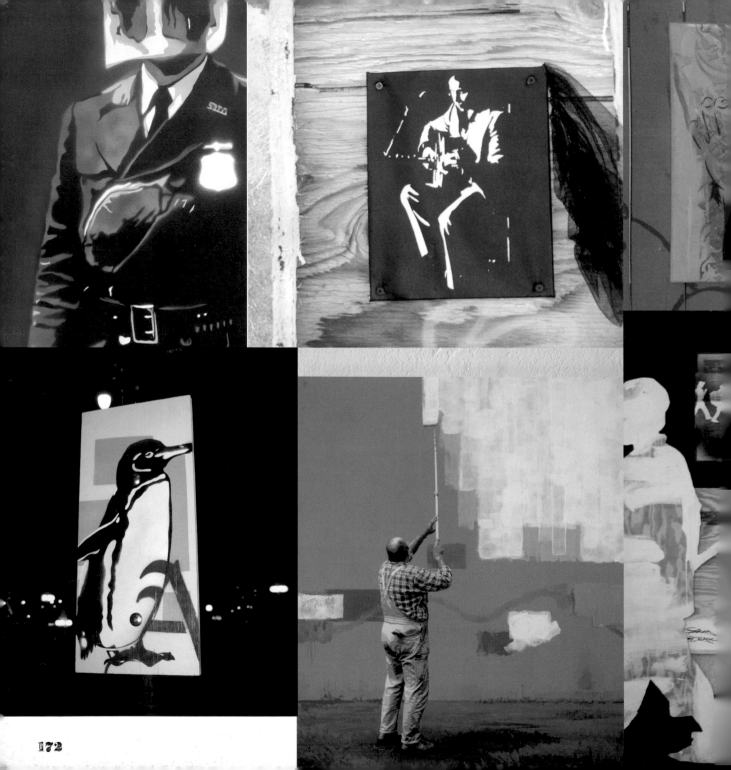

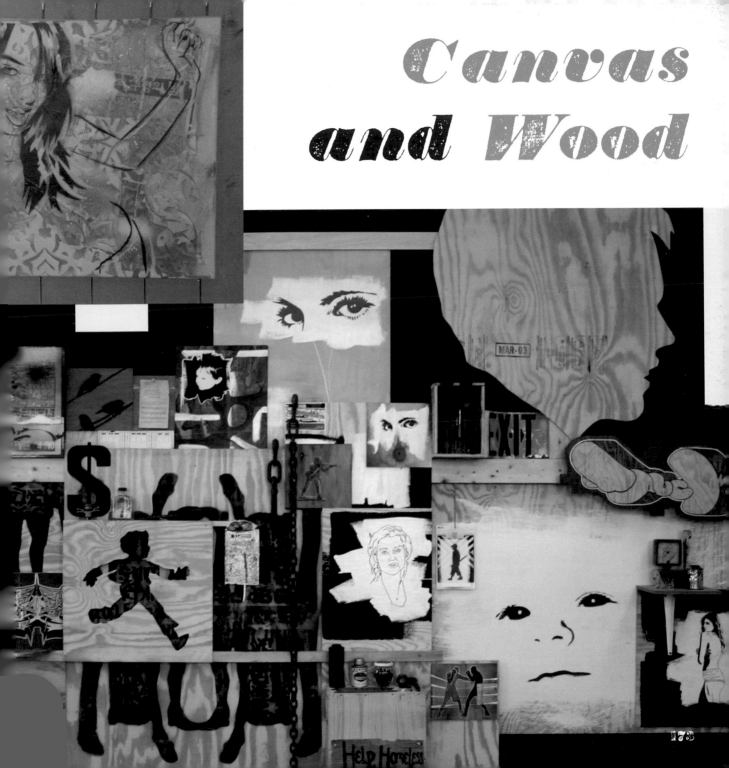

Canvas and Wood

ARTISTS' TIPS:
HOW TO MAKE STENCILS

Thousands of years ago, our prehistoric ancestors created stencils on the walls of caves. The person created a paint pigment from a plant or rock powder, put it in his or her mouth, placed a hand or object on the rock surface, and sprayed the pigment over it to create the negative image on the rock. These hand stencils, carbon-dated to tens of thousands of years ago, were created using pulverized charcoal among other naturally-derived pigments. Examples of these Paleolithic stencils are found throughout the world, from the European continent to the Americas.

Since then, the method hasn't changed much, yet the tools to make stencils have advanced so far that some artists now create screen-print quality images with multiple layers of cut-out negative space. Spraypaint, laser-cut images, computer applications, and online beginner forums have aided in this growth, but making a stencil remains a simple process. "A blade, a piece of paper or plastic, some paint, and an idea" has become the starting point for hundreds of artists now making stencils. Tips like carrying the stencils in a pizza box or bag to do graffiti is widely known and successfully implemented.

Though easy to create and paint, stencil art still holds many nuances and tricks that can only be discovered with practice and experience. Like any medium, individual artists work out their styles, develop their own tools, and find their voices, adding to the visual language of Stencil Nation. While one artist may be great at photorealism via his or her Photoshop skills, another might love the DIY letter styles that go up during street protests. Some artists stencil trains with paint, while others bleach stencil images on fabrics.

When a beginner picks up her X-Acto knife, the community supports her desire to join in on the fun. This collaborative feeling arises in online help forums and tutorials, at stencil gatherings and gallery shows, and in the streets when visiting artists go out together to paint on the walls and sidewalks. As an example of this camaraderie, artists submitted their tips and how-tos for the Stencil Nation book, hoping that anybody who wants to can participate by cutting their own ideas into negative space. Nothing replaces practice and experience, but the tips below will give the beginner an idea of how to start cutting and painting her first stencil.

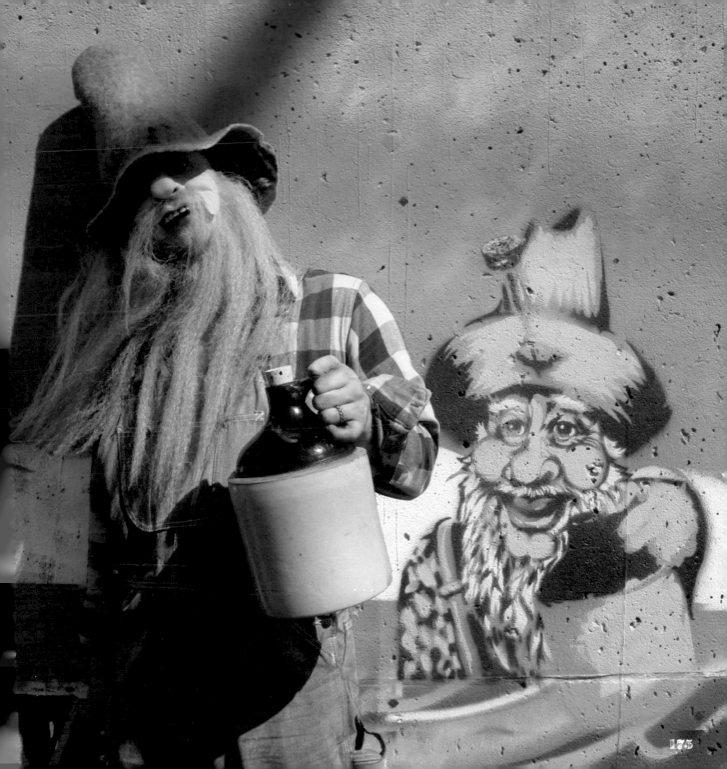

Tiago Denczuk, Portland, Oregon, USA

Unlike any other graphic technique, stenciling doesn't require any specialized tool or material. This makes it, in my opinion, the most democratic technique. The basic knowledge to cut and paint a stencil is all anyone needs to start creating, and from there, one can "evolve" his art by developing his creativity over time.

For a tip, I suggest that those who work with computer applications to create their pieces leave some space for creating with the knife; that is, finding "the lines" to cut as they go.

Anonymous

1. Cut your stencil out of material that will lie as flat as possible. This can include getting a piece of acrylic or some other hard material and having the stencil cut by a laser-cutting machine. You'll need vector files in order to get it cut by machine, so for this, create your final file in Adobe Illustrator.
2. For a large stencil use an extra-wide German spray cap (white with orange tip works well). These can be ordered online and will allow you to spray the stencil very quickly.
3. Krylon paint works well. Avoid Rustoleum as it tends to splatter and drip.
4. Most importantly, hold the can about a foot and a half away from the stencil. This will prevent bleeding around the edges, as the air pressure will have subsided and the paint mist will fall gently over the stencil.

Primo

1. Two common methods for carrying stencils on the street:
Pizza Box Method
Get a pizza box (it's cheap or can be found in the trash)
Get some wax paper
Glue the paper to any of the box's inside edges; this will mostly prevent stencils from sticking to the box
Always carry the box horizontally (it's kind of weird to carry your dinner vertically)
You can also cut the bottom of the box out and tape the stencil inside.
Folder Method
You can use artistic folders (they're much bigger, but less fun to carry around)
Wax paper works well also

2. Cutting
You can cut a stencil from almost anything. I use thick box cardboard for simple stencils and some plastic sheets I bought at a paper store for detailed stencils. These are great because you have a stencil forever.

You can cut with a blade used for cutting carpets, or use linoleum blades. It's the cheapest way, but also it's much worse than cutting with X-Acto blades. You can get blades at any hardware store.

The method I use to get a desired image on a stencil: I print the image of the stencil that I made on paper, which I stick to the plastic sheet. It's not as good as printing on the sheet, but it's possible to do if you can't print on plastic. The paper cutting can sometimes get tricky but don't panic. You can easily wash off the paper and the glue after cutting with just a stream of water

NILS WESTERGARD, WASHINGTON, DC, USA

1. Draw a stencil everyday.
2. Don't listen to your parents; they will understand eventually.
3. You don't need fancy-ass paint to be an artist.
4. Look for graffiti.
5. Try to imagine things as stencils.

THOMAS MÜLLER / TXMX, HAMBURG, GERMANY

I prefer paper or cardboard over plastic, because it can absorb some amount of paint before it crawls on the other side of the cutout, which makes an unpleasant dirty print on the contours. I'd rather accept a little overspray because paper bends more easily.

I always try to make a little frame (thick cardboard or thin wood with a stapler) around the cutout for easy one-hand holding, and then the cutout stays nice and flat.

If there are thin and fragile bridges, especially if they have to hold another large part of the cutout, I glue a toothpick or something on the other side for strength. This keeps the paper flat as well.

I wear gloves... if I don't forget them at home!

BLEACH STENCILING ON FABRIC TIPS FROM PHELYX

Bleach will not work on most synthetic fabrics. The good news is that even the cheap t-shirts are generally 50/50 Cotton and Polyester, and they will work just fine. 100% cotton will also work well; however, bleach weakens the material. If you get big wet drips of bleach on 100% cotton, they will quickly develop into holes in the material. I do know that, for at least one clothing company, this is actually the desired effect but I prefer the stronger 50/50 blends for bleach-designed clothing.

I use thin, plastic material to cut my stencils.

Bleach is a toxic chemical. Wear a respirator or work in well-ventilated areas, or both. Don't wear anything you love. You're spraying bleach.

Empty your spray bottle after you're done. If you store bleach in it, it will expand due to softening of the plastic and gasses from the reaction between the chemical and the plastic bottle. This can be messy and dangerous.

On the backside of the stencil, I use a repositionable spray adhesive. This product makes the stencil sticky but easily removable. It leaves no residue on the substrate. This is used to prevent under-spray for those clean, crisp lines and edges. It is important to also select a spray angle with your wrist position and stick to it. If you roll your wrist at all, you'll risk under-spray and inconsistent application.

This sprayed bleach mist will not be very wet. It should not soak into the material. It is a fine mist that will lie atop the fabric and cause the effect. You will have to wait a few moments for the reaction. It will develop like a Polaroid. You can leave the stencil on for this effect in case you want to add a little more to make it lighter.

Use a paper towel to pat the stencil. This is to prevent droplets and drips from the chemical beaded up on the stencil from dripping onto the fabric when the stencil is slowly peeled off.

When the bleach dries, it may crystallize. These tiny crystals are still dormant bleach. If these are re-hydrated, they can continue to bleach the fabric. Run the finished piece in a dryer to beat these crystals out of the fabric before getting it wet by washing. Be careful washing this with other clothing until it has been beaten and rinsed once.

PAHNL, OXFORD, UK

1. If you use temporary spray adhesive, it is easier to remove it from the object you're spraying if you can place it all in a freezer. Of course, you can't do this on the street but it's great for canvases. Leave it in there for fifteen to twenty minutes, after which the stencil will lift off easier because the glue doesn't work well at low temperatures.
2. To get more out of old stencils that have had spray adhesive used on them but have lost their stickiness, slightly heat up the glue side with a hair dryer. You'll get more use out of it without spraying more adhesive. Be careful if you use acetate or Mylar as stencil material. They can melt if you keep using the hair dryer.
3. Flat/Matte paint is best for stencils because it isn't as thick as gloss paint, which has a habit of creating blotchy edges.
4. Try not to use flat paint on top of gloss as it can create cracks and 'shrink' the layer you sprayed. Of course, if you want that effect, it saves you cutting another stencil.
5. Wear latex gloves. You'd be surprised how often a rogue dot of paint on your fingertip will touch the side of your clean canvas. The latex gloves dry any paint that gets on your hands very quickly; clenching your fist a few times will make sure your hands don't mess up a piece. There's also the bonus of having clean hands and we all know how much of a pain in the neck paint is to clean off.

CANCER

Some tips that I always forget but wish I didn't:
When cutting stencils, make sure the corners are completely cut before you try to pull out the cut piece. Doing this means you won't accidentally rip out anything that you need, and it means you get a crisp corner, rather than a 'fuzzy' one due to leftover torn paper.

If the stencil is one piece, keep the inside. It makes a new stencil that you can use as a negative: two for the price of one.

Finally, if it's worth doing and you have access, make the stencil out of something durable. A number of times I've made a stencil on paper that's turned out well, but I haven't used it again because I haven't had the patience to cut it out again. A good, relatively cheap source of A4-sized plastic for stencils is overhead projector film. They come in boxes of 100 sheets, and work well.

KIM McCARTHY, SEATTLE, WASHINGTON, USA

I like to print the image in black and white to get the shadows and depth. I then coat the paper with clear contact paper if I want it to last or if it's a fine detailed stencil. I only use knives with break-off blades. They work best for me since I tend to break them a lot. Over time, I've learned to be a little more patient with working on one image. I try to think large, so I can have one stencil cover a huge space.

ECCE, AUSTRALIA

First, I find or create an image I think will work as a stencil, then I photocopy it, enlarging or reducing it to the size I need. I then get it laminated as this is easy to cut and pretty sturdy. While I'm cutting it, I work out shadowing, islands, and everything else as I go. None of it is really planned, no matter how complicated the image is. You begin to notice what will work and what won't, but it takes practice.

HAO, PARIS, FRANCE

The best technique is to learn by yourself. It is so rewarding to solve a problem on your own!

I cut my stencils with a scalpel. I use hard cardboard paper to cut out. I never buy cardboard paper;

I pick it up from shops for free (they are used publicity cardboards). I collect wood/plastic boards, records, TVs, and canvas from the streets and paint on them. People throw everything away! I like to give a soul to these objects. Kustom Kulture! Brands of paint: Krylon is the best, but it's too expensive nowadays. I use Montana, True Colorz.

KLUTCH, PORTLAND, OREGON, USA

Belton is the most reliable paint there is.
The best knife so far for me is the X-Acto retractable.
For stencil material, I usually just use file folders. I like oil board but can't afford it. I cannot afford Dura-Lar either.

Stenciling T-Shirts

- Use a flat pallet (piece of wood, glass, or even marble) to keep the shirt flat
- Make a mark in the middle of the pallet so you can center your shirt
- Maybe use spray tack to keep the shirt from moving
- Put the shirts out in the sun or in the dryer to cure the paint
- If you want tight lines, practice improves your skills

Do not use a lot of paint; the shirt would stay rigid (and I mean really rigid).
Wash the shirt before the first use, adding a lot of softener, unless you want people to get high with your paint-smell as you pass by.

I use cardstock paper or binder divider paper to cut the stencils with. Then I use a glue stick, glue it on the paper, and stick it on the shirt. Then I spray it, and peel it off so no glue is visible. It's foolproof.

To make dark colors stand out on black shirts, place your stencil down and spray it with white, and then wait for a bit and then spray the dark color over it.

Janet Attard, Toronto, Canada

Too many tips to list! Just practice, practice, practice!

Chris Stain, New York, USA

I like to use clear Dura-Lar for cutting stencils. You can also get these poly-plastic place mats that hold up real well. For running about town, chipboard is good for the big stencils.

Amy Rice, Minneapolis, Minnesota, USA

On design:
- Make art that makes sense for you. Make art of what you love or what you hate, but always have some degree of passion for your subject.
- Other people's photographs are other people's art. Don't be an art thief.
On cutting:
- Challenge yourself; you'll only get better if you push it.
On spraying:
- For heaven's sake, wear a mask and don't spraypaint in your house.

PaperMonster, Madison, New Jersey, USA

The best pieces to cut a stencil from are x-ray films. You can place a white piece of paper of that size to draw your image and then cut through both the film and the paper. It is extremely durable and it's a great size for large stencils.Use a foam house-painting roller when painting a stencil on a shirt. Also be sure to place a flat, hard board inside the shirt to get the best results.

Don't be afraid to use a stick (i.e., chopstick or dowel rod) to hold down small pieces on your stencil while spraying. It will ensure that your image is sharp and clean once you remove the stencil.

Try different mixes of spraypaint colors when spraying a single stencil. It can be a useful and beautiful effect.

If you ever do a cut that can cause your stencil to fall apart, don't feel bad. Patch it up with any type of tape and cut out any leftover adhesive parts.

Be sure to always have some safety materials on when spraypainting. Don't be afraid to put on surgical-type gloves or a respirator/scarf/bandana. They help your ability to spray for a longer period of time.

Fame-Us, San Jose, California, USA

1. Always cut stencils downward! It's easiest for your hand, and will minimize the amount of errors you make due to the fact that you're only cutting in one direction and not twisting your wrist.
2. Looking for cheap stencil paper? Don't know what acetone is? Try cardstock paper. It's thin enough to go through a printer but thick enough so that paint won't bleed through it. It's easy to cut and it's cheap!
3. When spraypainting a multi-layer stencil, take the extra couple of seconds to mark off the corners of your first layer with chalk/paint so that you know exactly where to put the next layer (provided that all your stencils are the same size).
4. If you're spraypainting a stencil, lay off the spray cap a little. Shoot in small bursts or thin layers to keep the paint from bleeding under the stencil.
5. When washing painted tees and other clothing, flip them inside out to prevent the paint from fading.

P.N.G., Massachusetts, USA

1. The safest place to stencil is the lion's den, as they say. Try getting up on a police station's wall.

2. Working at dusk or the early morning is better than at 1:00 or 2:00 in the morning. Few people walk the streets. The police aren't looking as hard as they would late at night, and nobody's expecting any graffiti writing then.

3. Dark clothing is bad, unless you're going to be off the streets for most of the time and trespassing. Otherwise, stick to brighter/normal-looking street clothing.

4. Krylon and Wal-Mart are underrated paints for stencils; don't be fooled when people say you need Rustoleum or Montana. Sure they work, but if you're just starting out, you can't differentiate between them. You don't need such quality paint, so stick to the basics.

5. Don't do stencil graffiti just to vandalize. Nobody likes a rebel without a cause, so have a reason, and a lot of it, before you hit the streets. It's other people's property, and if nobody's going to get anything out of it (i.e., if they aren't going to hear your message or see something beautiful), then you shouldn't do graffiti. Vandalism is a waste of paint, and a pointless excuse for potentially winding up with fines and a criminal record.

ENDNOTES: CHRONOLOGY

1. "Chauvet Cave," Wikipedia: The Free Encyclopedia, http://en.wikipedia.org/wiki/Chauvet_Cave.

2. Clottes, Jean, et al, "Cosquer Cave," Bradshaw Foundation, http://www.bradshawfoundation.com/cosquer/.

3. Kelly, Chris, "Aboriginal Rock Art, Carnarvon National Park, Queensland, Australia," TRACCE, http://www.rupestre.net/tracce/carnarv.html.

4. Ibid.

5. Norman Laliberté and Alex Mogelon, The Art of Stencil (New York: Art Horizons, 1971), 7

6. Caroline Koebel and Kyle Schlesinger, Schablone Berlin (Arizona: Chax Press, 2005), 20

7. Ibid

8. "Shadow Puppetry," Wikipedia: The Free Encyclopedia, http://en.wikipedia.org/wiki/Shadow_puppetry

9. Susanne Schlapfer-Geiser, Scherenschnitte (Asheville: Lark Books, 1996), 118

10. Lawrence Mirsky, "Stenciling: Ornament & Activism," Ambush in the Streets, http://www.cooper.edu/art/lubalin/stencil.html

11. "The Art of the Pochoir Book," University Libraries, University of Cincinnati, http://www.libraries.uc.edu/libraries/arb/archives/exhibits2/Pochoir/Pochoir.html

12. "Explore/Highlights," The British Museum, http://www.thebritishmuseum.ac.uk/explore/highlights/highlight_objects/asia/s/stencil_for_a_five-figure_budd.aspx

13. Schlapfer-Geiser, 121

14. "Bingata," Wikipedia: The Free Encyclopedia, http://en.wikipedia.org/wiki/Bingata

15. "Playing card," Wikipedia: The Free Encyclopedia, http://en.wikipedia.org/wiki/Playing_card

16. "History," Consumer Specialty Products Association, http://www.aboutaerosols.com/industry/php

17. Bill Burns, "Edison's Electric Pen," FTL Design, http://electricpen.org/index.htm

18. "History," Consumer Specialty Products Association, http://www.aboutaerosols.com/industryphp

19. Stephen H. Van Dyk and Carolyn Siegel, "Introduction," Vibrant Visions, http://www.sil.si.edu/ondisplay/pochoir/intro.htm

20. "Screen-printing," Wikipedia: The Free Encyclopedia, http://en.wikipedia.org/wiki/Screen-printing

21. Alex Ward, "Power to the People," The Israel Museum Jerusalem, http://www.imj.org.il/eng/exhibitions/2004/russian/posters.html

22. Stephen H. Van Dyk and Carolyn Siegel, "Introduction," Vibrant Visions, http://www.sil.si.edu/ondisplay/pochoir/intro.htm

23. "History," Consumer Specialty Products Association, http://www.aboutaerosols.com/industry.php

24. Guido Indu, ed., Hasta la victoria, stencil!, (Buenos Aires: la marca ediora, 2004), 227-228

25. ILAB LILA, http://www.ilab.org/db/book1727_98927.html

26. "Aerosol paint," Wikipedia: The Free Encyclopedia, http://en.wikipedia.org/wiki/Aerosol_paint

27. Kirk Varnedoe, Jasper Johns A Retrospective, (New York: Museum of Modern Art, 1996), 174-175

28. "Ernest Pignon-Ernest – Interview," Les Artistes Contemporains, http://www.lesartistescontemporains.com/Artistes/pignon_ernest_interview.html

29. Richard Armstrong, Artschwager, Richard, (New York: Whitney Museum of American Art, 1988), 35-36

30. "Locations, 1969, and Blp's," Brooke Alexander Editions, http://www.baeditions.com/RA%20Details/Interview-Locations-Blps.htm

31. Guido Indu, ed., p. 221

32. "Graffiti," Wikipedia: The Free Encyclopedia, http://en.wikipedia.org/wiki/Graffiti#Pioneering_era_.281969-1974.29

33. Gloria Moure, Gordon Matta-Clark Works and Collected Writings, (Barcelona: Ediciones Polígrafa, 2006), 123

34. Larry Rivers, Drawings and Digressions, (New York: Clarkson N. Potter, Inc., 1979), 249

35. Josh MacPhee, Stencil Pirates, (Brooklyn: Soft Skull Press, 2004), 14

36. John Fekner, interview

37. Gee Vaucher, interview

38. Jef Aérosol, interview

39. Peter Walsh, "Mapping Social and Cultural Space: The Ramifications of the Street Stencil" (1996)

40. MacPhee, 16

41. Scott Williams, interview

42. Ibid

43. Rick Kang, "Blek le Rat," Format, no. 21 (2007), http://formatmag.com/art/spraycan-stories/blek-la-rat/

44. Guido Indu, ed., p. 222

45. The SubGenius Foundation, The Book of the SubGenius, (New York: Simon & Schuster, Inc., 1983),165

46. MacPhee, 98

47. Ibid., 90

48. D.S. Black, "From the Grey Ranks," Processed World, no. 26/27 (1991), http://www.processedworld.com/Issues/issue26_27/i26greyranks.html

49. Lincoln Cushing, "The Chilean Cultural Exchange Project," COMMUNITY MURALS MAGAZINE, Spring (1986), http://www.docspopuli.org/articles/Chile/ChileCulture.html

50. Jef Aérosol, interview

51. Peter Kuper interview

52. Scott Williams, interview

53. MacPhee, 80

54. Chris Carlsson interview

55. "Banksy", Wikipedia: The Free Encyclopedia, http://en.wikipedia.org/wiki/Banksy

56. Tara Mulholland, "From street to gallery, the pochoir artist arrives," International Herald Tribune, November 10 (2006), http://www.iht.com/articles/2006/11/10/features/pochoir.php?page=2

GLOSSARY

Bridges
Small, uncut parts of the paper or plastic board/sheet that hold the cut stencil image together.

Buff
Eradicating stencil graffiti via painting over the work or by using chemicals to remove the paint.

Getting up
Going out and painting stencil graffiti on walls, sidewalks, mailboxes, etc.

Islands
The negative space that you cut out, creating the image that you will paint through.

Overspray
Instead of a fine or sharp painted edge, stencils can sometimes cause fuzzy edges when the cut stencil is not flat on the painted surface.

Spray cap
The cap of a spraypaint can. Different caps have different desired spray widths and volumes.

Stencil
A tool, usually made from plastic or paper, that has text and/or images cut out of it. It is also the image that the cut stencil creates after paint, bleach, etc. has been pushed through the negative space. Stencil is used as a verb to signify the act of painting with the tool.

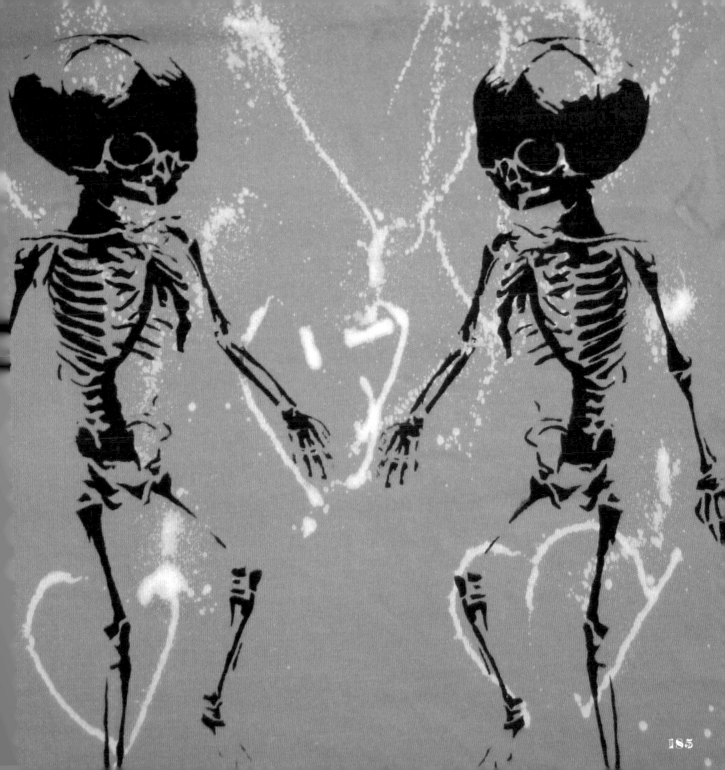

RESOURCES: ONLINE

ARTISTS AND GROUPS

http://www.adam5100.com/

http://www.amyrice.com/

http://www.arofish.org.uk/arofish/

http://www.banksy.co.uk/

http://www.chrisstain.com

http://jefaerosol.free.fr/

http://www.johnfekner.com/

http://klutch.org/

http://www.loganhicks.com/

http://www.m-city.org/

http://www.stensoul.com/ (Peat Wollaeger)

http://www.pixnitproductions.com/

http://streetartworkers.org/

http://soule5675.mosaicglobe.com/ (KiM McCarthy)

http://tiagodenczuk.blogspot.com/

COLLECTIONS, GATHERINGS, PUBLICATIONS, ETC.

http://www.stencilarchive.org/

http://www.stencilrevolution.com/

http://woostercollective.com/

http://www.overspraymag.com/

http://groups.myspace.com/stencil

http://stencilstribe.tribe.net/

http://www.stencilfestival.com/

http://www.nuart.no/nuart/

http://www.difusor.org/

http://www.artofthestate.co.uk/

http://www.vinylkillers.com/

http://www.flickr.com/groups/stencils/

http://www.flickr.com/groups/wwwflickrcomgroupsstencil/

DOCUMENTARIANS

http://www.duncancumming.co.uk/

http://www.drexlermusic.com/ (David Drexler)

http://www.flickr.com/photos/60812181@N00/ (jnj_sh_graffitecture)

http://www.designwallah.com/photography/ (Francis Mariani)

http://worldofstencils.blogspot.com/ (Maya)

http://txmx.de/ (Thomas Müller)

http://tino.ca/ (Martin Reis)

http://flickr.com/photos/mayu/ (Mayu Shimizu)

http://www.flickr.com/photos/hey-gem/ (Gem)

http://flickr.com/photos/treetop_apple_juice (Gem)

A FEW MORE STENCIL NATION CITIZENS

http://www.papermonster.org/

http://tehranwalls.blogspot.com/ (A1one)

http://dolk.blogspot.com/

http://www.gayshamesf.org/

http://www.flickr.com/groups/sf-salt/

http://colectivozape.blogspot.com/

http://www.myspace.com/losartejaguar

http://www.faile.net/

http://www.funk25.net/

http://www.flickr.com/photos/prvrt

http://www.n1Oz.com/ (Jeremiah Garcia)

http://www.justseeds.org/artists/erik_ruin/

http://www.artiste-ouvrier.com/

http://www.boxi.eu.com/

http://www.phibs.com/

STENCIL BIBLIOGRAPHY

Aérosol, Jef. VIP: Very Important Pochoirs. Paris, FR: Alternatives, 2007.

Banksy. Banging Your Head Against a Brick Wall. London, UK: Weapons of Mass Distraction, 2001.

Banksy. Cut It Out. London, UK: Banksy, 2004.

Banksy. Existencilism. London, UK: Weapons of Mass Distraction, 2002.

Banksy. Wall and Piece. London, UK: Random House, 2007.

C100. The Art of Rebellion: World of Street Art. Corte Madera, CA, USA: Gingko Press, 2003.

C100. The Art of Rebellion 2: World of Urban Art Activism. Corte Madera, CA, USA: Gingko Press, 2006.

C215. Stencil History X. Paris, FR: C215, 2007.

Claessen, Thordis. Icepick: Icelandic Street Art. Corte Madera, CA, USA: Gingko Press, 2007.

Deville, Nicolas, Marie-Pierre Massé, and Josian Pinet. Vite Fait, Bien Fait. Paris, FR: Editions Alternatives, 1986.

Dew, Christine. Uncommissioned Art: The A-Z of Australian Graffiti. Melbourne, AU: Melbourne University Publishing, 2007.

Huber, Joerg. Paris Graffiti. Paris, FR: Thames and Hudson, 1986.

Indij, Guido, ed. 1000 Stencil Argentina Graffiti. Buenos Aires, AR: La Marca Editoria, 2007.

Indij, Guido, ed. Hasta La Victoria, Stencil! (Colleccion Registro Grafico). Buenos Aires, AR: La Marca Editoria, 2004.

Koebel, Caroline, and Kyle Schlesinger. Schablone Berlin. Tucson, AZ, USA: Chax Press, 2005.

MacNaughton, Alex. London Street Art. London, UK: Prestel, 2006.

MacPhee, Josh. Cut & Paint, 1-2. Chicago, IL, USA: Just Seeds, 2004, 2006.

MacPhee, Josh. Stencil 'zine, 1-4. Chicago, IL, USA: Just Seeds.

MacPhee, Josh. Stencil Pirates. Brooklyn, NY, USA: Soft Skull Press, 2004.

Manco, Tristan. Stencil Graffiti. New York, NY, USA: Thames and Hudson, 2002.

Nyman, Carl, Jake Smallman. Stencil Graffiti Capital: Melbourne. New York, NY, USA: Mark Batty Publisher, 2005.

Pierson, Solange, Kriki, et al. Pochoir a la Une. Paris, FR: Editions Paralleles, 1986.

Robinson, David. Soho Walls. London, UK: Thames and Hudson, 1990.

Wolbergs, Benjamin. Urban Illustration Berlin: Street Art Cityguide. Corte Madera, CA, USA: Gingko Press, 2007.

PHOTO CREDITS

ORIGINS

10-Klutch, Portland, OR

13-Top L-photo: D.S. Black, San Francisco, CA, 1989**-Top R-**Scott Williams, San Francisco, CA, photo: Russell Howze, 1990**-Bottom R-**Cockroach, Rats and Trolley by Jef Aérosol, Villeneuve d'Ascq, FR, 1986**-Bottom L-**Beauty's Only Street Deep by John Fekner & Don Leicht, Wooster on Spring Project, New York, NY, photo: Jeewon Shin, ©2006-2008

John Fekner: 18-Top-No TV, Jackson Heights, NY, ©1980-2008**-Bottom-**Rust Decay, Bayside, NY, ©1980-2008 **19-Top-**Asphalt Indian Trails, Manorville, NY, photo: Don Fiorino, ©1979-2008**-Middle-**My Ad is No Ad, Sunnyside, NY, photo: Don Fiorino, ©1980-2008**-Bottom-**Toxic Waste Barrels, Woodside, NY, ©1982-2008 **20-Clockwise-**Deer, Bayside, NY, ©1982-2008; NY&DK 4 Ever, Coney Island, Brooklyn, NY, photo: Bridgette Gorman, ©1981-2008; Decay, Roslyn, NY, ©1980-2008 **21-**Broken Promises/Decay, South Bronx, NY, ©1980-2008 (all photos courtesy of John Fekner Estate)

Jef Aérosol: 22-Top L-Death in Venice, Venice, IT, 2006**-Top L-**Lennon Jagger, London, UK, 2007**-Bottom R-**Marc Bolan, London, UK, 2007**-Bottom L-**Think Slow, Armentiéres, FR, 2007 **23-Clockwise-**Nick Drake, Lyon, FR, 2007; Paul Auster, Lille, FR, 2007; J.M. Basquiat, 2006 **24-Clockwise-**Vanessa Redgrave, Trier, DE, 1988; Slow Death 3, 1987; 4 poses, Paris, FR, 1985; Shake Some Action, Lille, FR, 1984 **25-Clockwise-**Natalys, Lille, FR, 1986; leather jacket, Lille, FR, 1985; Painting Vanessa Redgrave, photo: Christoph Maisenbacher, Trier, DE, 1988; Making Faces, photo: AsmodeÐe, Lille, FR, 1985

Scott Williams: 26-Top-2004**-Bottom-**2004 **27-Top-**2004**-Bottom-**Strange Beast, 1987-1990 **28 to 29-Left-**Social Illusionism**-Middle-**untitled**-Right-**Valencia (all photos: Russell Howze, San Francisco, CA)

D.S. Black: 30-Clockwise-1985; 1985; 1990; 1986 **31-Clockwise-**1990; 1988; 1991; 1989; 1991; 1985; 1988; 1985 (all photos San Francisco, CA)

STENCIL NATION CITIZENS - ARTISTS

32-Nerve System by Logan Hicks

Adam5100: all art and photos: Adam5100

Amy Rice: 44-Clockwise-Forecast Spring Door; Discovering Fuzzy with Blossoms; Eggs; Keep Spring in Your Heart; You Can Hold the Bunny if I Can Wear the Mask; Accordion; Bday Party Pony **45-Clockwise-**Set a Course; Wings (with Attitude); Make a Wish; Lepidopterist; Anemone Triptique; Listen

Arofish: 46-Clockwise-Cleaning Up the Streets, Beirut, LB; Walking, Baghdad, IQ; Trash TV, Beirut, LB; A View to Peace, Abu Dis, PS, photo: N. Tomasini, Jan. 2004 **47-Clockwise-**Old Palestinian Man, Nablus, PS, Jan. 2004; Family Portrait, Baghdad, IQ; Spraying Family Portrait, Baghdad, IQ, photo: Tom A. Peter; Shells and Skulls, London, UK; Strawman, London, UK

Banksy: 48-Clockwise-Naples, IT; photo: anonymous, London, UK; Naples, IT; photo: anonymous, Glastonbury, UK **49-Clockwise-**Berlin, DE, 2004; 2002; Berlin, DE, 2004; photo: Duncan Cumming, Bristol; Naples, IT, 2003; photo: anonymous, Liverpool, UK; Berlin, DE; photo: PodP, Berlin, DE, 2006 (all other photos: Thomas Müller)

Chris Stain: 50-Clockwise-wheatpastes, w/Josh MacPhee, Albany, NY; Drive On, Braddock, PA; Winter, Baltimore, MD; Brooklyn, Brooklyn, NY **51-Clockwise-**Door, Braddock, PA; Jackhammer, MA; Warsaw Ghetto, MA; Sweety, Braddock, PA

Hao, Paris: 52-Clockwise-She Devil; Kula Tiki; Burn Tiki Burn; Moai Fish; Know My Enemies; Kosmopolite, 2005 **53-Clockwise-**Spraycan Tiki; Happy & Happy; Tribal Masks; Hot & Bad; Dream; Outlaw

STENCIL NATION CITIZENS - DOCUMENTARIANS

GALLERIES, SHOWS, GATHERINGS

Vinyl Killers: **102-Bottom Row (l-r)-**Mr. Prvrt; Chris Stain; Beefcon, DOLK **103-top left, bottom row-**photos: Russell Howze (all other photos: Klutch)

In the Streets

104-photo: Russell Howze, San Francisco, CA
Buffed, covered, crossed, ripped 110-Top Row (l-r)-San Francisco, CA; San Francisco, CA; Tel Aviv, IL**-Bottom Row (l-r)-**Jerusalem, IL; art and photo: Jef Aérosol, Lyon, FR; art by DOLK, Lisbon, PT, photo: Maya World of Stencils **111-Clockwise-**art and photo: boxi, DE; San Francisco, CA; Gay Shame by Gay Shame, San Francisco, CA; London, UK; San Francisco, CA; Portland, OR; Chicago, IL (all other photos: Russell Howze)
Conversations 112-Clockwise-photo: Duncan Cumming, Dundee, Scotland, UK; New York, NY; She Loves the Moon by The Strangers, San Francisco, CA; San Francisco, CA; Tel Aviv, IL; Portland, OR; She Loves the Moon by The Strangers, San Francisco, CA; Jerusalem, IL; photo: Thomas Müller, Hamburg, DE; Stop Bush, Burlington, VT; Alfred E. Neuman, San Francisco, CA; San Francisco, CA; London, UK **113-Top-**Hosier Lane, Melbourne, AU, photo: Logan Hicks**-Bottom-**London, UK (all other photos: Russell Howze)
Horizontal Placement 114-Clockwise-Do the Abu, San Francisco, CA; Taxes 4 Terror, San Francisco, CA; Never Again!, San Francisco, CA; Queers on Gears, San Francisco, CA; San Francisco, CA; Oakland, CA; Empire, San Francisco, CA **115-Clockwise-**MLK, San Francisco, CA; Boombox Bike, New York, NY; Dancers, San Francisco, CA; San Francisco, CA; Astronaut, San Francisco, CA; by Claire, San Francisco, CA; San Francisco, CA, (all photos: Russell Howze)
Vertical Placement 116-Clockwise-by Nemo, Paris, FR, photo: PaperMonster; San Francisco, CA; San Francisco, CA; by Gigantic, San Francisco, CA; San Francisco, CA; London, UK **117-Clockwise-**San Francisco, CA; Jerusalem, IL; Bush Bombs, art and photo by A1one, Thran, IR; art and photo: Shlomo Faber, Dresden, DE; New York, NY; New York, NY (all other photos: Russell Howze)

Cities of Stencil Nation

118-Smek, Colectivo Arte Jaguar, Oaxaca, MX, photo: Itandehui Franco Ortiz
Black Rock City, NV **122-lower right-**"Steakhouse" Pritchett & Jared "Jast" Davey for Radio Free Valhalla (all photos: Russell Howze, courtesy of www.burningman.com)
Montreal, CA **124-Clockwise-**MOR; FDOE; MOR; unknown **125-top right-**Young People's Foundation Collective (all photos: Francis Mariani)
Oaxaca, MX 126-Clockwise-photo: Peter Kuper; Ana Santos; Smek, Colectivo Arte Jaguar; untitled; photo: B. Rex **127-Clockwise-**photo: B. Rex; colectivo revolver; Beta, Asaro; Beta y Yezka, Asaro; untitled; photo: Peter Kuper; untitled **128thru129-Clockwise-**Colectivo Arte Jaguar, photo: Peter Kuper; Aler, Colectivo Arte Jaguar; Ser, ak Crew; Vil, Colectivo Zape (all other photos: Itandehui Franco Ortiz)
San Francisco, CA 130 to 131-Top Row-1998; 2007; 2006; Mung by En, 2005; 2006; Margaret, 2006**-Middle Row-**2007; 2+2=5, 2006; Against War, 2007; PNEU, 2003; 2007**-Bottom Row-**2003; 2007; 2004; 2007; 2005 **132-Clockwise-**2006; 2005; Above, 2002; 2005 **133-Clockwise-**Craig McPhee, 2004; Swoon, 2003; Niz, 2007; 2007 (all photos: Russell Howze)
Taipei, TW 134-Top Row-photo: Gem; photo: Gem**-Middle Row-**Granix, photo: Mayu Shimizu; photo: Mayu Shimizu; photo: Gem; photo: Mayu Shimizu**-Bottom Row-**Shepard Fairy, photo: Gem; photo: Gem; art and photo: LSB **135-Clockwise-**Brother, photo: Mayu Shimizu; photo: Gem; photo: Mayu Shimizu; photo: Gem; photo: Gem; EZO, photo: Mayu Shimizu
Tel Aviv, IL 136-Lower Left-AME72 (all photos: Russell Howze, 2007)
Tokyo, JP 138-Clockwise-photo: JNJ Graffitecture; photo: Mayu Shimizu; photo: Mayu Shimizu; photo: Mayu Shimizu; Dense, photo: JNJ Graffitecture **139-Clockwise-**photo: JNJ Graffitecture; photo: Mayu Shimizu; photo: JNJ Graffitecture; photo: Mayu Shimizu; photo: JNJ Graffitecture

STENCIL MEDIUMS

(all photos: Russell Howze unless otherwise stated)

140-art and photo: Adam5100

Cutout Stencils 146-Clockwise-Phibs, photo: Logan Hicks; Josh MacPhee, Claude Moller with Russell Howze, San Francisco, CA, 2005; Nikki Sudden art and photo: Jef Aérosol, 2007; Pez, San Francisco, CA, 2005; art and photo: Logan Hicks; San Francisco, CA, 2004 **147-Clockwise-**Ciclofficina art and photo: Herzog, Vicenza, Italy; New York, NY, 2006; Salt, San Francisco, CA, 2005; Mind Fuck, photo: Thomas Müller, Hamburg, DE **148-**art and photo: PaperMonster **149-**Deathless art and photo: boxi, DE

Fabric 150-Clockwise-Cancun, MX, 2003; art and photo: PaperMonster, Madison, NJ; San Francisco, CA, 2006 **151-Clockwise-**Iowa City, IA, 2006; Cancun, MX, 2003; San Francisco, CA, 2006; San Francisco, CA, 2006

Found Objects 152-Clockwise-Craig McPhee, San Francisco, CA, 2003; San Francisco, CA, 2003; New York, NY, 2003; sucht, Hamburg, DE, photo: Thomas Müller; Quasikunst, Hamburg, DE, photo: Thomas Müller **153-Clockwise-**San Francisco, CA, 2002; We Bee Walkin' Through art and photo: Ephemera, Innsbruck, AT; Eugene, OR, 2005; funk25, Copenhagen, DK; vierkommafunffreunde, Hamburg, DE, photo: Thomas Müller **154-**art and photo: Julie Shiels, AU **155-**PNEU, San Francisco, CA

Murals and Large Stencils 156 to 157-Clockwise-art and photo: Amy Rice; Doctor H, is bach, Difusor, Barcelona, ES, photo: Maya World of Stencils, 2007; Kontra, San Francisco, CA, 2005; Scott Williams, San Francisco, CA, 2000; boxi & Kowalski, photo: boxi; Klutch, -struct, and Ashley Montague, Portland, OR, 2004; Josh MacPhee, Claude Moller with Russell Howze, San Francisco, CA, 2004 **158-**Fragil, Difusor, Barcelona, ES, photo: Maya World of Stencils, 2007 **159-Top-**Claude Moller, San Francisco, CA, 2004**-Bottom-**San Francisco, CA, 2004 **160 to 161-**Scott Williams, San Francisco, CA, 2000

Paper 162-Clockwise-photo: Martin Reis, Toronto, ON, CA; Brooklyn, NY, 2006; art and photo: funk25, Hamburg, DE; San Francisco, CA, 2007 **163-Clockwise-**art by Mr. Prvrt, Dwell, Unit, Montreal, CN, photo: Mr. Prvrt; art and photo: biafra, Neenah, WI; Sacramento, CA, 2003 **164-Clockwise-**San Francisco, CA, 2005; ALIAS, Hamburg, DE, photo: Thomas Müller; Chicago, IL, 2006; Los Piratos, Hamburg, DE, photo: Thomas Müller **165-**Sub, San Francisco, CA, 2005

Vinyl 166-Top Row-Ripper 1331, Vinyl Killers, Portland, OR, photo: Klutch; Adam5100, San Francisco, CA, 2004; photo: Thomas Müller, Hamburg, DE**-Middle Row-**art and photo: Nils Westergard, Washington, DC; struct, Vinyl Killers, Portland, OR, photo: Klutch; Scott Williams, San Francisco, CA, 2007**-Bottom Row-**Mephisto Jones, Vinyl Killers, Portland, OR, photo: Klutch; photo: Thomas Müller, Hamburg, DE; art and photo: Klutch, Vinyl Killers, Portland, OR **167-Clockwise-**art and photo: Klutch, San Francisco, CA, 2005; Eelus, Vinyl Killers, Portland, OR, photo: Klutch; art and photo: Hao; art and photo: Mr. Prvrt, Albany, NY; J. Grider, Vinyl Killers, Portland, OR, photo: Klutch

Stickers 168-Clockwise-Salt, San Francisco, CA, 2005; San Francisco, CA, 2007, photo: Thomas Müller, Hamburg, DE; Brooklyn, NY, 2003; art and photo: Hao, Paris, FR **169-Clockwise-**San Francisco, CA, 2005; PNEU; San Francisco, CA, 2004; photo: Thomas Müller, Hamburg, DE; San Francisco, CA, 2007; 2+2=5, San Francisco, CA, 2006; San Francisco, CA, 2005 **170-**San Francisco, CA, 2007 **171-**San Francisco, CA, 2004 Canvas and Wood **172 to 173-Clockwise-**art and photo: Nils Westergard, Washington, DC; Craig McPhee, San Francisco, CA, 2004; PaperMonster, Madison, NJ; art and photo: Billy Mode; art and photo: boxi, DE; San Francisco, CA, 2006

ARTISTS' TIPS **175-**Bill Hilly the Stencilbilly by Peat Wollaeger, photo: David Weaver, 2007
GLOSSARY **185-**art and photo: Soule
PHOTO CREDITS **192-**art and photo: A1one, Tehran, IR

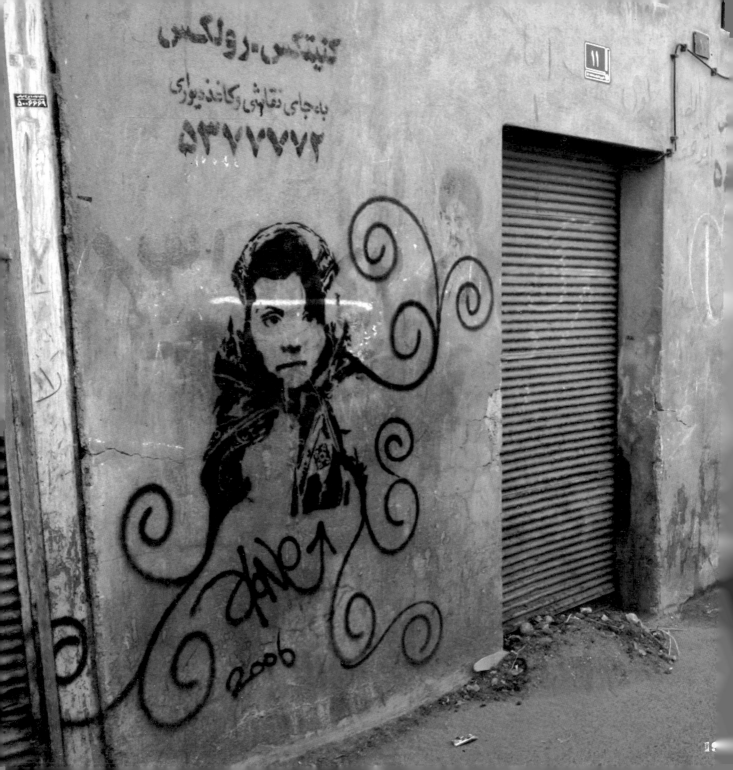